MANGA
MANIA

BISHOUJO

CHRISTOPHER
HART

WATSON-GUPTILL PUBLICATIONS/NEW YORK

MANGA MANIA

BISHOUJO

HOW TO DRAW THE ALLURING WOMEN OF JAPANESE COMICS

Dedicated to Francesca and Isabella

Executive Editor: Candace Raney
Senior Development Editor: Alisa Palazzo
Designer: Bob Fillie, Graphiti Design, Inc.
Production Manager: Hector Campbell

Published in 2005 by
Watson-Guptill Publications
a division of VNU Business Media, Inc.
770 Broadway
New York, NY 10003
www.wgpub.com

Library of Congress Cataloging-in-Publication Data
Hart, Christopher.
 Manga mania bishoujo : how to draw the alluring women
of Japanese comics / Christopher Hart.
 p. cm.
Includes index.
ISBN 0-8230-2975-1 (pbk.)
1. Women in art. 2. Comic books, strips, etc.—Japan—Technique.
3. Cartooning—Technique. I. Title.
NC1764.8.W65H375 2005
741.5'0952—dc22
 2005001344

Printed in the United States

1 2 3 4 5 6 7 8 9 / 13 12 11 10 09 08 07 06 05

CONTRIBUTING ARTISTS:

Diana F. Devora: 8, 50–59, 60–65, 70–75,
 88–91, 98, 99, 118
Vanessa Duran: 4, 22, 23, 68, 69, 126, 127
Christopher Hart: 6, 24–37, 66, 67
Atsuko Ishida: 100–113
Roberta Pares Massensini: 128–143
Maki Michaux: 114–117
Romy: 49, 92–97
Aurora G. Tejado: cover, 2, 3, 9–21, 38,
 39, 40–48, 119–125
Cindy Yamuchi: 76–87

Color by MADA Design, Inc., with the
exception of pages 76, 79, 81, 83, 85, 87,
92, 93, 100, 101, 103–113 by the artists

VISIT US AT
www.artstudiollc.com

CONTENTS

INTRODUCTION

I'm very excited to introduce you to what I believe is, by far, the most comprehensive, authentic and eye-catching book on *bishoujo*—an incredibly popular genre of manga. *Bishoujo* is a Japanese term that means *beautiful women*. Knowing how to draw beautiful women is an essential skill for every aspiring *mangaka (manga artist)*. The bishoujo genre encompasses a wide range of character types and subgenres, from uniformed schoolgirls to the immensely popular Magical Girl subgenre, and from heroic fighter pilots of the Sci-Fi genre to fairies, martial arts masters, undercover agents, the Urban Chic subgenre, and much, much more.

Have you ever had difficulty drawing dazzling women? Most artists have. Drawing the beautiful eyes, the gentle contours of the face and figure, the hair, the lips, all of it can either make or break a drawing. This book is the definitive resource on how to draw beautiful women. As you flip through the pages, you'll see the widest possible assortment of bishoujo characters in a variety of styles. As an aspiring artist, you should have exposure to the entire spectrum of styles so that your work remains exciting and current.

This book is comprehensive like no other. To start, it breaks down—into clear and easy-to-follow instructions—exactly how to draw the eyes so that they glisten and beam with expression. Eyelashes, eyebrows, pupils, and irises are all explained and illustrated in such detail that nothing will remain a mystery to you. Then follows the section devoted to drawing the mouth in various positions and expressions. Moving on, you'll learn how to draw the attractive female head in every conceivable angle, which will give you confidence as an artist and allow you to create your own characters in any position, in any scene. All of the latest and most appealing hairstyles are shown, as are facial expressions, emotions, the body, posture, body language, action poses, character types, costumes, and hands and feet.

Did I leave out anything? I don't think so. But there's more! A section on glamour, which shows you the secret to turning ordinary females into sparkling beauties. You'll learn how to draw two characters together in a scene so that you won't have to draw scenes with only one figure anymore. And as a bonus, there's a fabulous section on the fighting women of the famous Magical Girl subgenre. It's a dazzling section sure to inspire you to put pencil to paper.

Not only will this book show you how to draw manga, but it will also improve your drawing skills in general. You'll be learning the solid art principles used by top professional manga illustrators. So, whether you're a big-time manga fan or you draw American-style comic book art, you'll get valuable drawing instruction.

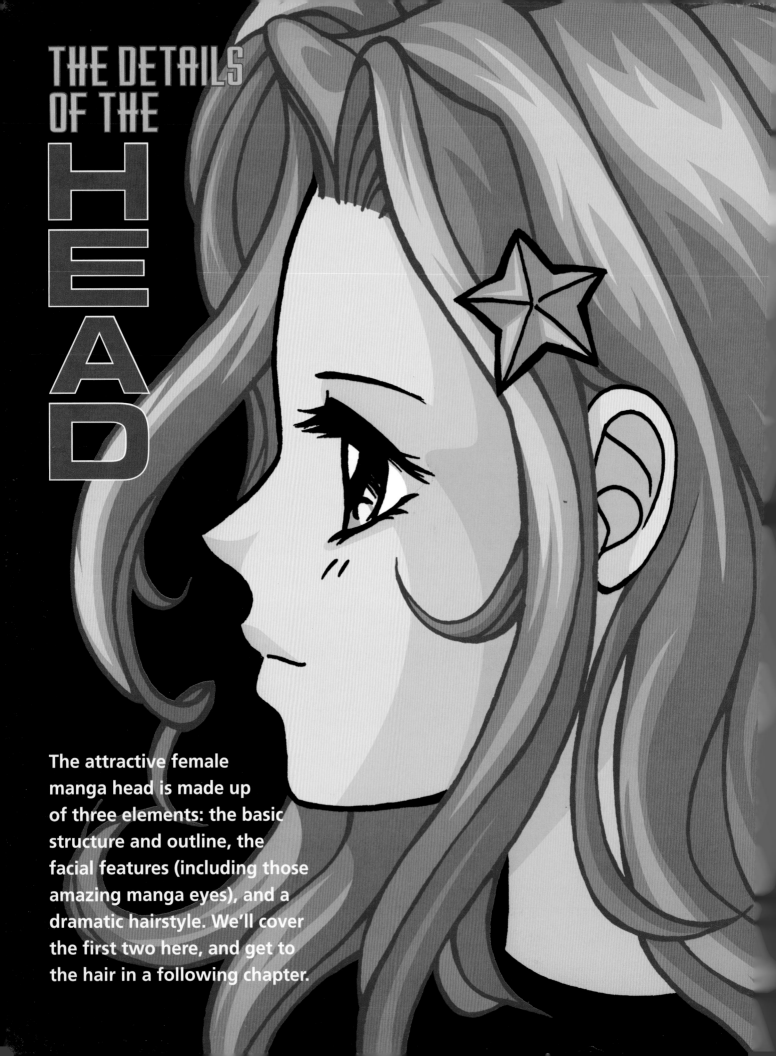

THE DETAILS OF THE

HEAD

The attractive female manga head is made up of three elements: the basic structure and outline, the facial features (including those amazing manga eyes), and a dramatic hairstyle. We'll cover the first two here, and get to the hair in a following chapter.

Enchanting eyes are an essential part of the beautiful women of manga. Eyes are the focus of the face and are more important to the expression than any other feature. They make a stronger statement about the character than even the costume. Who has ever seen a seductive villainess without long elegant eyelashes, or a pretty heroine without large glistening eyes? The eyes create the character. In fact, you could almost say that the character is created around the eyes.

Most beginners use the same shape of eye for every female character they create. But eyes are not "one size fits all." Different character types require different eye shapes. A young girl will have a different eye shape than a twentysomething-year-old woman.

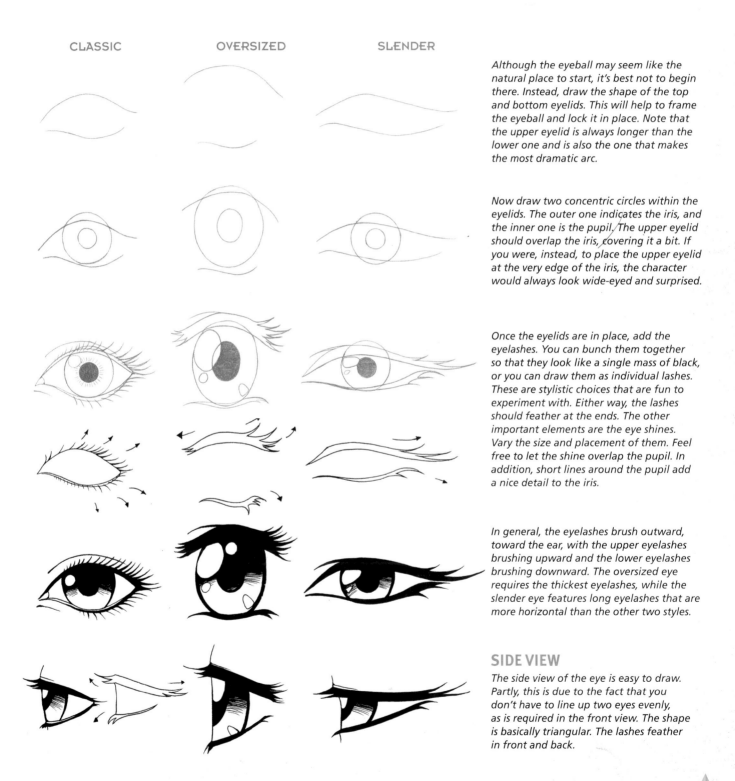

CLASSIC OVERSIZED SLENDER

Although the eyeball may seem like the natural place to start, it's best not to begin there. Instead, draw the shape of the top and bottom eyelids. This will help to frame the eyeball and lock it in place. Note that the upper eyelid is always longer than the lower one and is also the one that makes the most dramatic arc.

Now draw two concentric circles within the eyelids. The outer one indicates the iris, and the inner one is the pupil. The upper eyelid should overlap the iris, covering it a bit. If you were, instead, to place the upper eyelid at the very edge of the iris, the character would always look wide-eyed and surprised.

Once the eyelids are in place, add the eyelashes. You can bunch them together so that they look like a single mass of black, or you can draw them as individual lashes. These are stylistic choices that are fun to experiment with. Either way, the lashes should feather at the ends. The other important elements are the eye shines. Vary the size and placement of them. Feel free to let the shine overlap the pupil. In addition, short lines around the pupil add a nice detail to the iris.

In general, the eyelashes brush outward, toward the ear, with the upper eyelashes brushing upward and the lower eyelashes brushing downward. The oversized eye requires the thickest eyelashes, while the slender eye features long eyelashes that are more horizontal than the other two styles.

SIDE VIEW

The side view of the eye is easy to draw. Partly, this is due to the fact that you don't have to line up two eyes evenly, as is required in the front view. The shape is basically triangular. The lashes feather in front and back.

More Captivating Eyes

Here are a few more popular eye types, divided into two categories. The top row represents the cleaner, simpler look, with bold crisp lines and no sketch marks. The bottom row features sketchier eyelids and lashes, as well as shading on the eyeball itself. The top look is used for younger characters, and the Fantasy and Sci-Fi genres. The bottom row is more for romantic and alluring characters.

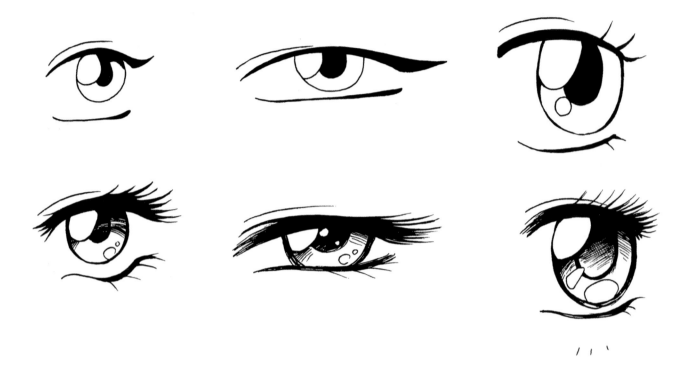

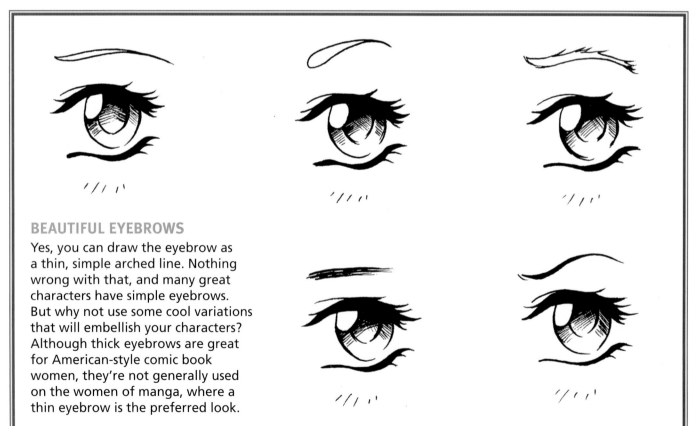

BEAUTIFUL EYEBROWS

Yes, you can draw the eyebrow as a thin, simple arched line. Nothing wrong with that, and many great characters have simple eyebrows. But why not use some cool variations that will embellish your characters? Although thick eyebrows are great for American-style comic book women, they're not generally used on the women of manga, where a thin eyebrow is the preferred look.

Do you draw full lips or a single line? Do you use continuous or broken lines? Only female characters have full lips. And thicker lips are, generally, for more mature characters. Also, the more attractive the character, the thicker the lips should be.

Leaving some lines broken is a cool look, because the eye naturally tends to fill in the gaps in the lines. With the broken-line style, you can place an accent mark just above the central dip in the middle of the upper lip and a small shadow below the bottom lip.

When the mouth is open, the upper teeth tend to show; the bottom ones do not, unless the character is angry. The upper teeth are not indicated with a straight line across the mouth but with an upward-curving one. Or, the lips give form to the teeth, as in the bottom left example. In the side view, the top lip protrudes with an overbite, extending beyond the lower lip.

| FULL | BROKEN LINES—WITH TOP LIP INDICATED | BROKEN LINES—WITHOUT TOP LIP INDICATED |

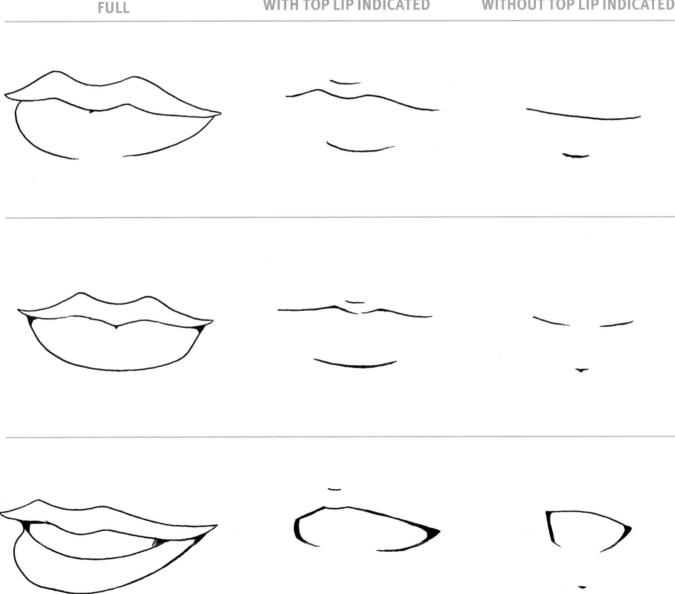

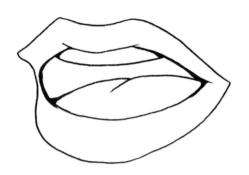

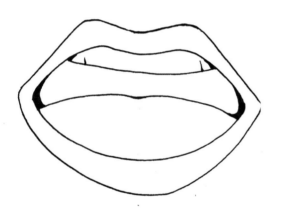
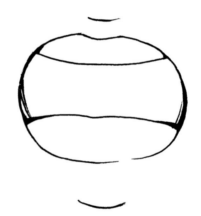

In manga, when the mouth is open the tongue can occupy up to 3/4 of the area inside the mouth.

Note that there's always some black shading around the edges of the teeth to indicate the spaces between the teeth and the inside of the cheeks.

As on the previosu page, the simpler mouth eliminates the small line above the top lip altogether. Generally, this style of mouth should be small. If it's wide, the absence of that small line becomes more curious.

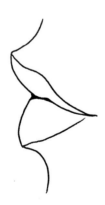
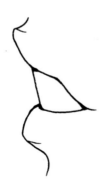

When the mouth opens slighly in profile, that opening doesn't break the solid line that makes up the outline of the face.

Smiles can be drawn in many different ways. Compare the four here:

Simple but effective, with a shine on the bottom lip.

A typical full-lipped smile

Emphasizing strong shadows.

Showing a bit of teeth.

CREATING EXPRESSIONS

Beautiful manga characters have a subdued look that makes them alluring. But when they react, they do so with big emotions. There are no wallflowers in manga!

A character won't lose her femininity when she has a big outburst of emotion, so long as she returns to her softer side once the moment of agitation subsides.

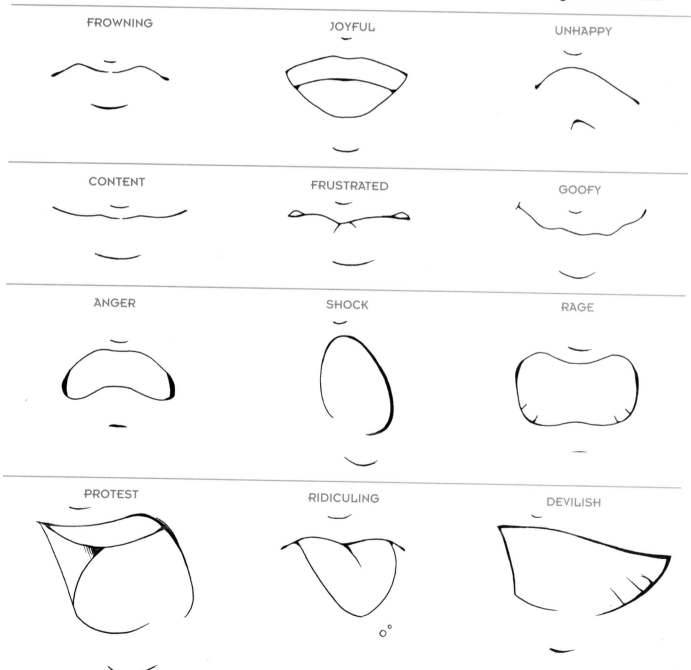

FROWNING JOYFUL UNHAPPY

CONTENT FRUSTRATED GOOFY

ANGER SHOCK RAGE

PROTEST RIDICULING DEVILISH

The Head in Four Ridiculously Simple Steps

The outline of the head should be simple and subtle—no hard angles, except for the famous pointed manga chin. Allow the eyes and hair—not the shape of the head—to provide the glamour. And, don't rush; for the best results, approach this in a thoughtful way.

FRONT

This is a typical manga girl who, depending on her costume, could be anywhere from sixteen to twenty years of age. A great deal depends on costuming, as you'll see in later chapters.

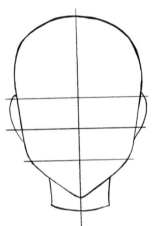

The basic face must be wide to accommodate the large eyes. Sketch a vertical center line down the middle to make sure everything lines up evenly on both sides of the face, and sketch three horizontal guidelines across the lower half of the face.

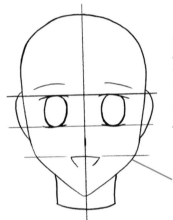

The eyes go between the two top horizontal guidelines, and the tops of the eyes are level with the tops of the ears (the top line). The third guideline (the bottom one) is where the mouth goes. It should appear at the point where the jawline angles in toward the chin.

JAW ANGLES IN TOWARD THE CHIN AT SAME LEVEL AS MOUTH

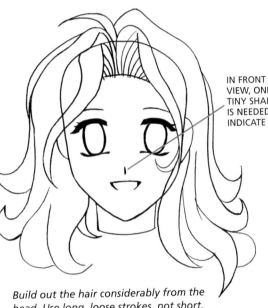

IN FRONT VIEW, ONLY A TINY SHADOW IS NEEDED TO INDICATE NOSE

Build out the hair considerably from the head. Use long, loose strokes, not short, choppy ones. Let the hair fan out as it cascades down to the shoulders. You can also now erase the guidelines, and start darkening the eyelashes.

Create elaborate and elegant eyelashes. Draw additional strands of hair, which will underscore the flowing feeling.

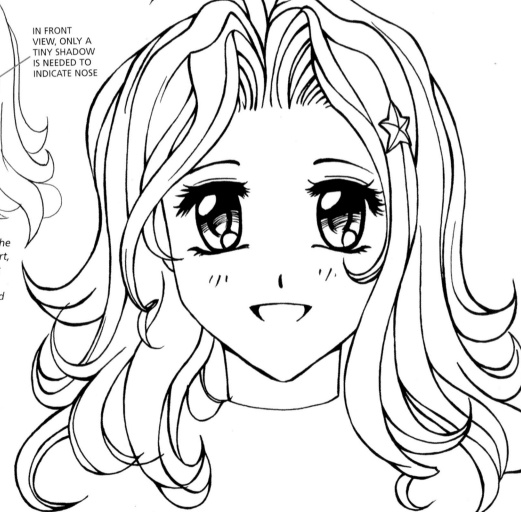

PROFILE

In order to maintain the character's femininity in the side view, it's essential to emphasize the curve of the forehead, and allow it to gently sweep into the bridge of the nose. There should be a considerable amount of head behind the ears. The underside of the jaw should always look soft, never bony, and it should rise up to the ear on a gentle curve.

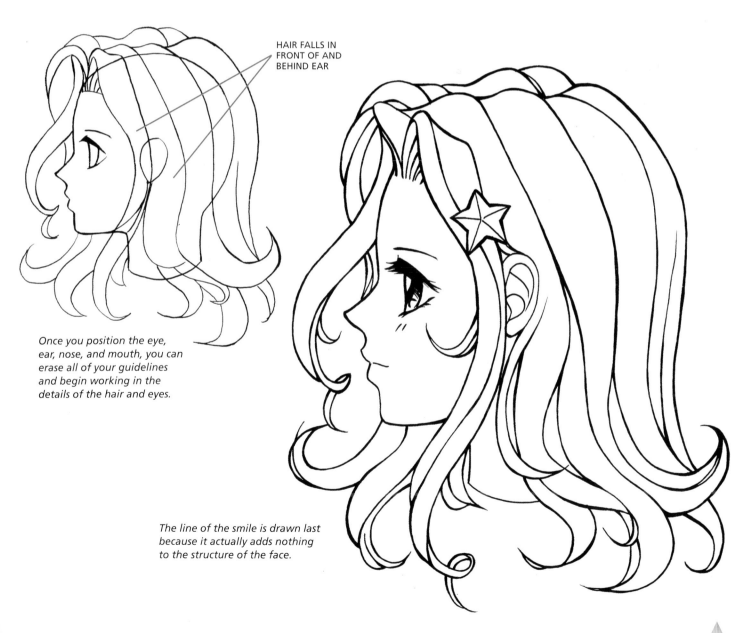

The front of the face is first drawn as a straight vertical line. Then the bridge of the nose is created, along with a diagonal line from the tip of the nose to the point of the chin.

The tip of the nose, the lips, and the chin all appear along the diagonal line running from the nose to the chin.

SIGNIFICANT MASS TO BACK OF HEAD

HAIR FALLS IN FRONT OF AND BEHIND EAR

Once you position the eye, ear, nose, and mouth, you can erase all of your guidelines and begin working in the details of the hair and eyes.

The line of the smile is drawn last because it actually adds nothing to the structure of the face.

3/4 VIEW

In this view, very little of the rear mass of the head (behind the ear) is visible. And, we see far more of the surface area of the near side of the face than of the far side.

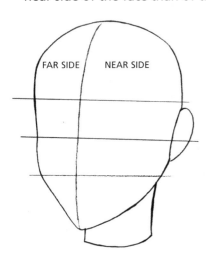

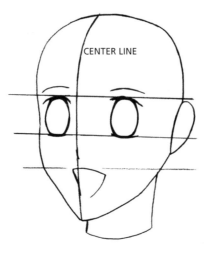

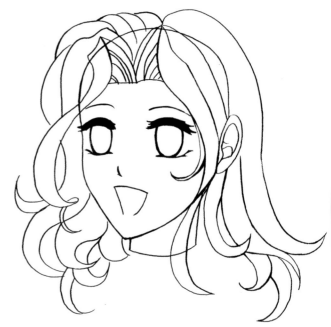

The same three horizontal guidelines that you used in the front view also apply here.

The vertical center line curves over the forehead, indicating the three-dimensionality of the face. The eyes, ears, nose, and mouth all fall in the same places along the horizontal guidelines as they did in the front view.

The part begins at the center line, which is slightly left of center in the 3/4 view.

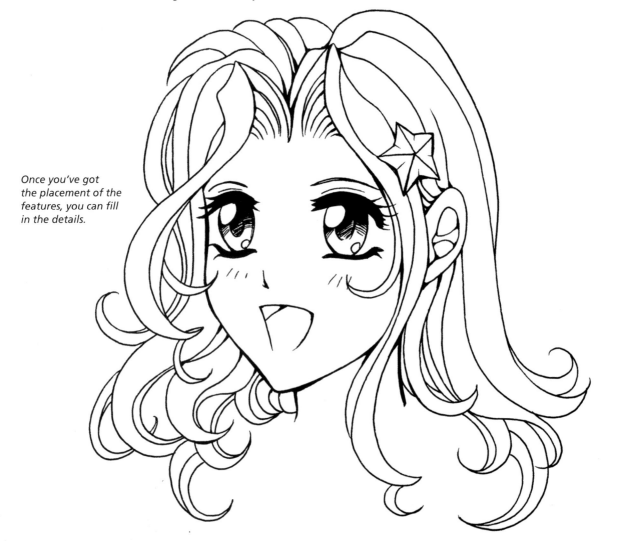

Once you've got the placement of the features, you can fill in the details.

Most people never think about drawing rear views of the head—until they have to! When might you be called on to draw a character in such a pose? When two characters are talking to each other, the viewer looks over the back of the listening character at the face of the speaking character. And in this case, you'd need to draw the back of the listener's head. Of course, any scene in which a character turns and walks or runs away from the reader/viewer also requires a rear view.

REAR

3/4 REAR RIGHT

EXTREME (7/8) REAR RIGHT

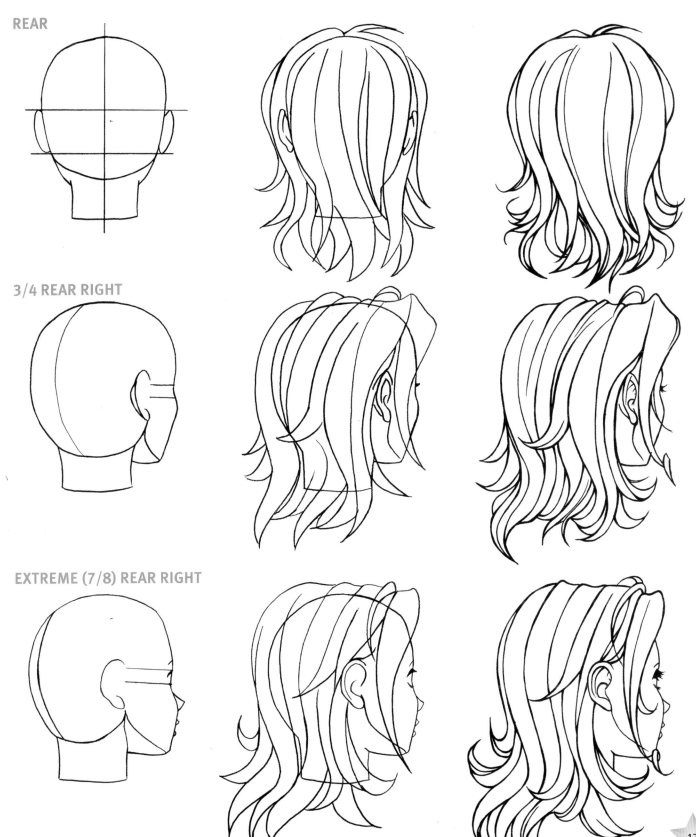

Low Angles

It's the most common question among beginning and intermediate artists: How do I draw a character in different positions and still make her look the same? The answer lies not in how you draw the eyes, the nose, or the mouth, but in your grasp of the overall shape of the head. Characters drawn from below and above look cool. These angles are used often by professional manga artists but almost never by amateurs. You can raise the level of your drawings to new heights by using these "head tilts." Continue to use the center line and the horizontal guidelines to correctly map out the face and help determine where to place the features once you tilt—or change the angle of—the head.

We'll start with low angles and then move on to high and rear views. Low angles are those in which you are below the subject, looking up at it. Low angles exhibit a mild amount of foreshortening. In other words, as the character's head tilts back, the spaces between the features—especially between the eyes and the nose—appear to compress and are drawn closer together than you would normally draw them.

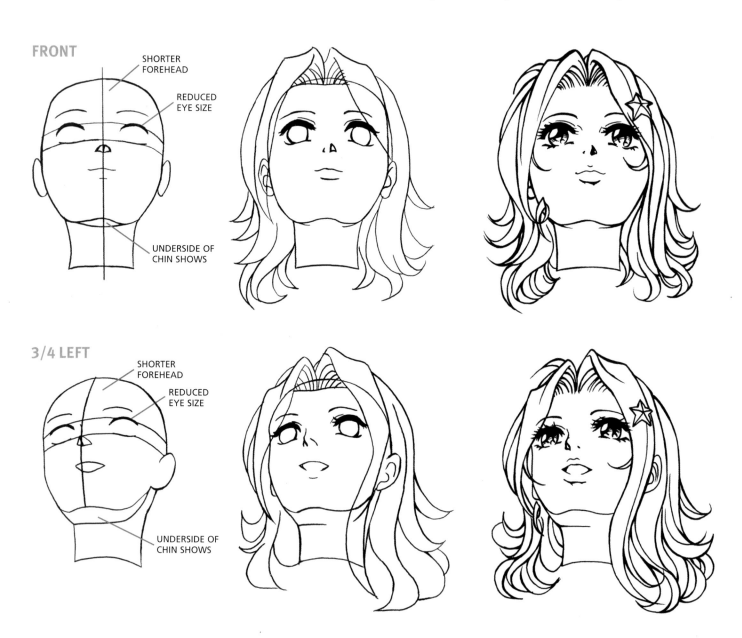

FRONT

SHORTER FOREHEAD

REDUCED EYE SIZE

UNDERSIDE OF CHIN SHOWS

3/4 LEFT

SHORTER FOREHEAD

REDUCED EYE SIZE

UNDERSIDE OF CHIN SHOWS

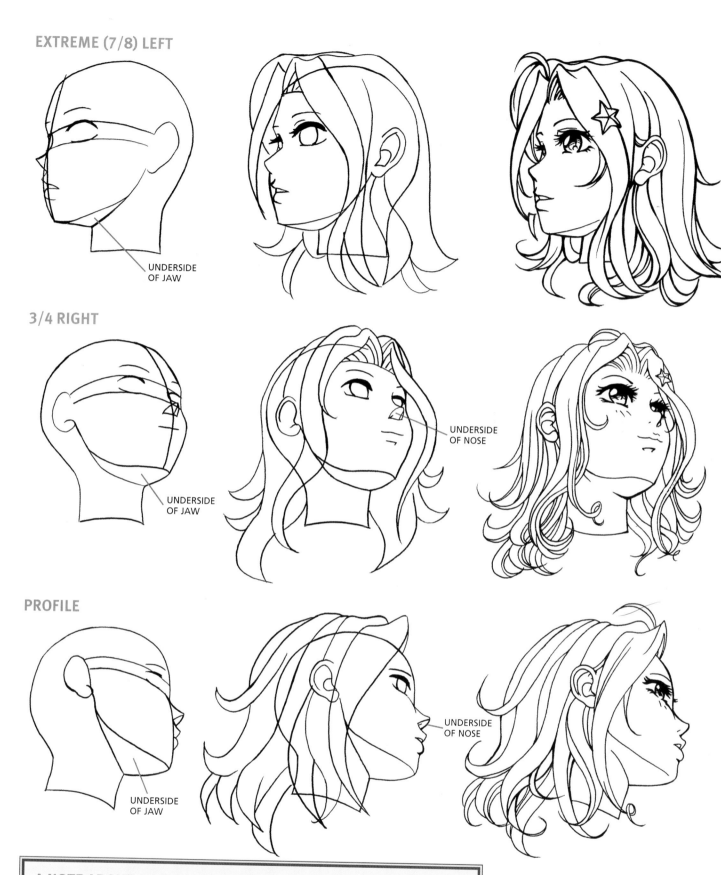

EXTREME (7/8) LEFT

UNDERSIDE
OF JAW

3/4 RIGHT

UNDERSIDE
OF JAW

UNDERSIDE
OF NOSE

PROFILE

UNDERSIDE
OF JAW

UNDERSIDE
OF NOSE

A NOTE ABOUT ANGLES AND FRACTIONS

You can slice these fractions as small as you like. Simply turn the head a small notch to create a new angle. To help you visualize these positions and draw these angles accurately, you can purchase model busts or full-body wooden mannequins from art supply stores and Web sites.

High Angles

High angles are those in which you are positioned above the subject, looking down at it. As a result of the perspective involved in a high angle, the mouth and nose will look slightly compressed and, therefore, should be drawn closer together than they would appear in a neutral angle (when you are at the same level as your subject). The chin also diminishes in size in the high angle. And, you'll need to show more of the top of the head; as a result, more of the hair's part will be visible.

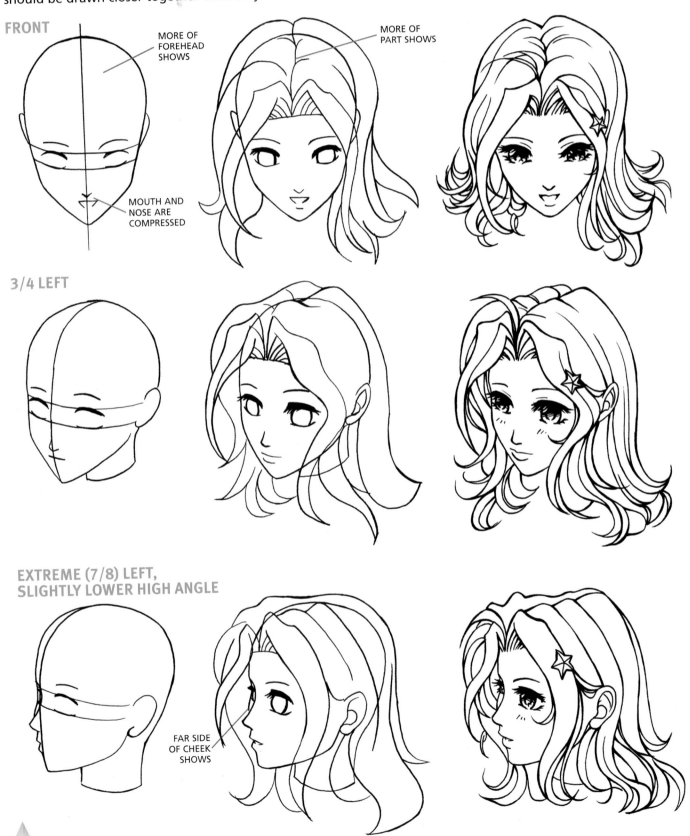

FRONT

MORE OF FOREHEAD SHOWS

MORE OF PART SHOWS

MOUTH AND NOSE ARE COMPRESSED

3/4 LEFT

EXTREME (7/8) LEFT, SLIGHTLY LOWER HIGH ANGLE

FAR SIDE OF CHEEK SHOWS

EXTREME 3/4 RIGHT

PROFILE (EXTREME HIGH ANGLE)

MOUTH
EXTENDS
PAST LINE
OF FACE

2/3 RIGHT

Expressions

Bishoujo characters look pretty, and some are even drop-dead gorgeous. But they've still got to have life to them. Their faces can't look like expressionless mannequins or fashion magazine cover models. Manga characters love, laugh, cry, rage, and pout. That's why they're so popular—because behind those pretty eyes, they're real people to whom everyone can relate.

The way to convey this is to create "elasticity of the face." That simply means that the face must be somewhat rubbery. Not a lot, but just enough to allow it to distort slightly for specific attitudes and expressions. For example, when a person is surprised the eyes widen, the mouth opens, and the face stretches slightly. The shape of the eyes also changes with the expression. Happy eyes are large, angry eyes are narrow, and sad eyes tilt downward at the outer corners.

This doesn't mean you should overlook the beauty of the character. A female character should look just as pretty when she's furious as she does when she's happy.

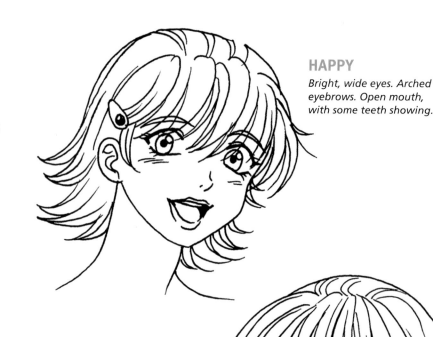

HAPPY

Bright, wide eyes. Arched eyebrows. Open mouth, with some teeth showing.

CONCERNED

Tight lips. Wide eyes that tilt down at the outer corners. High, arched eyebrows.

CONTENT

Eyelids resting on pupils.

EMBARRASSED

A single line for the mouth. Furrowed eyebrows. Blush lines streaking across the face. (Note how the face is squashed and compressed.)

RESENTFUL

Top lip is bitten. Eyes are determined and half cut off by eyelids. Gaze is intense.

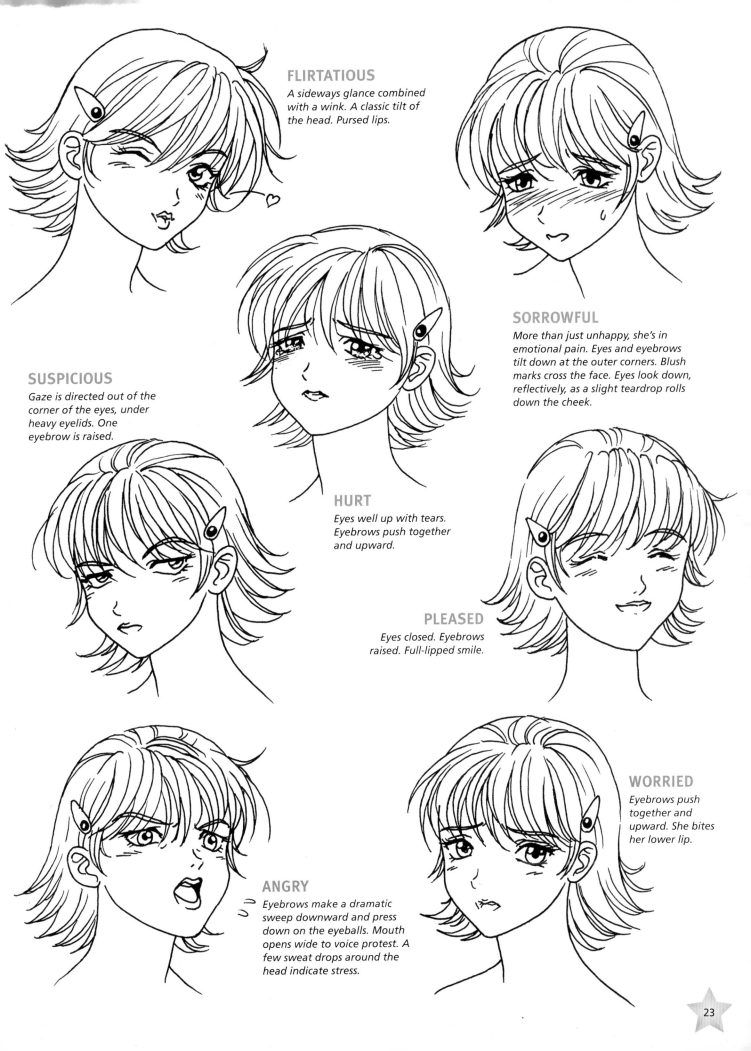

FLIRTATIOUS

A sideways glance combined with a wink. A classic tilt of the head. Pursed lips.

SORROWFUL

More than just unhappy, she's in emotional pain. Eyes and eyebrows tilt down at the outer corners. Blush marks cross the face. Eyes look down, reflectively, as a slight teardrop rolls down the cheek.

SUSPICIOUS

Gaze is directed out of the corner of the eyes, under heavy eyelids. One eyebrow is raised.

HURT

Eyes well up with tears. Eyebrows push together and upward.

PLEASED

Eyes closed. Eyebrows raised. Full-lipped smile.

WORRIED

Eyebrows push together and upward. She bites her lower lip.

ANGRY

Eyebrows make a dramatic sweep downward and press down on the eyeballs. Mouth opens wide to voice protest. A few sweat drops around the head indicate stress.

23

CHARACTER TYPES

Now that you've got some of the basics down, it's time for the fun part: drawing some very cool, very attractive bishoujo character types. These characters are all based on their roles (*fighter pilot* or *student*, for example) and on personality types. The process of deciding these aspects is called "character design," and it's one of the most satisfying creative areas in comics and anime. Even though this section still concentrates mostly on head shots (the body will come later), there will be an indication of the costumes, which also helps to define a character's occupation.

School Girl

The schoolgirl is a *very* popular character type in manga. Schoolgirl types are ordinarily from twelve to seventeen years old. They're pretty, energetic, and stylish. They should have bright eyes and a squeaky-clean look, with bubbly personalities. Long hair isn't a requirement for the manga school girl, but it is one of the better looks for this type of character. Young female characters generally start out with long hair, and as they become women, their hairstyles usually become somewhat shorter.

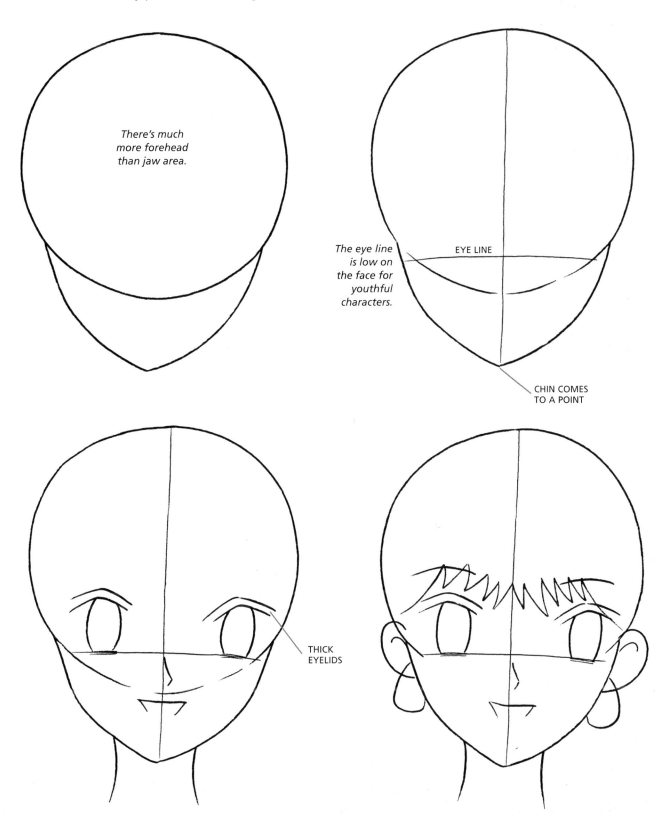

There's much more forehead than jaw area.

The eye line is low on the face for youthful characters.

EYE LINE

CHIN COMES TO A POINT

THICK EYELIDS

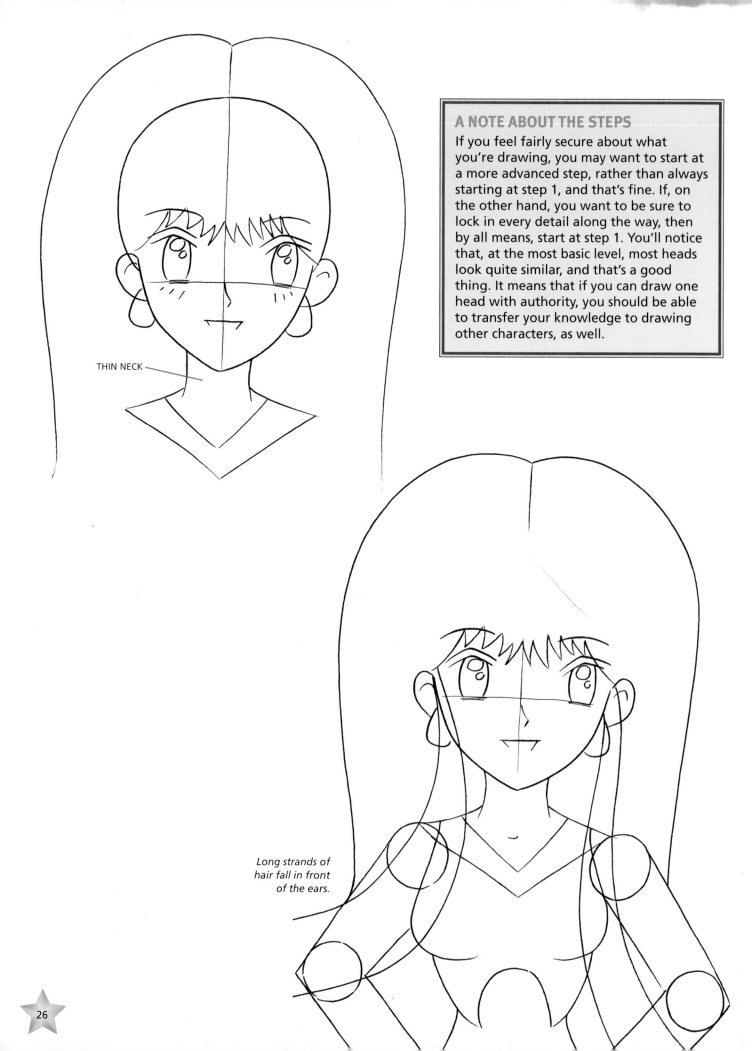

THIN NECK

A NOTE ABOUT THE STEPS

If you feel fairly secure about what you're drawing, you may want to start at a more advanced step, rather than always starting at step 1, and that's fine. If, on the other hand, you want to be sure to lock in every detail along the way, then by all means, start at step 1. You'll notice that, at the most basic level, most heads look quite similar, and that's a good thing. It means that if you can draw one head with authority, you should be able to transfer your knowledge to drawing other characters, as well.

Long strands of hair fall in front of the ears.

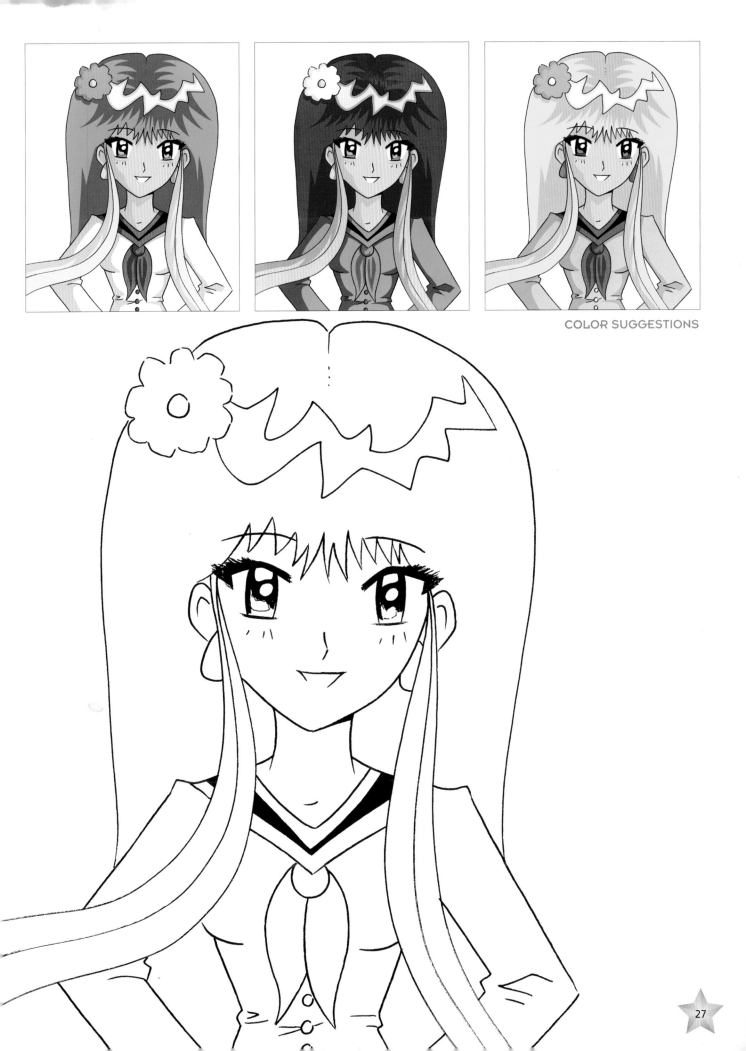

Basic Teen or Tween

Here's a simple but appealing profile you should try out. In other art styles, including American-style comics, eyeballs shown in profile always curve outward. But in manga, they curve inward. This gives them a sharp graphic look, which is desirable and has an authentic Japanese flair. The eyes are quite large on manga teens and tweenagers. If she were, say, twenty-five years old, I would make the eyes about two thirds as tall as they are here and more horizontal in shape. Although the pupil is quite slender in profile, there's still ample room to add the eye shines, which are a necessity. The long, flowing bands of hair that fall in front of the ears are an extremely popular look. Draw a few far bands of hair on the far side of the face, as this will prevent the character from appearing flat.

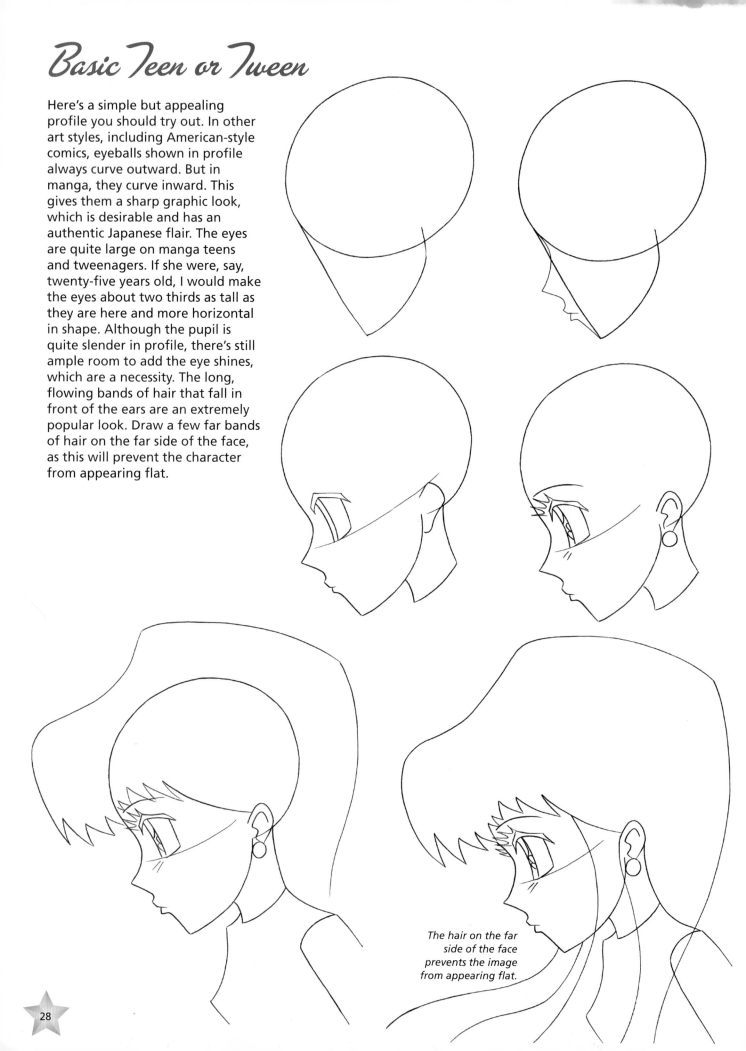

The hair on the far side of the face prevents the image from appearing flat.

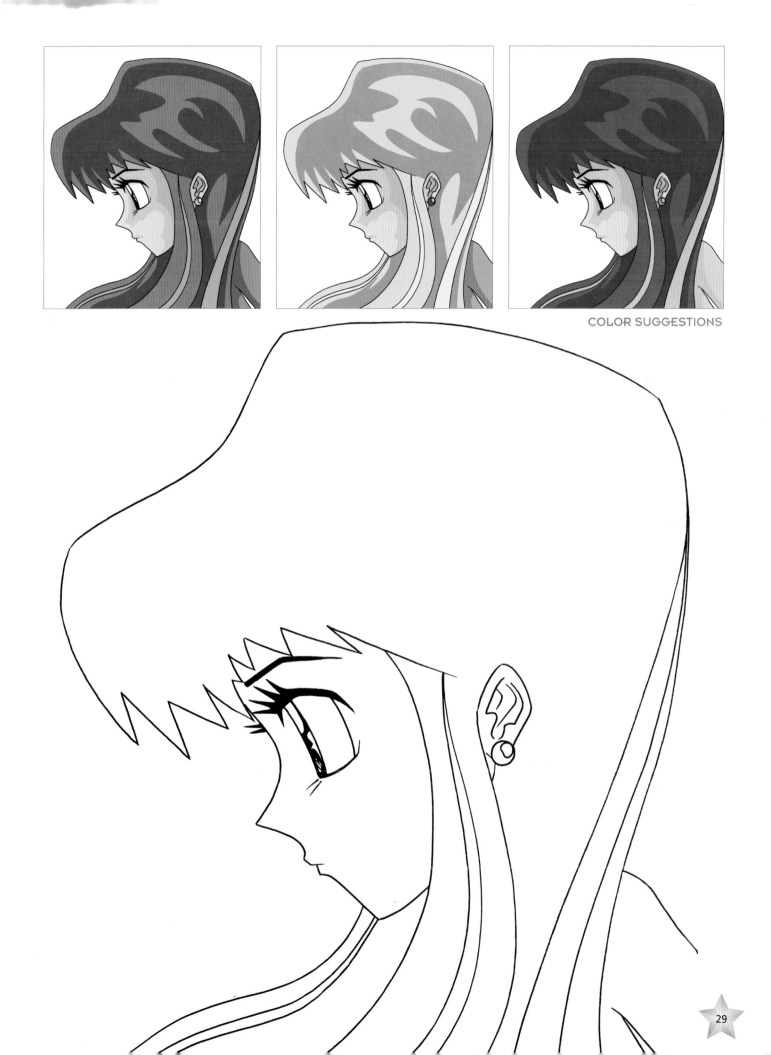

COLOR SUGGESTIONS

Space Ranger

Characters like this—spaceship and fighter pilots and the like—are the scene-stealers in Sci-Fi comics and most anime. In the profile, note how far out in front of her face her upper eyelashes extend. That creates added glamour, as does the high, angled eyebrow. The eyebrows should also be thin, to stress the femininity of the character. Remember, you've got to do all you can to bring out her feminine qualities when she's in such a tough-as-nails uniform. The mouth should be small but delicate, with full but petite lips. Strands of hair should fall over the eyes. And perhaps most

importantly, she needs a high, nicely rounded jawline that gives her a soft look—not hard or angular.

In addition, remember the profile on the previous page? I noted that her large eyes were typical for a teenager but that an older character would have eyes that were more horizontal. Well, now you're looking at that older version. In fact, all I'd have to do to turn this character into a teenager would be to give her the same eyes as on the previous profile. So, it's important that the features you use match the age of the character you're drawing.

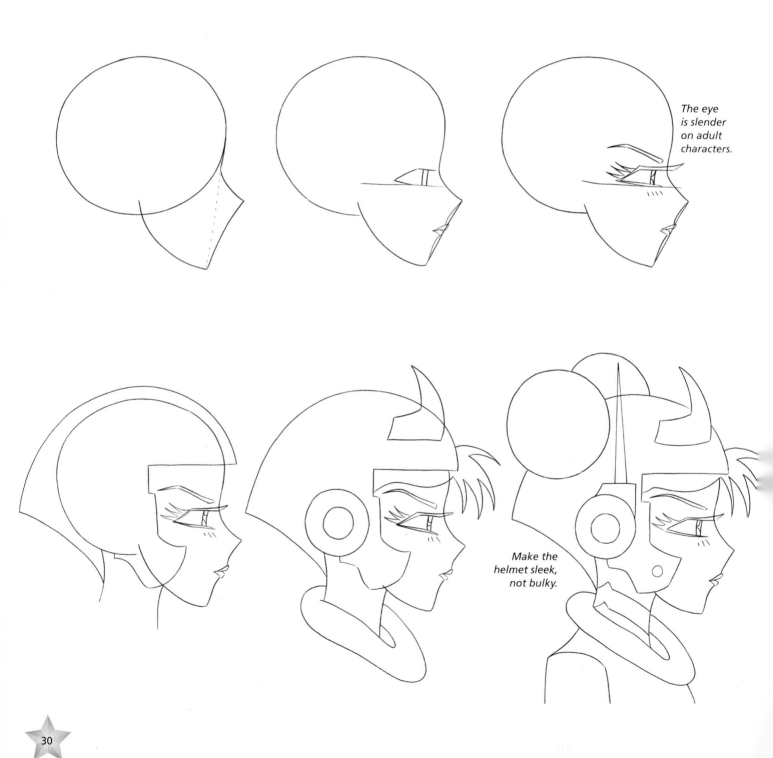

The eye is slender on adult characters.

Make the helmet sleek, not bulky.

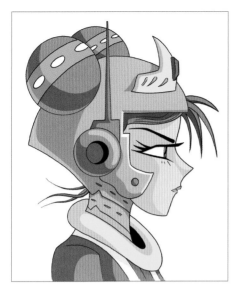 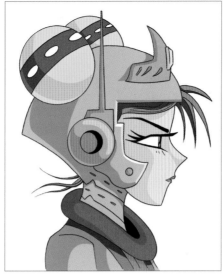 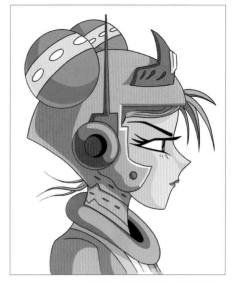

COLOR SUGGESTIONS

A NOTE ABOUT PROFILES

Logically, one would assume that if you can draw a left profile (page 29), you can draw a right profile without any trouble. You would think. But artists often find, to their dismay, that they naturally tend to favor certain angles over others, and so it's important to practice drawing both left and right profiles.

Perhaps the most important thing to notice about attractive manga profiles is that there's very little change of angle from the bottom of the nose to the top of the upper lip. It's all one diagonal line. Also, the chin always recedes. Keep these things in mind, and you won't go wrong!

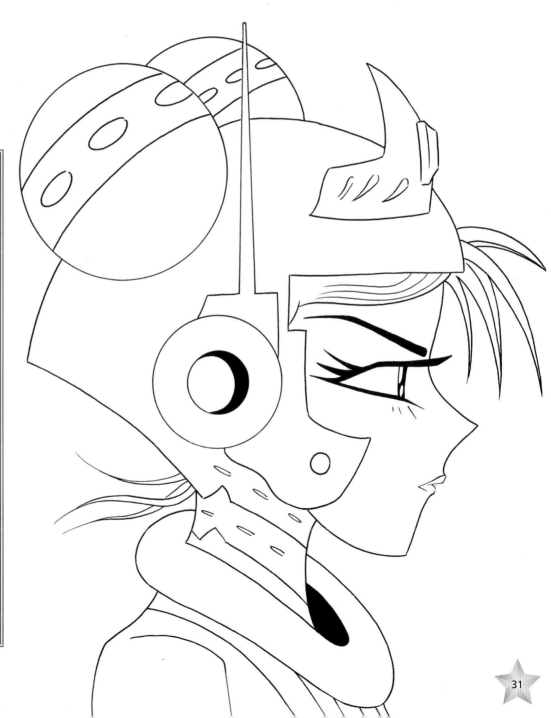

31

Trendy Girl

Here's a nice example of a short haircut. The current trend is to bunch the strands of hair into thick bands that taper to a point and drift in front of the face. Note that most of the important parts of the hairstyle occur just above the forehead. That's true of most characters, regardless of hair length. Short hair makes for a trendier, sharper character. The more traditional and Fantasy-style characters have long hair. (See pages 40–49 for more on drawing flashy hairstyles.) Again, notice how effective it is to draw petite lips. This leaves the face uncluttered. Also, the outward bend of the neck is distinctly feminine. A few pieces of jewelry and Asian-style hair accessories add a nice accent.

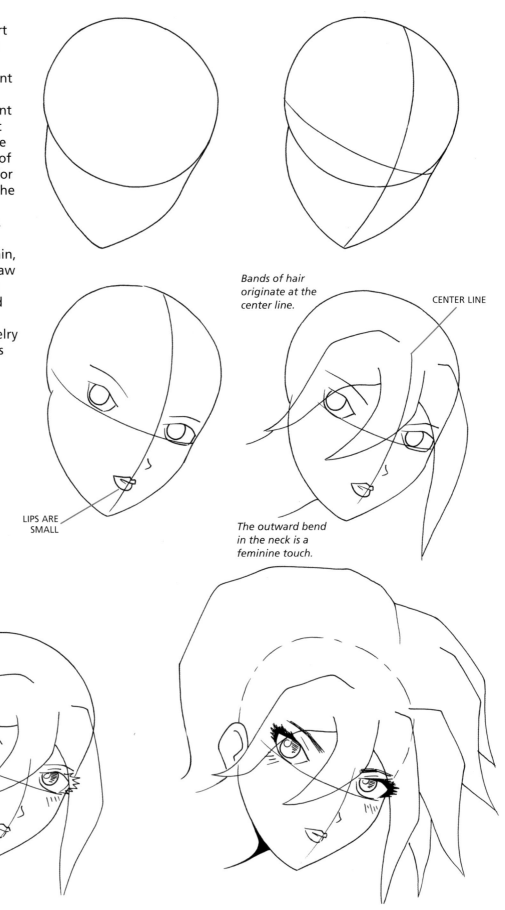

Bands of hair originate at the center line.

CENTER LINE

LIPS ARE SMALL

The outward bend in the neck is a feminine touch.

 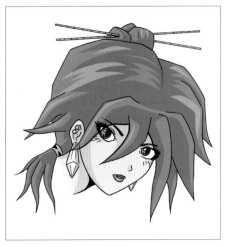

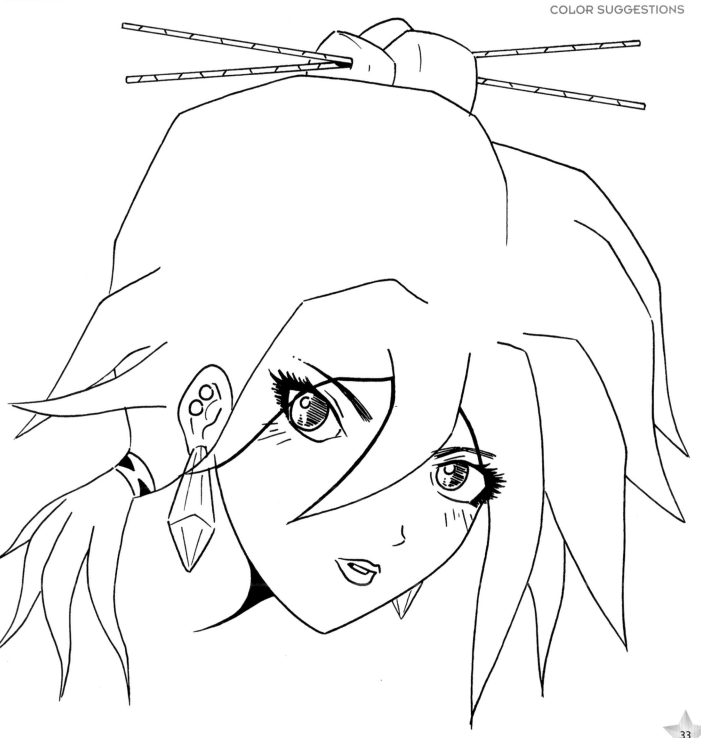

Dangerous Woman

A cold heart and a beautiful face make a thrilling combination in Action manga. Her eyes are as sharp as stilettos. The lashes, too. To create a dangerous look, draw the eyeballs peering up from under the eyelids. In other words, cut off the tops of the eyes with the eyelids. It adds a feeling of intensity. On good-natured characters, the eyebrows arch high above the eyes. The mouth should be small and taut, the lips almost pursed—as if she's not sure if she wants to kiss you or kill you. Cover parts of the face with wisps of hair to give her a mysterious look.

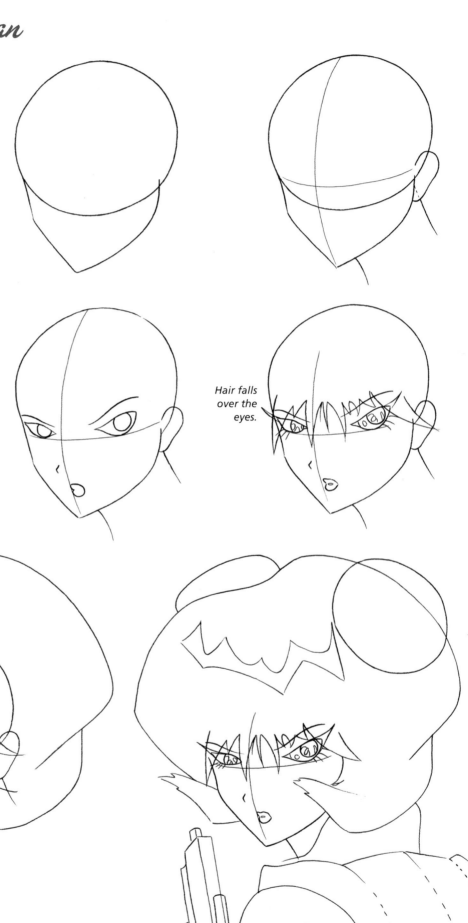

Hair falls over the eyes.

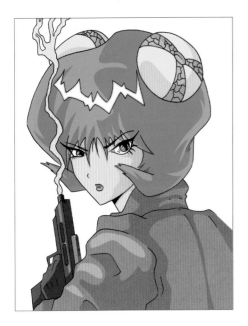

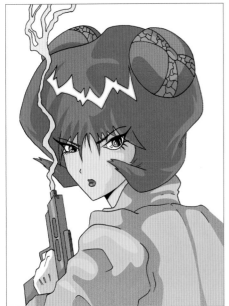

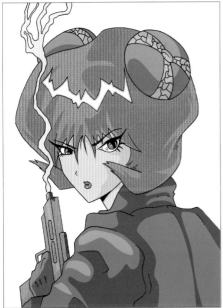

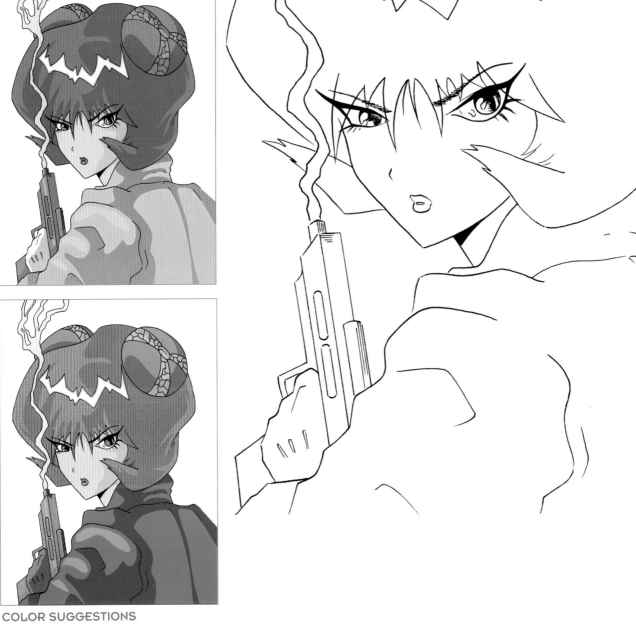

COLOR SUGGESTIONS

Fantasy Princess

The beautiful, alluring, and somewhat mysterious princess from another world is a very popular bishoujo character. You'll see this type across many different genres of manga, from shoujo (girls' comics) to Fantasy, Sci-Fi, and even some Occult and Horror. The fantasy princess should have an open, appealing face with big, wide eyes and a pleasant expression. Note the big pools of reflected light in the eyes; this is an important element in designing "good" characters (as opposed to "bad girls"). If you want to give her a tiara, keep it small, and be sure that you don't invent something that looks like a crown from the Middle Ages. That's corny. Her hair should have buns combined with flowing locks. That's the quintessential look for this character type.

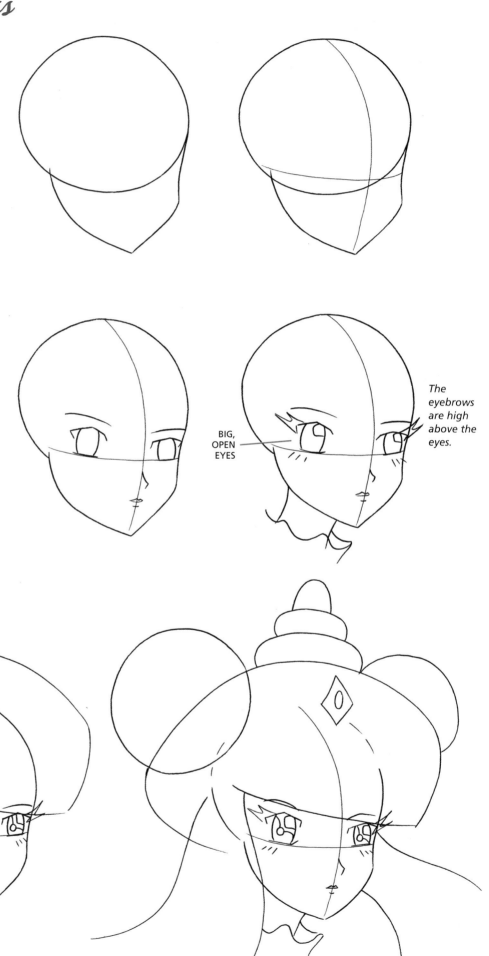

BIG, OPEN EYES

The eyebrows are high above the eyes.

The Cheat

The *cheat* is not a character type; it's an important drawing technique, so I want to mention it here before we proceed. *Cheating* is drawing aspects of a figure or scene that, strictly speaking, wouldn't really be seen in that view from that angle. Even though this character is in a front view, she's angled slightly to the viewer's left and you're looking at her from an angle that's just slightly above her. These shifts are *cheats*, and they are so slight that they are almost imperceptible—but what they do for the drawing is

considerable. Drawing the character subtly to one side allows the artist to draw the nose slightly to one side with a delicate cast shadow, which is more attractive than showing both nostrils flat on in a true frontal angle. And, even more importantly, turning the head slightly to one side results in a sleek jawline on one side of the face and a soft cheek area on the other, which brings out the character's femininity and keeps the image from being completely symmetrical (hence, less interesting).

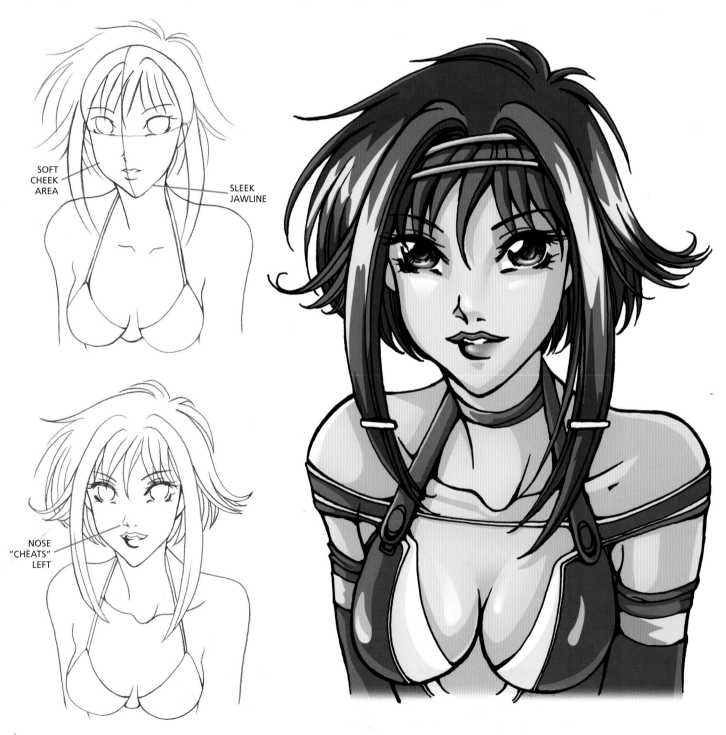

SOFT CHEEK AREA

SLEEK JAWLINE

NOSE "CHEATS" LEFT

Pretty Girl

This is your basic pretty bishoujo character. The attractive manga woman has an elongated chin that comes to a point. But the rest of the head is rounded and soft so that the character doesn't come off as angular and hard.

When drawing a 3/4 view, always sketch in a vertical center line on the head, as in the first step here. Use this as a guide to help you determine the correct placement of the features. Note how, in this angle, the far eye is close to the center line, while the near eye is far from it. That eye placement it essential in a 3/4 pose, and the center line helps you get it down.

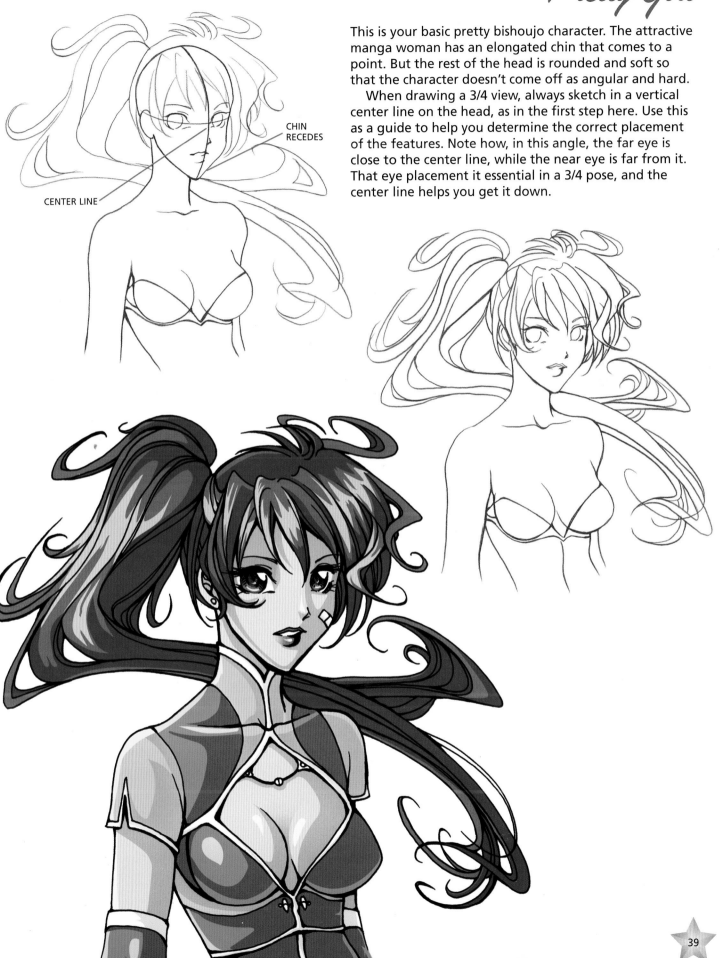

CHIN RECEDES

CENTER LINE

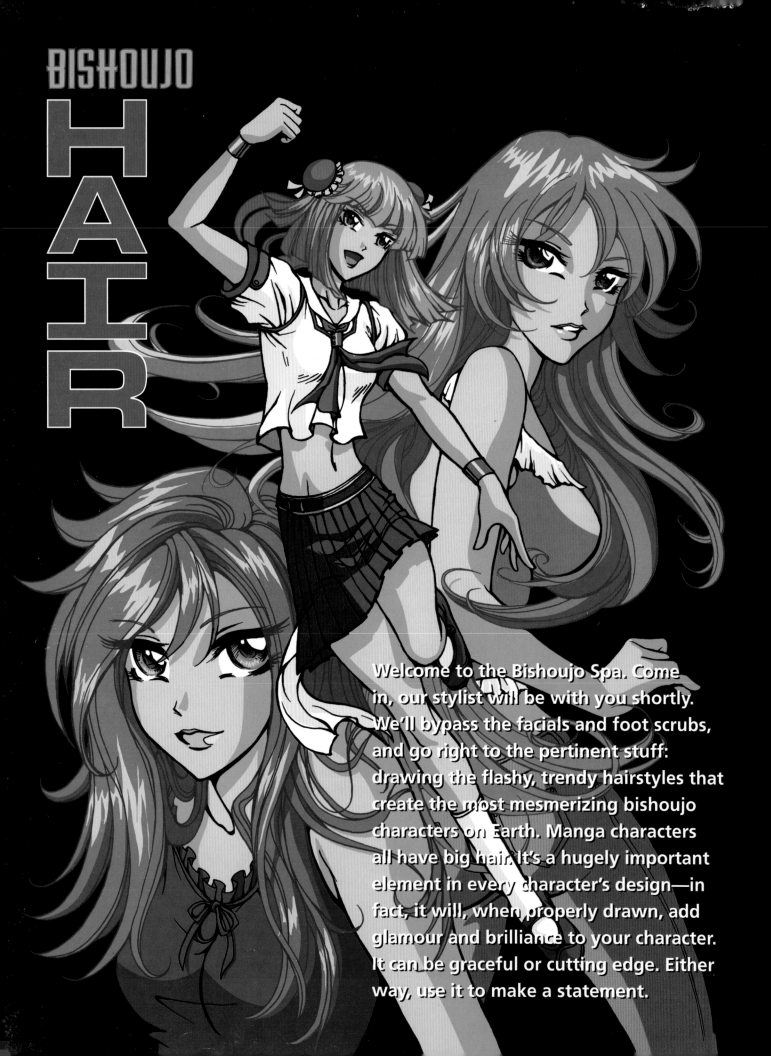

BISHOUJO HAIR

Welcome to the Bishoujo Spa. Come in, our stylist will be with you shortly. We'll bypass the facials and foot scrubs, and go right to the pertinent stuff: drawing the flashy, trendy hairstyles that create the most mesmerizing bishoujo characters on Earth. Manga characters all have big hair. It's a hugely important element in every character's design—in fact, it will, when properly drawn, add glamour and brilliance to your character. It can be graceful or cutting edge. Either way, use it to make a statement.

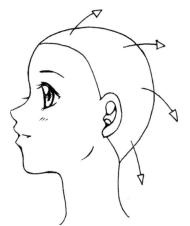

The hair originates at many different points all over the scalp.

Think in terms of the direction the hair travels when combed and the direction it falls when loose. Start off with a simple hairstyle: brushed back, which is typical for younger teens and girls.

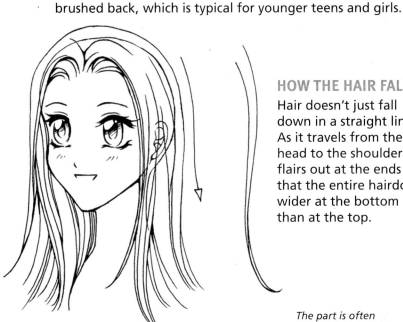

HOW THE HAIR FALLS

Hair doesn't just fall down in a straight line. As it travels from the head to the shoulders, it flairs out at the ends so that the entire hairdo is wider at the bottom than at the top.

The hair flips up before curving down over the forehead.

The part is often indicated by an accent of ruffled hair at the back of the head.

The hair accents can kick out as they travel down the head, making for a cool look.

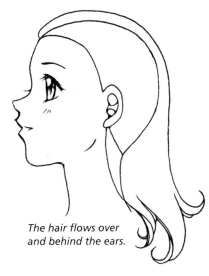

The hair flows over and behind the ears.

WHERE TO ADD ACCENTS

Hair with thickness and body is fun to draw, because it provides more opportunities to add interesting accents.

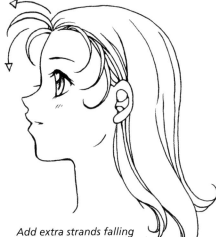

Add extra strands falling forward, off the forehead, to add style and so that the forehead is not too prominent.

WAVY OR CURLY HAIR

Curly hair is curly right from the start.

Windswept Hair

The most graceful and attractive hair is of the windswept variety. It also increases the effectiveness of Fantasy characters. Plus, it's exceedingly popular in the Magical Girl manga genre, in which school-age girls have magical powers. You should definitely add it to your repertoire. Here are the four basic windswept styles and drawing techniques.

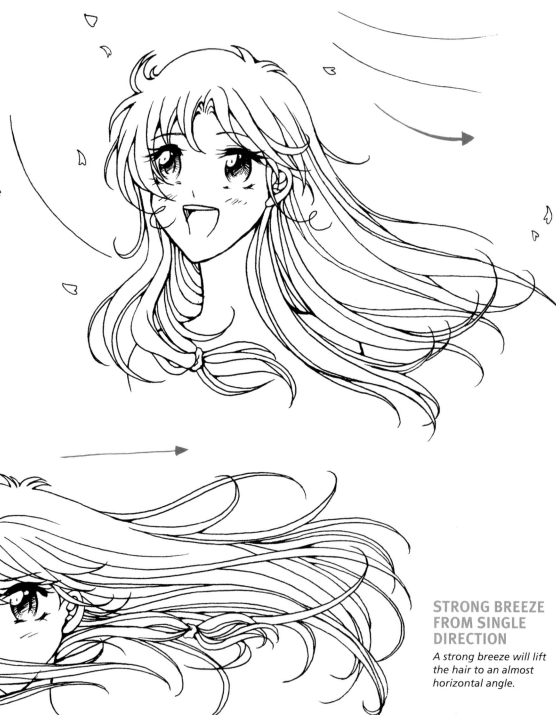

SOFT BREEZE FROM SINGLE DIRECTION

A soft breeze will cause the hair to blow at a diagonal. Most of the action occurs at the bottom of the hairstyle, where the hair gathers. Note that the hair on the left, as well as the right, side of the head is affected by the breeze.

STRONG BREEZE FROM SINGLE DIRECTION

A strong breeze will lift the hair to an almost horizontal angle.

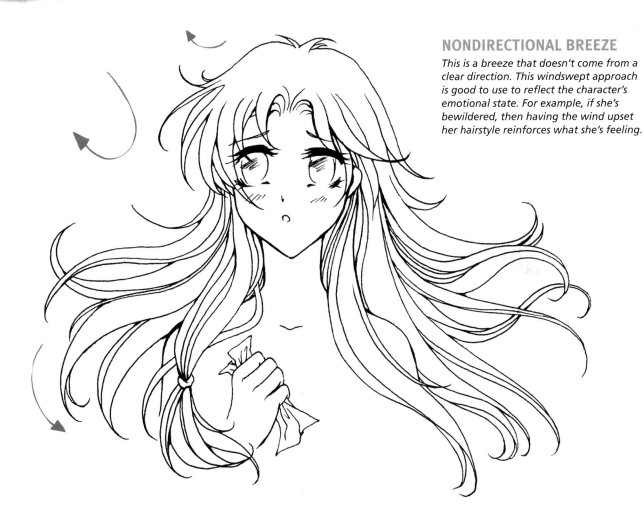

NONDIRECTIONAL BREEZE

This is a breeze that doesn't come from a clear direction. This windswept approach is good to use to reflect the character's emotional state. For example, if she's bewildered, then having the wind upset her hairstyle reinforces what she's feeling.

FANTASY WINDSWEPT HAIR

In this very popular style, there's no breeze at all; rather, the hair seems to float by itself in graceful, swirling patterns. This is a very appealing technique, especially for characters with special powers.

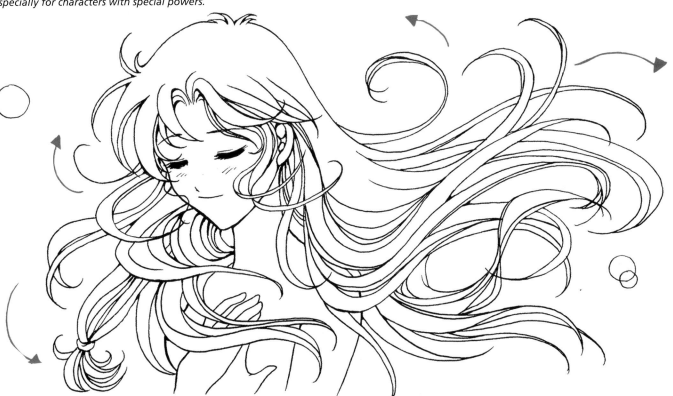

Braids, Ponytails, and More

You can combine one, two, or more of these ponytails and other elements on a character to create elaborate, fanciful hairstyles. The more elaborate hairdos suit Fantasy and Magical Girl characters best.

Short and Trendy Hair

Short hair can be very attractive, very sharp looking. It's a great match for hip, cosmopolitan characters. Their clothes will also have to match their hairstyles; in other words, no flowing robes or fantasy gowns for short-haired bishoujo characters. They get short skirts, tight jeans, or Sci-Fi body-hugging space suits.

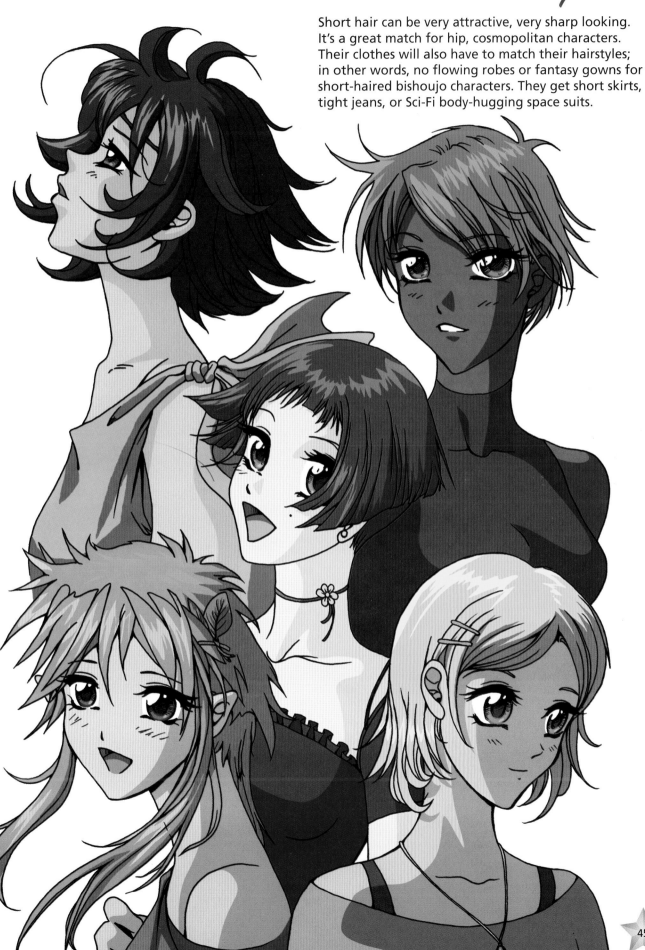

Long Hair

On real people, long hair means shoulder length, more or less. On bishoujo characters, however, it can mean as long as the entire figure! But remember, the longer the hair, the more swirls you must add to it to keep it looking graceful. In addition to bringing out the supergraceful qualities of female characters, long hair is also the best approach for drawing enchanted beings, such as faeries, elves, and any type of princess.

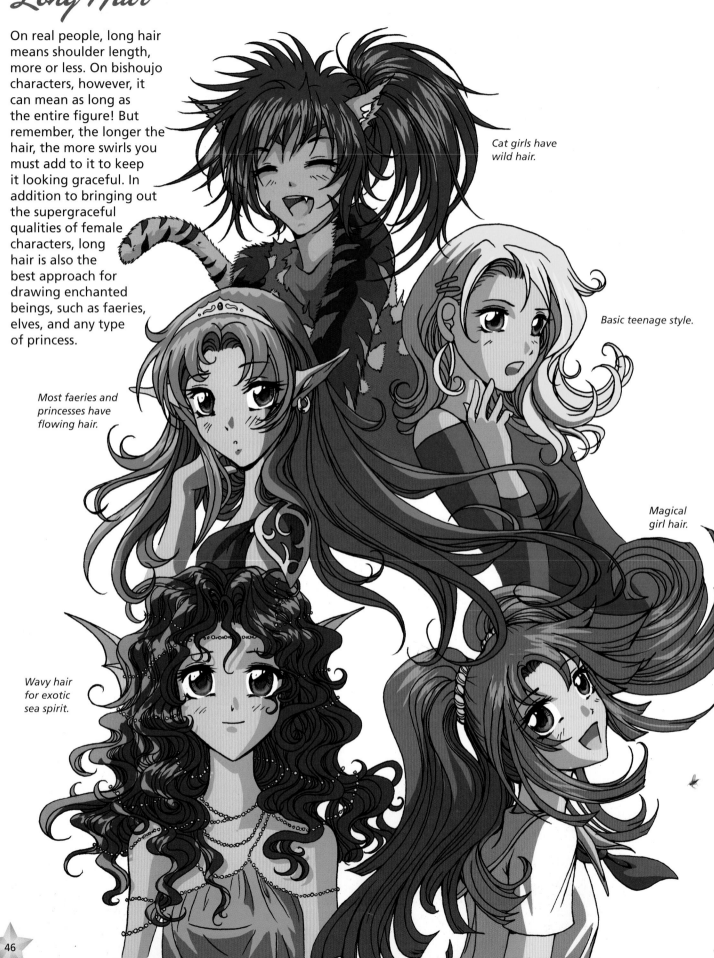

Cat girls have wild hair.

Basic teenage style.

Most faeries and princesses have flowing hair.

Magical girl hair.

Wavy hair for exotic sea spirit.

Medium Length Hair

You can also split the difference between short and long to create hairstyles with a medium length. This is the most common style for the sweet, girl-next-door type, but you can also use it on many other characters, too. Bangs, scarves, flower accessories, clips— you can use the whole shebang to spruce up your character.

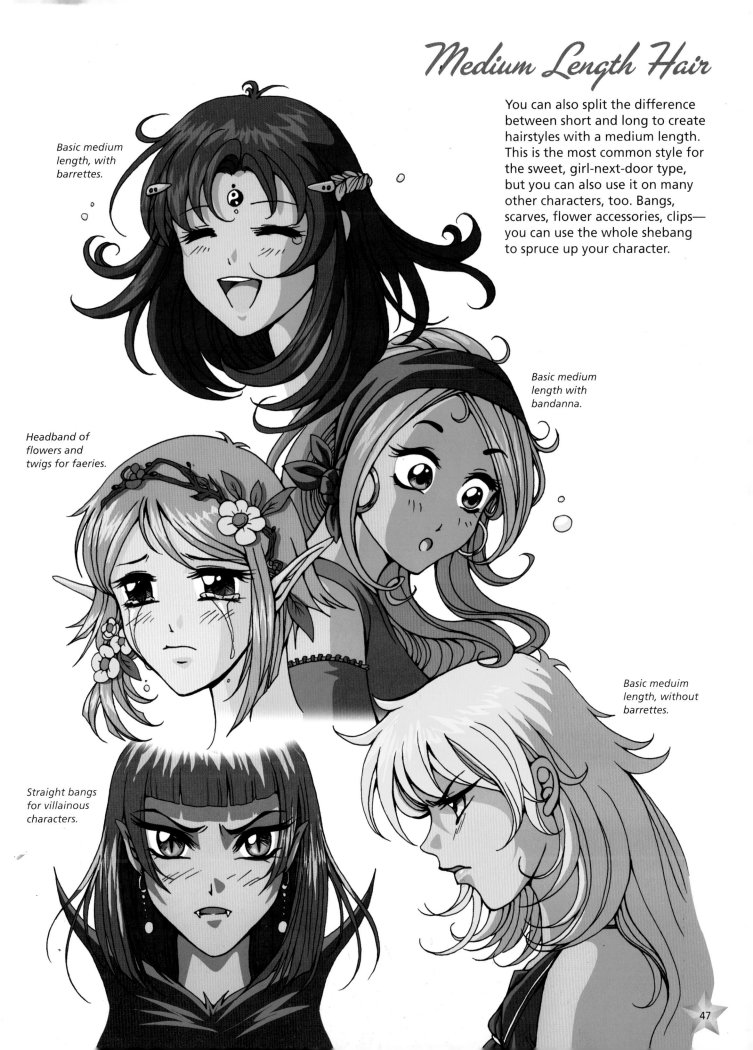

Basic medium length, with barrettes.

Headband of flowers and twigs for faeries.

Basic medium length with bandanna.

Basic meduim length, without barrettes.

Straight bangs for villainous characters.

The Wild Side of Hairstyles

You can go as far out as you like with the hair, provided that it's consistent with your vision for the character and her costume. Aren't these cool?

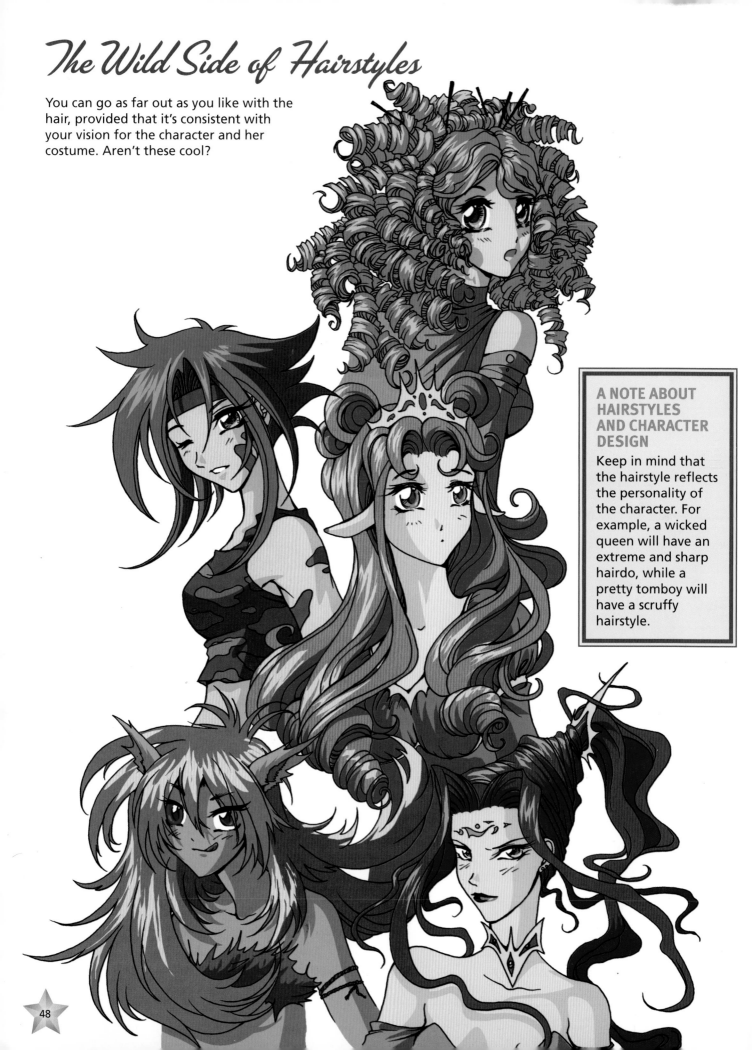

A NOTE ABOUT HAIRSTYLES AND CHARACTER DESIGN

Keep in mind that the hairstyle reflects the personality of the character. For example, a wicked queen will have an extreme and sharp hairdo, while a pretty tomboy will have a scruffy hairstyle.

Change a Hairstyle, Change a Character

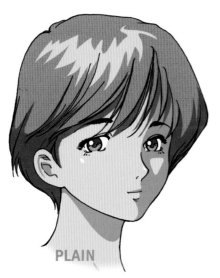

PLAIN

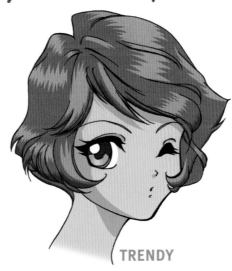

TRENDY

While you cannot create an entirely new character simply by changing the hairstyle, the hairstyle is, perhaps, the single most significant element in carving out a character's visual identity. By altering the cut, shape, and length of the hair, you'll go a long way toward inventing a new character. Most of the time, new characters aren't so much created from scratch as they are reinvented from the old. By making a costume change and a few adjustments to the eyes, you'll add a new player to your cast.

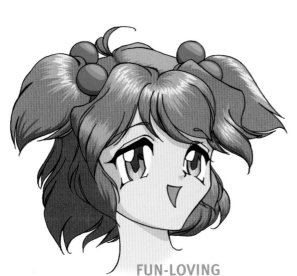

FUN-LOVING

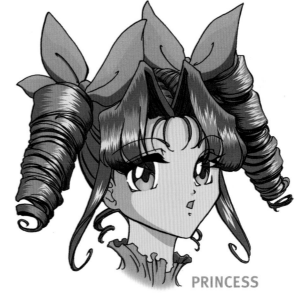

PRINCESS

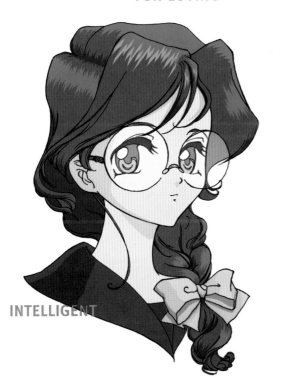

INTELLIGENT

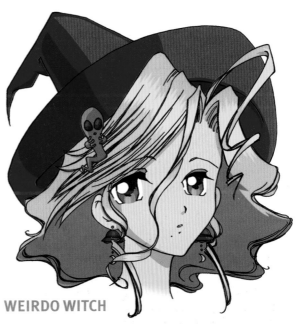

WEIRDO WITCH

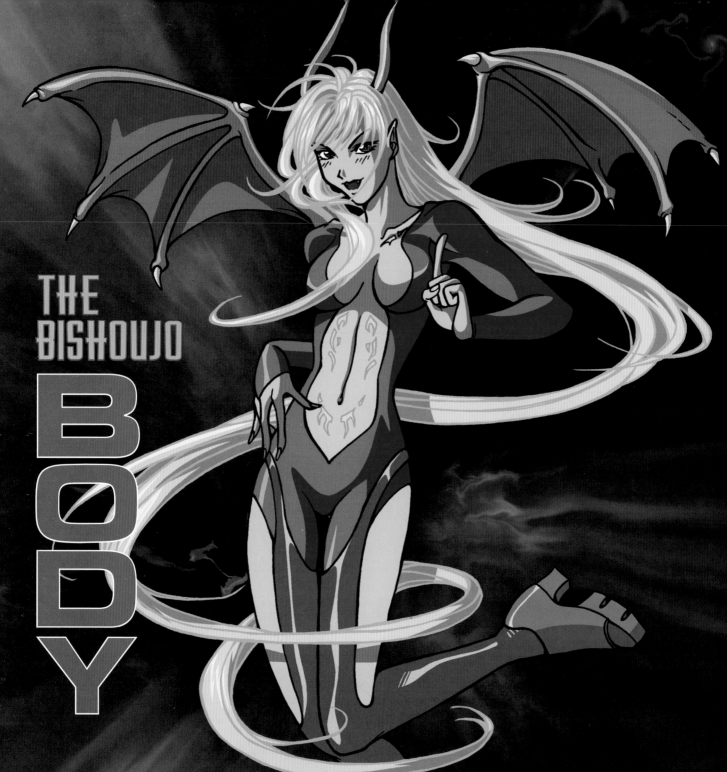

THE BISHOUJO BODY

In addition to facial expression, the figure is an important tool for communicating feelings to the reader; using it will make your manga more successful. The common problems beginners have are getting the proportions and shapes of the major body parts correct. The legs and neck end up way too long, for example, or the hips and chest are much too skinny. But by starting with a basic construction of the female figure, you can easily avoid these problems. Once you get this down, you can move on to the more advanced poses and costumes that help your characters convey the emotion of the story.

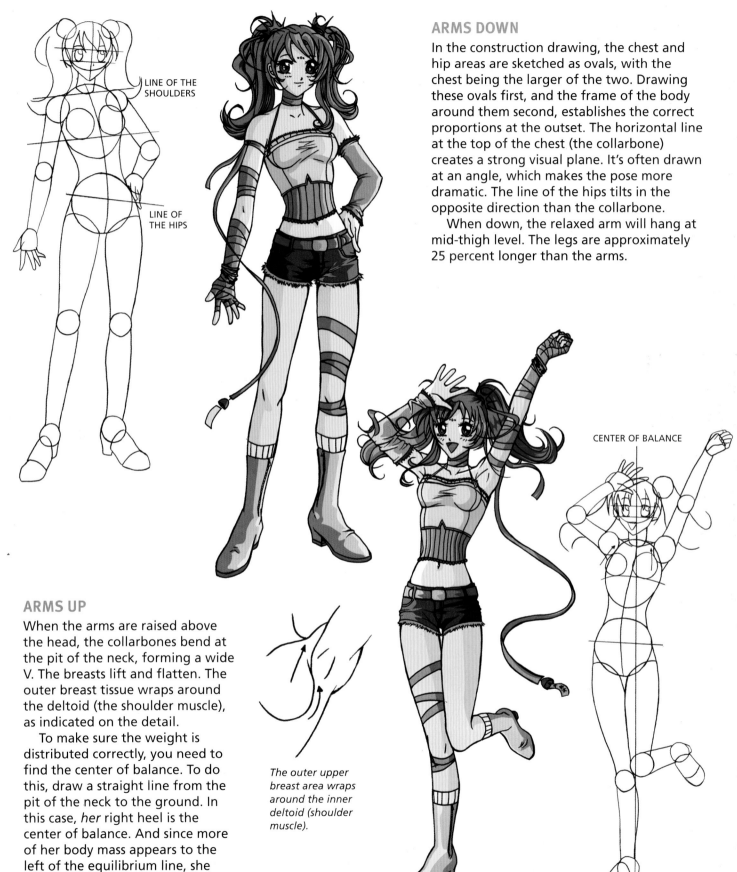

LINE OF THE SHOULDERS

LINE OF THE HIPS

ARMS DOWN

In the construction drawing, the chest and hip areas are sketched as ovals, with the chest being the larger of the two. Drawing these ovals first, and the frame of the body around them second, establishes the correct proportions at the outset. The horizontal line at the top of the chest (the collarbone) creates a strong visual plane. It's often drawn at an angle, which makes the pose more dramatic. The line of the hips tilts in the opposite direction than the collarbone.

When down, the relaxed arm will hang at mid-thigh level. The legs are approximately 25 percent longer than the arms.

CENTER OF BALANCE

ARMS UP

When the arms are raised above the head, the collarbones bend at the pit of the neck, forming a wide V. The breasts lift and flatten. The outer breast tissue wraps around the deltoid (the shoulder muscle), as indicated on the detail.

To make sure the weight is distributed correctly, you need to find the center of balance. To do this, draw a straight line from the pit of the neck to the ground. In this case, *her* right heel is the center of balance. And since more of her body mass appears to the left of the equilibrium line, she must lean slightly back to the right to maintain balance.

The outer upper breast area wraps around the inner deltoid (shoulder muscle).

3/4 View

When you turn the body in a 3/4 view (halfway between a front and a side view), the center line becomes all-important. Serving the same function as it does when you draw the head, the center line runs vertically through the center of the body. It's not used to indicate balance but is a guideline to divide the body equally in half. When the body is turned 3/4 of the way around, the halfway point (and, therefore, the center line) will appear to be 3/4 of the way over. In addition to aiding the artist in visualizing the body correctly, the center line helps the artist draw the costume in the correct proportions. Belt buckles, zippers, and buttons often appear down the middle of the body, so they naturally fall on the center line.

In addition, artists use circles—spheres, really (because they're envisioned as three-dimensional)—to represent the various joints of the body. This serves as a reminder that the joints have mass. Many beginners draw joints that are far too thin, so this is a good technique to use.

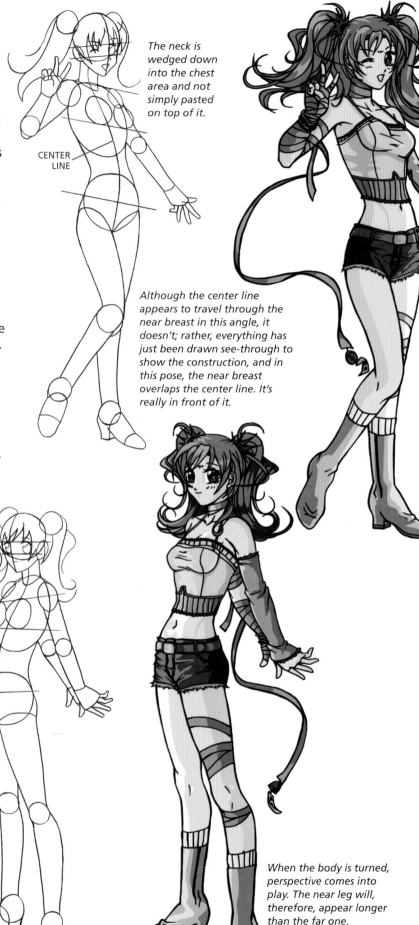

CENTER LINE

The neck is wedged down into the chest area and not simply pasted on top of it.

Although the center line appears to travel through the near breast in this angle, it doesn't; rather, everything has just been drawn see-through to show the construction, and in this pose, the near breast overlaps the center line. It's really in front of it.

FEET ON DIFFERENT LEVELS

When the body is turned, perspective comes into play. The near leg will, therefore, appear longer than the far one.

Side View

In the side view, the chest tilts up slightly while the hips tilt down slightly, as indicated by the horizontal guidelines. These two forces combine to create an attractive curve in the small of her back. Also observe the shoulder socket: it should fall within the oval of the chest area. And here's one more item to keep in mind: even though it's only slightly noticeable, the far foot must be placed a tiny bit higher than the near foot, due to the effects of perspective (when things that are farther away from us appear smaller than things that are closer to us).

CURVE IN SMALL OF BACK

CHEST TILTS UP

HIPS TILT DOWN

BALANCE LINE

Since most of her body is in front of the balance line, she leans back to maintain balance.

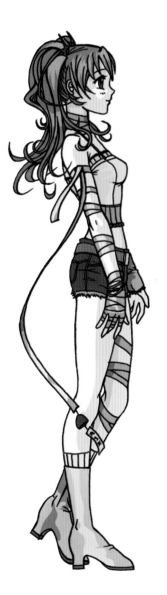

Back View

A pose tends to look more natural if the weight of the figure is distributed unevenly. The leg that carries most of the weight is the straight one. The relaxed leg shifts away from the body, with the knee slightly bent, sometimes barely touching the ground with the toes. As the relaxed leg moves away from the center of the body, it pulls some of the body in its direction. You can see this by looking at the line of the spine, which pulls away from the central balance line in the direction of the relaxed leg.

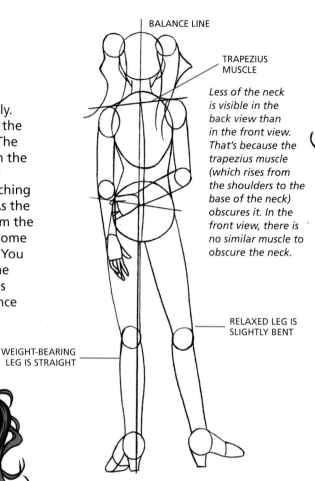

BALANCE LINE

TRAPEZIUS MUSCLE

Less of the neck is visible in the back view than in the front view. That's because the trapezius muscle (which rises from the shoulders to the base of the neck) obscures it. In the front view, there is no similar muscle to obscure the neck.

WEIGHT-BEARING LEG IS STRAIGHT

RELAXED LEG IS SLIGHTLY BENT

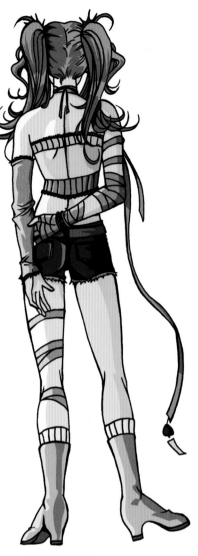

WEIGHT ON LEFT LEG

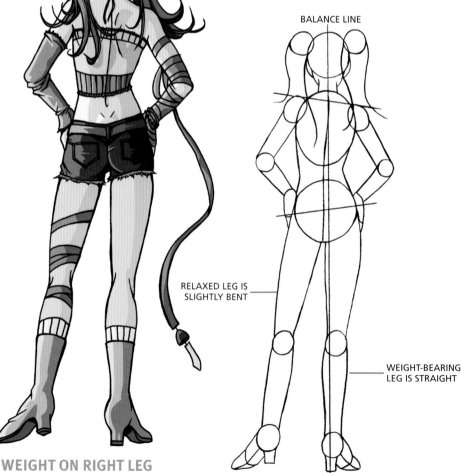

BALANCE LINE

RELAXED LEG IS SLIGHTLY BENT

WEIGHT-BEARING LEG IS STRAIGHT

WEIGHT ON RIGHT LEG

Drawing Pretty Hands

FINGERS HAVE THREE JOINTS

THUMB HAS TWO JOINTS

JOINT AT BASE OF THUMB

You can't draw your characters with their hands in their pockets or behind their backs and not expect everyone to realize that you're hiding your inadequacies. Hey, I understand the frustration: you've drawn a good character, and you're afraid you might ruin it if you show the hands. Be brave! You're probably a lot closer to drawing a convincing hand than you realize. Here are some tips that will get you drawing hands like a pro.

Pay attention to the joints in the fingers. Each finger has three joints.

Each finger is a different length, but the pinky is a real shrimp.

JOINT AT BASE OF THUMB

The thumb has a moveable joint at its base, which is pronounced. This is what gives the thumb its width.

When having trouble, study your own hand in the pose you are trying to draw. But, if you're a guy, keep in mind that a woman's hand is narrower than yours.

NAIL TIP VARIATIONS

FLAT ROUND POINTED TRIMMED

Hand Poses and Accessories

You can draw hands in all sorts of expressive poses, even using extreme foreshortening (bottom right). You can also liven up your hands by adding rings, bracelets, hand guards, gloves, gold chains, and even mysterious tattoos.

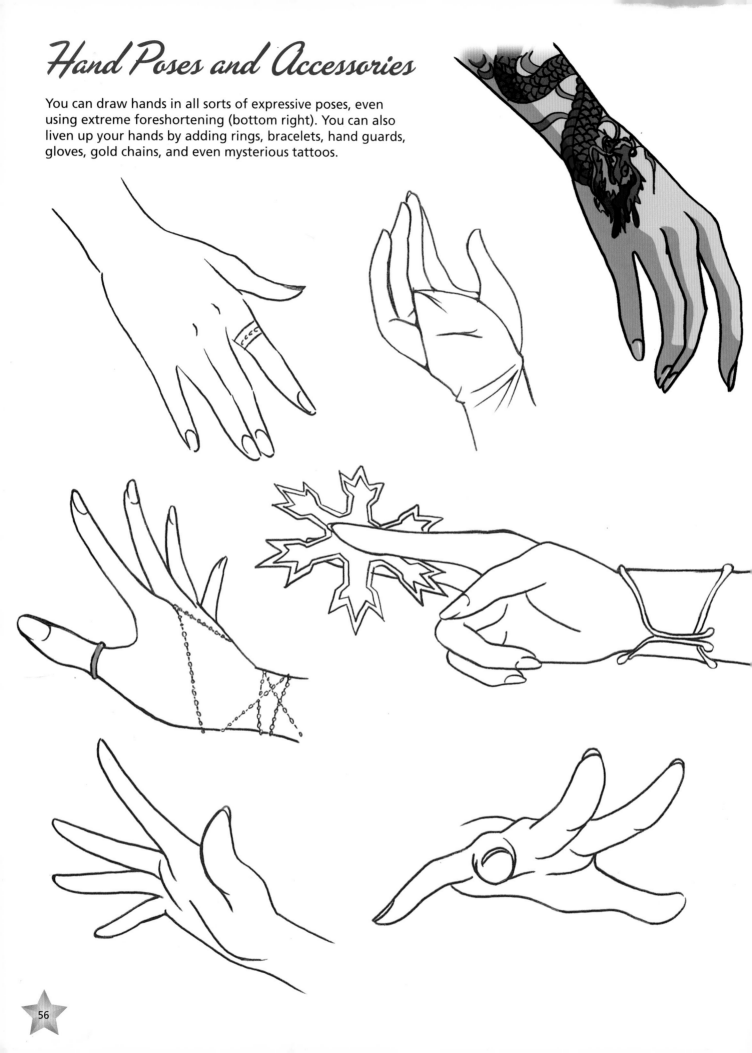

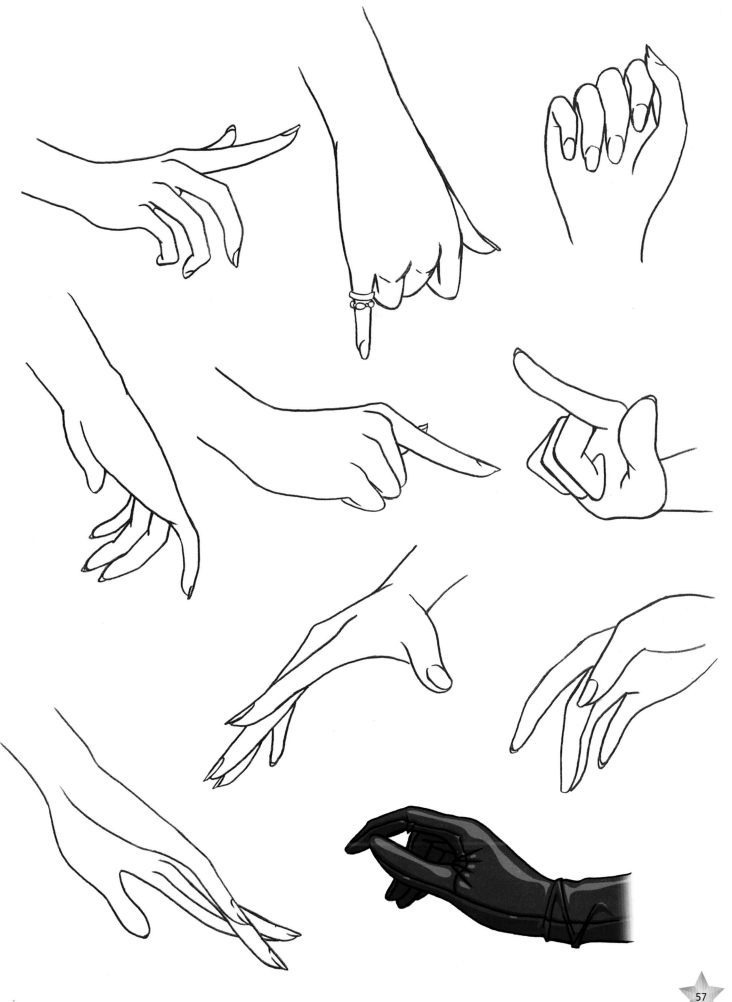

Feet, Shoes, and Boots

A woman's foot will always appear more attractive when the heel is lifted off the ground. This holds true whether your character is wearing stiletto shoes or space-fighter-pilot boots. The elevated heel causes the bridge of the foot to slope downward, elongating the look of the leg and creating a smoothly tapered appearance.

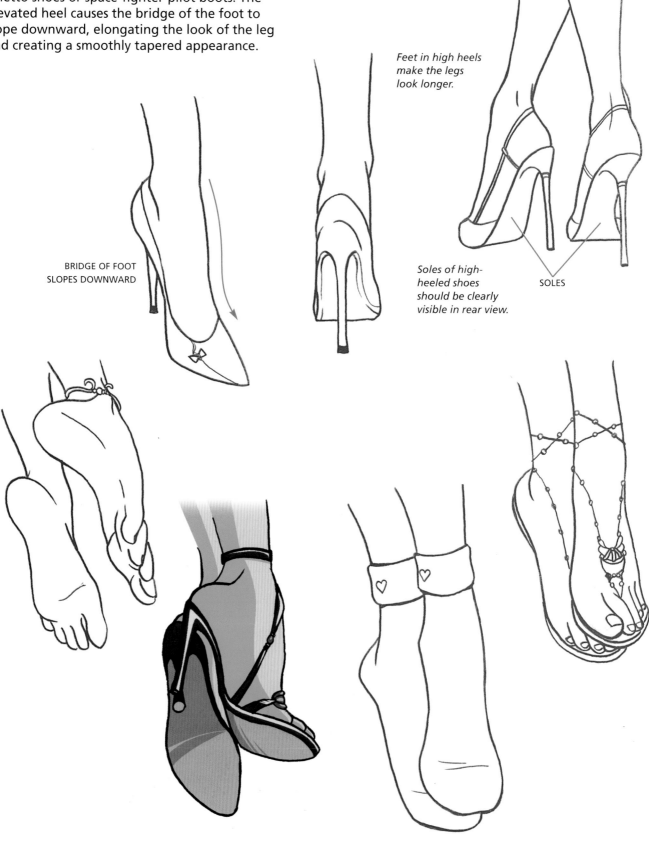

Feet in high heels make the legs look longer.

BRIDGE OF FOOT SLOPES DOWNWARD

Soles of high-heeled shoes should be clearly visible in rear view.

SOLES

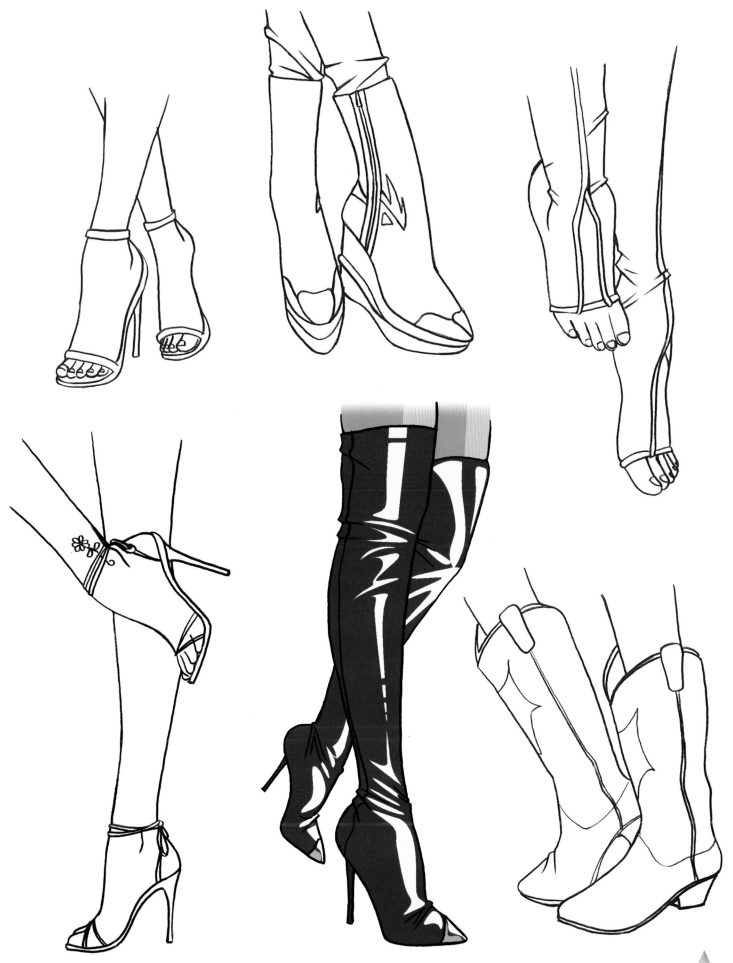

Stylish Figure

Let's put some costumes together with poses so that the personalities of the characters come through. This is a playful pose that works well with this attractive character, who wears stylish, casual clothing. To create a playful look, keep the figure light on her feet, with a bounce to her walk.

Broken down into its elements, this lively and appealing pose is actually quite easy to draw. It might not seem that way if you only look at the finished drawing, but if you examine the first construction step, you can see how the pose breaks down. That's what you should be fixing your mind on. Most of the important decisions are made in the first construction step. With that locked in, you're actually more than halfway done, and everything else falls into place. By making sure you begin at the first step, you're starting to draw correctly; most people start at the final stage and, consequently, never get it right and have no clue why.

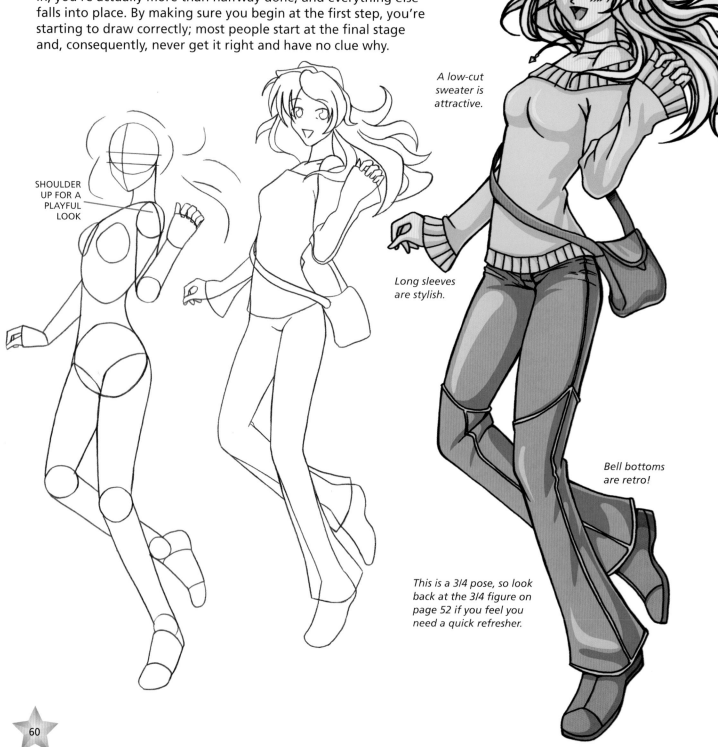

SHOULDER UP FOR A PLAYFUL LOOK

A low-cut sweater is attractive.

Long sleeves are stylish.

Bell bottoms are retro!

This is a 3/4 pose, so look back at the 3/4 figure on page 52 if you feel you need a quick refresher.

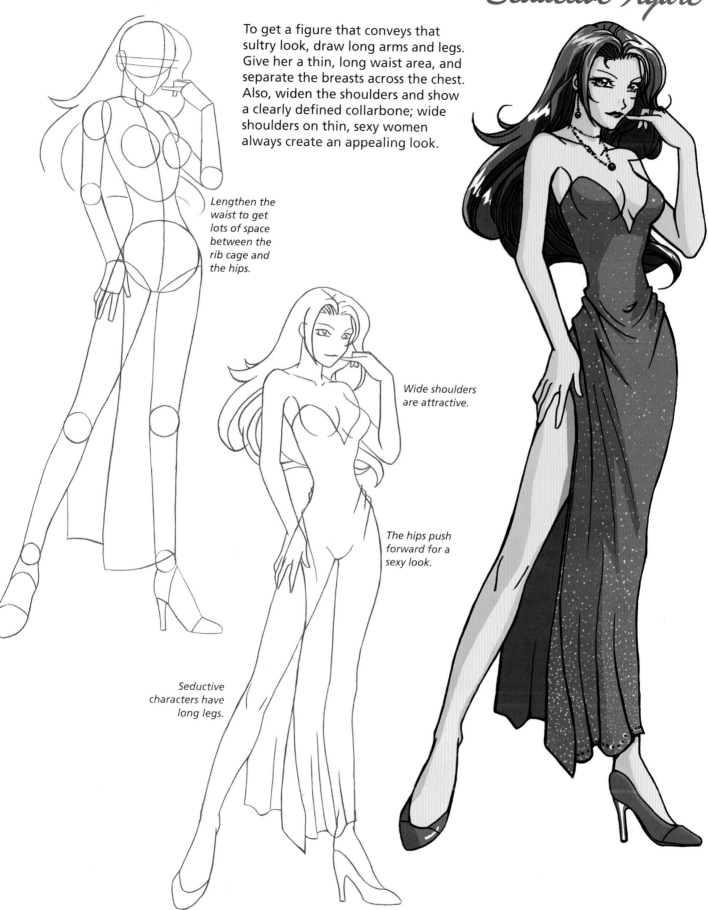

To get a figure that conveys that sultry look, draw long arms and legs. Give her a thin, long waist area, and separate the breasts across the chest. Also, widen the shoulders and show a clearly defined collarbone; wide shoulders on thin, sexy women always create an appealing look.

Lengthen the waist to get lots of space between the rib cage and the hips.

Wide shoulders are attractive.

The hips push forward for a sexy look.

Seductive characters have long legs.

61

Cool Figure

You definitely can't wear this to your next job interview, but for bishoujo characters, it's sensational! Sometimes, the clothes are so dramatic that you should let them do most of the work. For example, this character's pose is subdued to give the viewer a chance to get a good look at her flashy costume. With the long coat and the belt flapping in the wind, the outfit provides all the movement the figure needs.

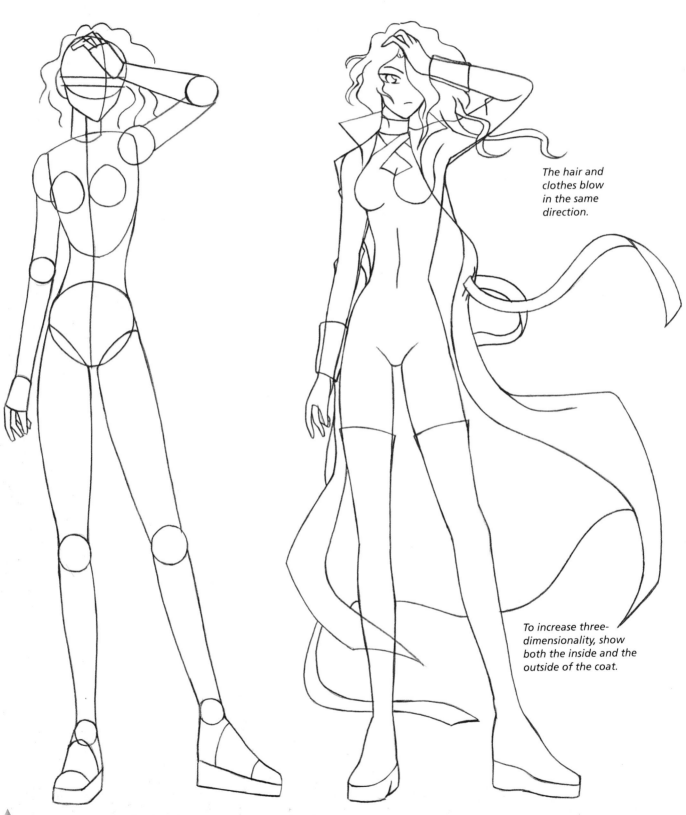

The hair and clothes blow in the same direction.

To increase three-dimensionality, show both the inside and the outside of the coat.

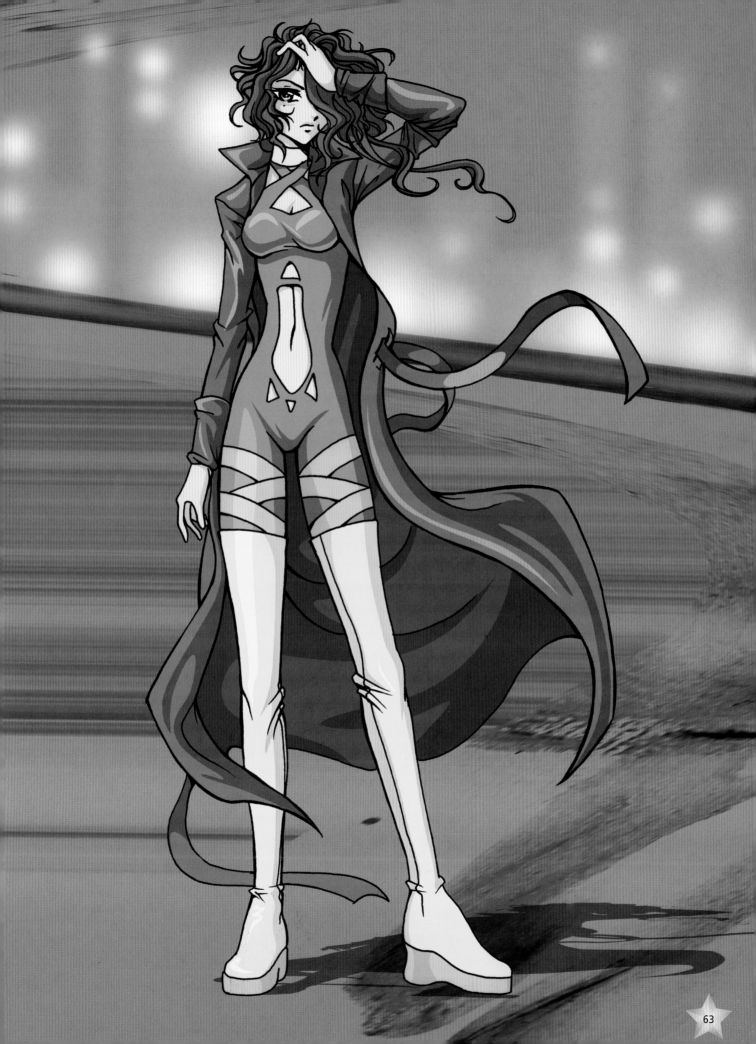

Warrior Figure

In keeping with her character, this figure is more athletic and rugged than the previous examples. She's an expert with the longbow. A wide stance is used to add stability. Archers are an important part of the Fantasy genre. They dress as if they were from the medieval peasant class; in other words, no armor, which was a trapping of the elite classes back then.

 Even though she has a warrior's heart, she should still have attractive features, such as dark eyelashes, a petite mouth and nose, and dramatic hair.

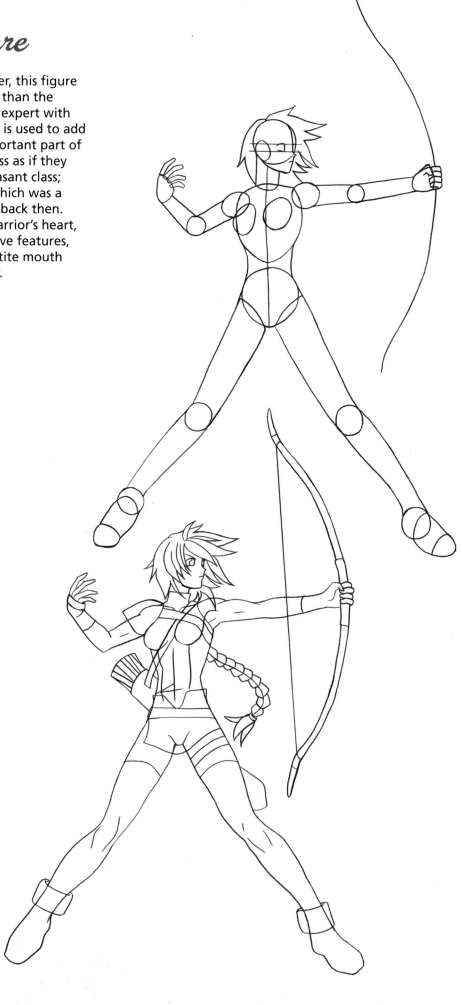

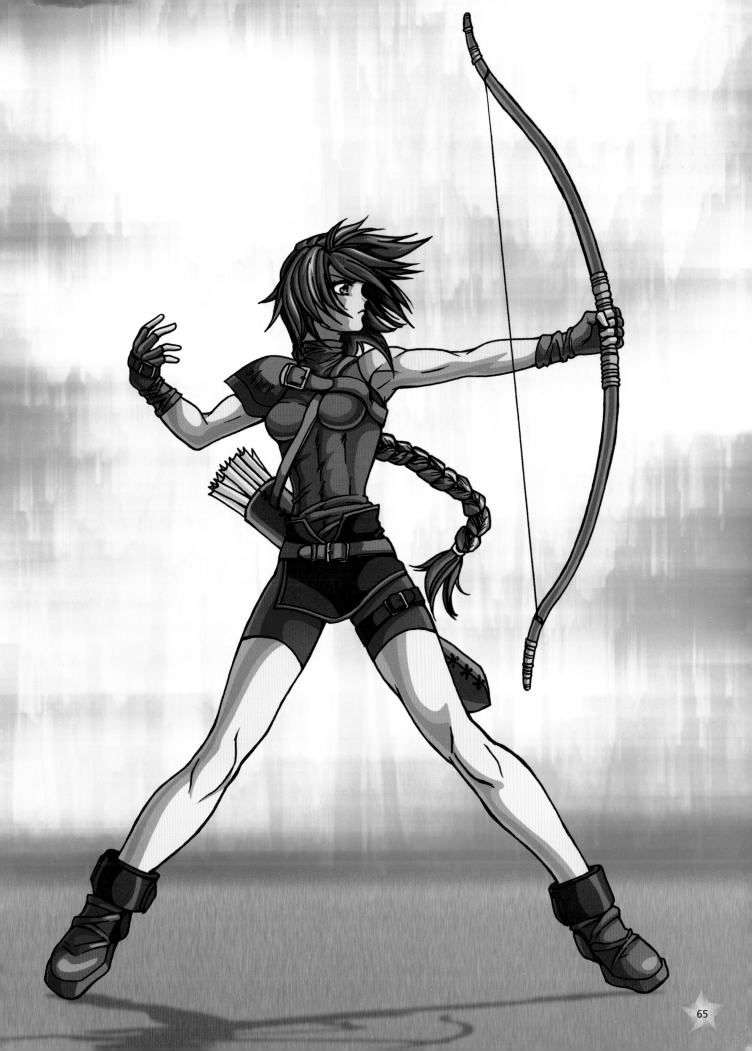

Posture and Emotion

In comics, characters communicate through words in speech balloons. But if words were enough, artists wouldn't need to draw facial expressions. Likewise, if facial expressions alone did the trick, there would be no need for dynamic poses. However the truth is that, we need the whole shebang: the words, facial expressions, and expressive posture.

Posture reflects the inner turmoil of a character. Positive emotions (such as joy), as well as forceful emotions (such as anger), require postures in which the chest is held out. Negative emotions (such as cowardice, sneakiness, and sadness) require postures with a sunken chest. Depending on the emotion, the shoulders tense up or droop, the head is either held high or low, and the spine stiffens or bends. Take a look at some of the ways the body typically conveys mood.

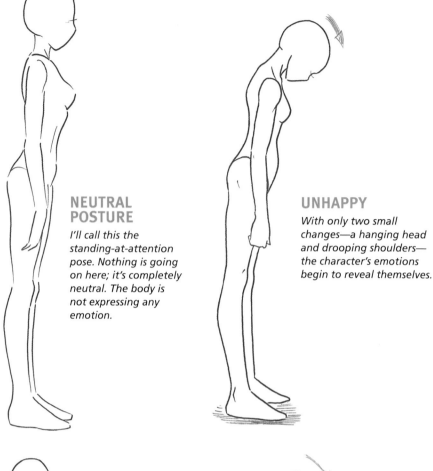

NEUTRAL POSTURE

I'll call this the standing-at-attention pose. Nothing is going on here; it's completely neutral. The body is not expressing any emotion.

UNHAPPY

With only two small changes—a hanging head and drooping shoulders—the character's emotions begin to reveal themselves.

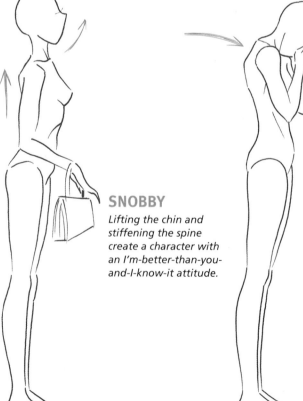

SNOBBY

Lifting the chin and stiffening the spine create a character with an I'm-better-than-you-and-I-know-it attitude.

GRIEF

The shoulders shift forward and the head tilts down, exactly like the Unhappy pose—but in this variation the head is held in the hands.

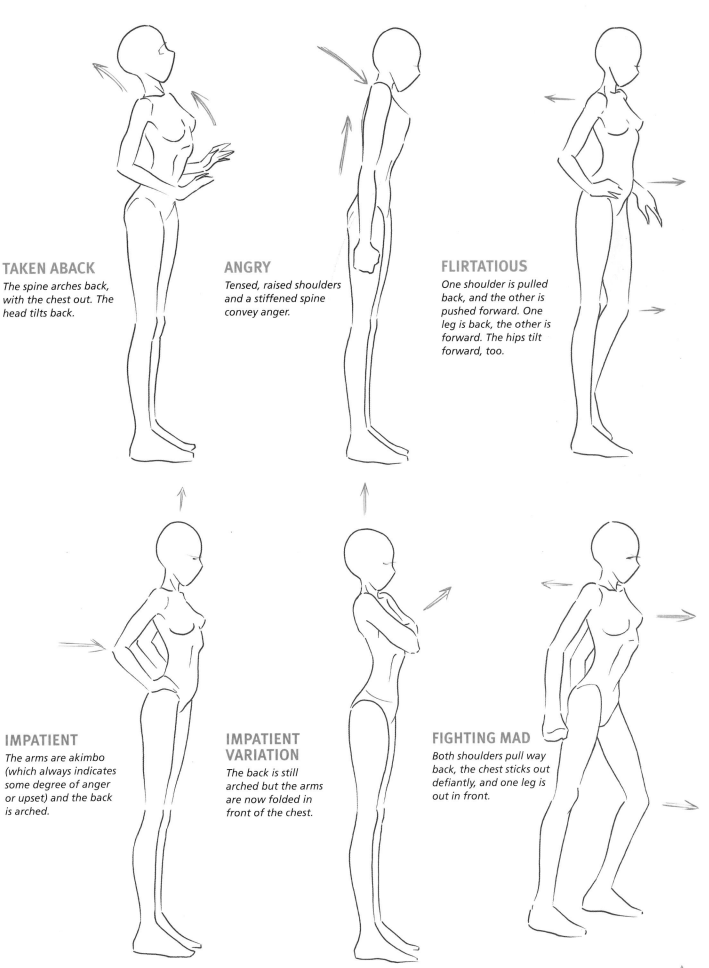

TAKEN ABACK

The spine arches back, with the chest out. The head tilts back.

ANGRY

Tensed, raised shoulders and a stiffened spine convey anger.

FLIRTATIOUS

One shoulder is pulled back, and the other is pushed forward. One leg is back, the other is forward. The hips tilt forward, too.

IMPATIENT

The arms are akimbo (which always indicates some degree of anger or upset) and the back is arched.

IMPATIENT VARIATION

The back is still arched but the arms are now folded in front of the chest.

FIGHTING MAD

Both shoulders pull way back, the chest sticks out defiantly, and one leg is out in front.

Emotions on Finished Figures

Now let's go one step further and vary the angles of the poses on finished figures. You'll see that despite the more elaborate rendering, the attitude reads just as clearly as it did before, because it's based on the body *posture*, not on the smaller details. The facial expressions assist the body language, making a strong statement even stronger.

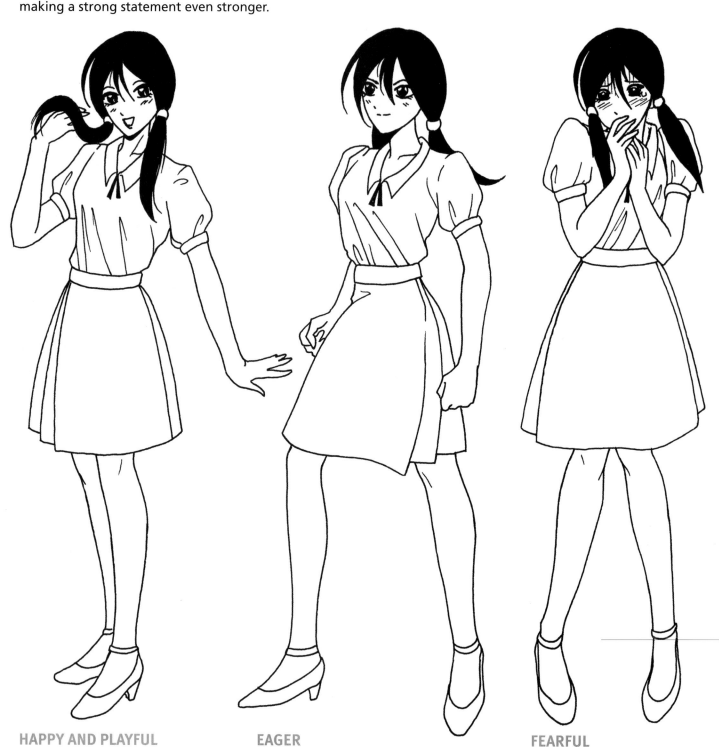

HAPPY AND PLAYFUL
An arched spine combines with a playful twist of one ponytail.

EAGER
This is similar to the Fighting Mad pose on page 67, but less intense.

FEARFUL
The knees knock together in a sign of weakness, the chest is sunken, and the shoulders rise nervously.

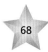

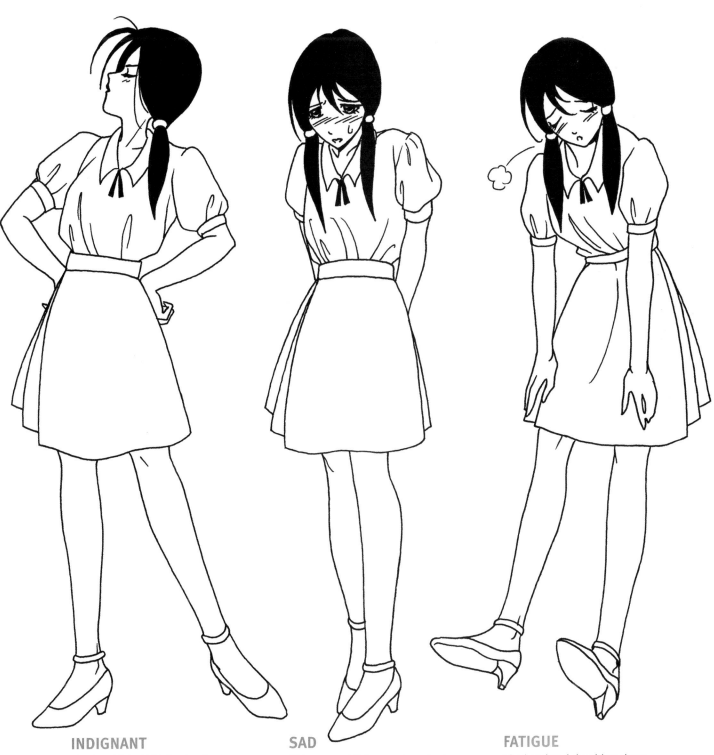

INDIGNANT

The head is held high, the chest is out, and the arms are akimbo.

SAD

This pose exhibits a sunken chest, shoulders that droop, and feet that turn slightly inward (always a sign of weakness).

FATIGUE

The head and shoulders slump, and the body bends forward in a sign of sapped strength.

Advanced Body Language

There are many ways to portray an emotion through body language. But ultimately, the most important tool you have is your own gut instinct. After you rough out a drawing, pause a moment to see whether it conveys the emotion you're trying to portray. If it doesn't, then you've still got work to do. But if you can look at your drawing and say, "Yeah, she looks tired [or happy or in love or whatever emotion you're after]," then you've nailed it and you can proceed. It's your job to be the final arbiter of what works and what doesn't. This section contains a few more advanced poses that you can copy exactly as they are for practice or that you can use as a springboard when developing your own original characters.

FLIRTATIOUS
The head tilts down, nesting in the shoulder. This is classic, flirtatious posture.

IMPATIENT
Sometimes, a simple action will read more clearly than an overly detailed pose. Instead of gritting her teeth and clenching her fists, all this character has to do is check her wristwatch for us to know what's happening.

READY TO GET EVEN
Clenched and half-clenched fists telegraph emotions clearly.

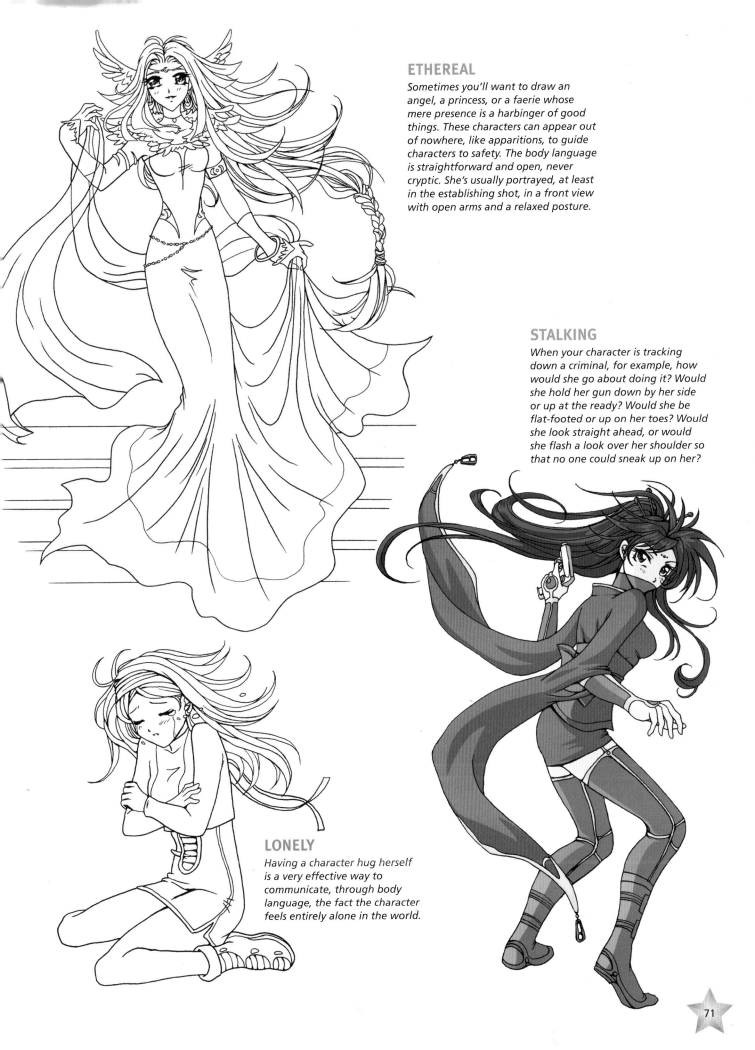

ETHEREAL

Sometimes you'll want to draw an angel, a princess, or a faerie whose mere presence is a harbinger of good things. These characters can appear out of nowhere, like apparitions, to guide characters to safety. The body language is straightforward and open, never cryptic. She's usually portrayed, at least in the establishing shot, in a front view with open arms and a relaxed posture.

STALKING

When your character is tracking down a criminal, for example, how would she go about doing it? Would she hold her gun down by her side or up at the ready? Would she be flat-footed or up on her toes? Would she look straight ahead, or would she flash a look over her shoulder so that no one could sneak up on her?

LONELY

Having a character hug herself is a very effective way to communicate, through body language, the fact the character feels entirely alone in the world.

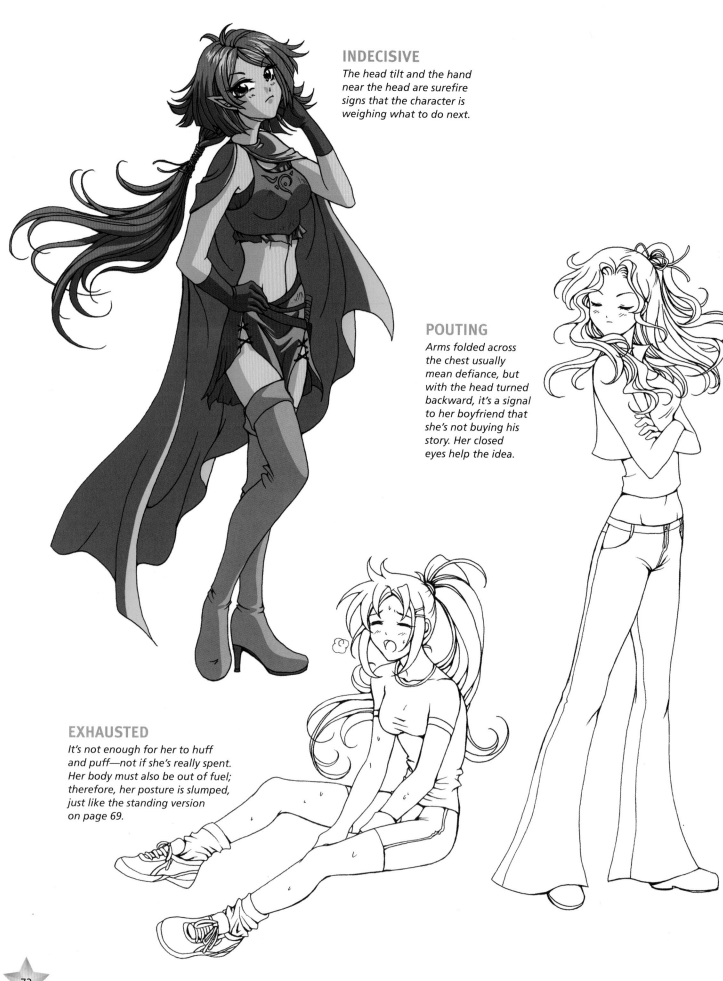

INDECISIVE

The head tilt and the hand near the head are surefire signs that the character is weighing what to do next.

POUTING

Arms folded across the chest usually mean defiance, but with the head turned backward, it's a signal to her boyfriend that she's not buying his story. Her closed eyes help the idea.

EXHAUSTED

It's not enough for her to huff and puff—not if she's really spent. Her body must also be out of fuel; therefore, her posture is slumped, just like the standing version on page 69.

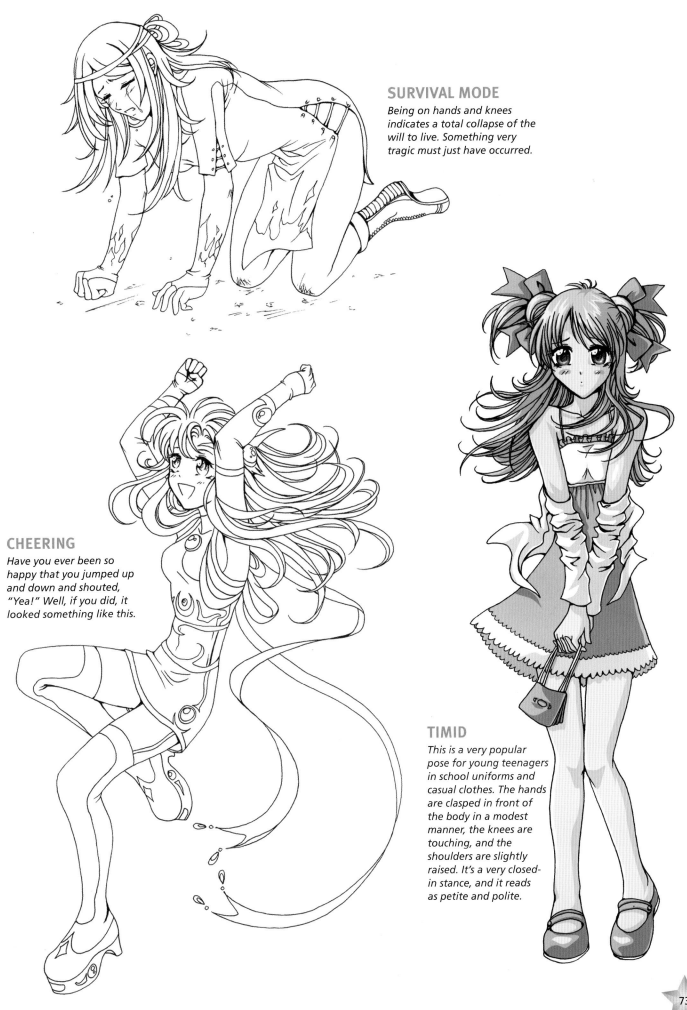

SURVIVAL MODE

Being on hands and knees indicates a total collapse of the will to live. Something very tragic must just have occurred.

CHEERING

Have you ever been so happy that you jumped up and down and shouted, "Yea!" Well, if you did, it looked something like this.

TIMID

This is a very popular pose for young teenagers in school uniforms and casual clothes. The hands are clasped in front of the body in a modest manner, the knees are touching, and the shoulders are slightly raised. It's a very closed-in stance, and it reads as petite and polite.

73

Turning a Plain Pose into a Sexy One

What makes a pose sexy? First of all, a sexy pose is fluid, never stiff. Generally, the legs are placed apart or one leg bends more than the other. This causes the hips to tilt to one side, which is essential for a sexy pose. Don't position the hips square; they must be tilted unevenly if they are to be attractive. You can also push the hip area forward, which causes the figure to lean back and the breasts to rise up slightly.

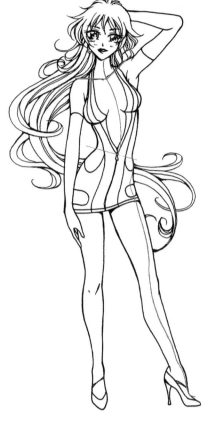

SHIFTING THE LEG

Simply moving a leg further to one side dramatically improves a pose. When you do this, it's not just the legs that are affected. The entire body adjusts, like a set of dominoes falling into place. Look at the line of the hips and shoulders: the hips appear curvier and the shoulders more severely angled.

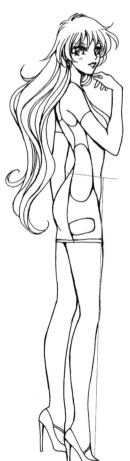
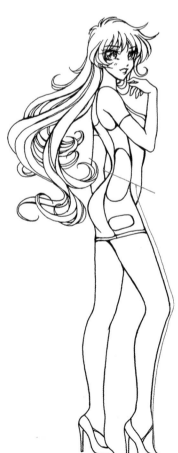

BENDING THE LEG

As one leg bends, the arch in the small of the back increases and the rear end pushes outward, accentuating the curves of the figure more. The upper back also adjusts, leaning back slightly, which in turn causes the breasts to lift slightly.

Ordinary vs. Attractive Posture

Comparing these before-and-after examples will give you an idea of what you're looking for.

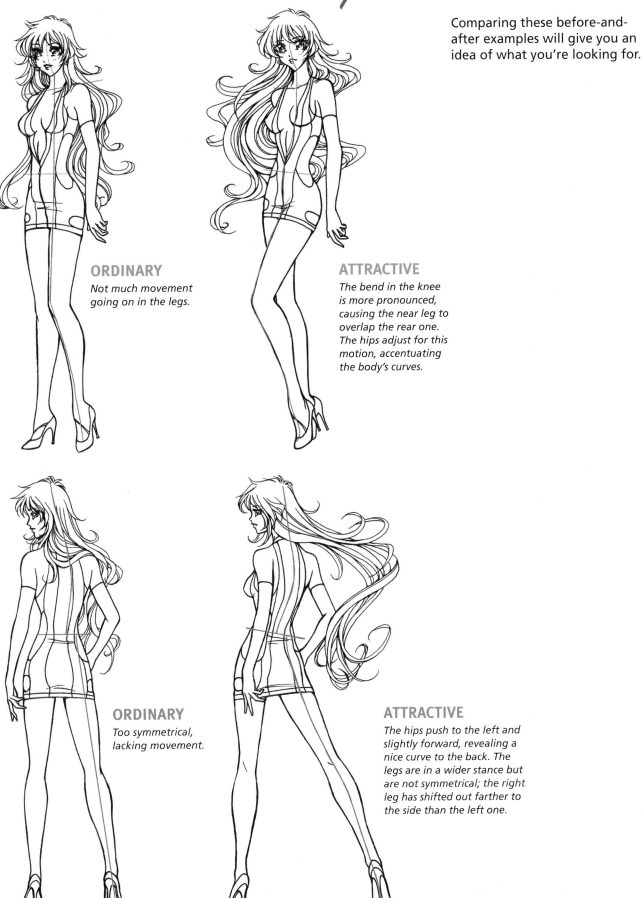

ORDINARY

Not much movement going on in the legs.

ATTRACTIVE

The bend in the knee is more pronounced, causing the near leg to overlap the rear one. The hips adjust for this motion, accentuating the body's curves.

ORDINARY

Too symmetrical, lacking movement.

ATTRACTIVE

The hips push to the left and slightly forward, revealing a nice curve to the back. The legs are in a wider stance but are not symmetrical; the right leg has shifted out farther to the side than the left one.

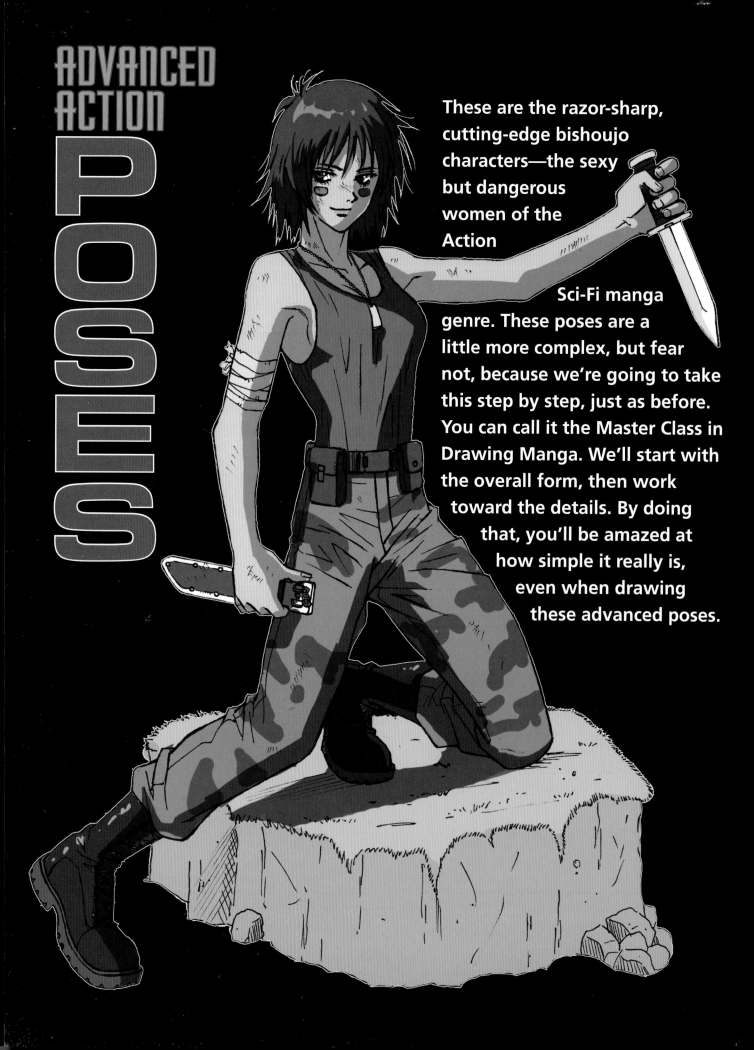

ADVANCED ACTION POSES

These are the razor-sharp, cutting-edge bishoujo characters—the sexy but dangerous women of the Action

Sci-Fi manga genre. These poses are a little more complex, but fear not, because we're going to take this step by step, just as before. You can call it the Master Class in Drawing Manga. We'll start with the overall form, then work toward the details. By doing that, you'll be amazed at how simple it really is, even when drawing these advanced poses.

What Makes an Action Character?

The Action gals of bishoujo are usually about twenty to twenty-five years old. Sometimes this bishoujo Action genre is referred to as *bijo*. In this style, characters of this age have heads that are not as large in comparison to their bodies as the younger characters and schoolgirls. The proportions of the bodies are more realistic, and the eyes are not so huge. In addition, these are characters on a mission, sent by the secret service to rescue someone or complete some other equally dangerous assignment. They don't wear anything that would get in the way of accomplishing their goals. They're sharp, pretty, and highly attractive characters.

MILITARY CHARACTERS

Military characters like this commando gal have been through the gauntlet. They're tough and proud. They look you straight in the eye.

When drawing commando gals, I suggest that you make her look as if she has crawled through a few trenches and left behind a few garments in the process. It makes her mission look more dramatic than if she's wearing a starched uniform.

Classic Action Character Pose

This crouching posture is famously employed by spy characters working undercover. As she infiltrates enemy territory, she must take care not to reveal her presence. Therefore, her body language tells us she's hiding, tucking everything in. Keep the shoulders tensed and the character's back slightly hunched in a pose like this. The arm that holds the gun should either be held straight or should be bent and at eye level—both ways show the character on edge, ready for a split-second response.

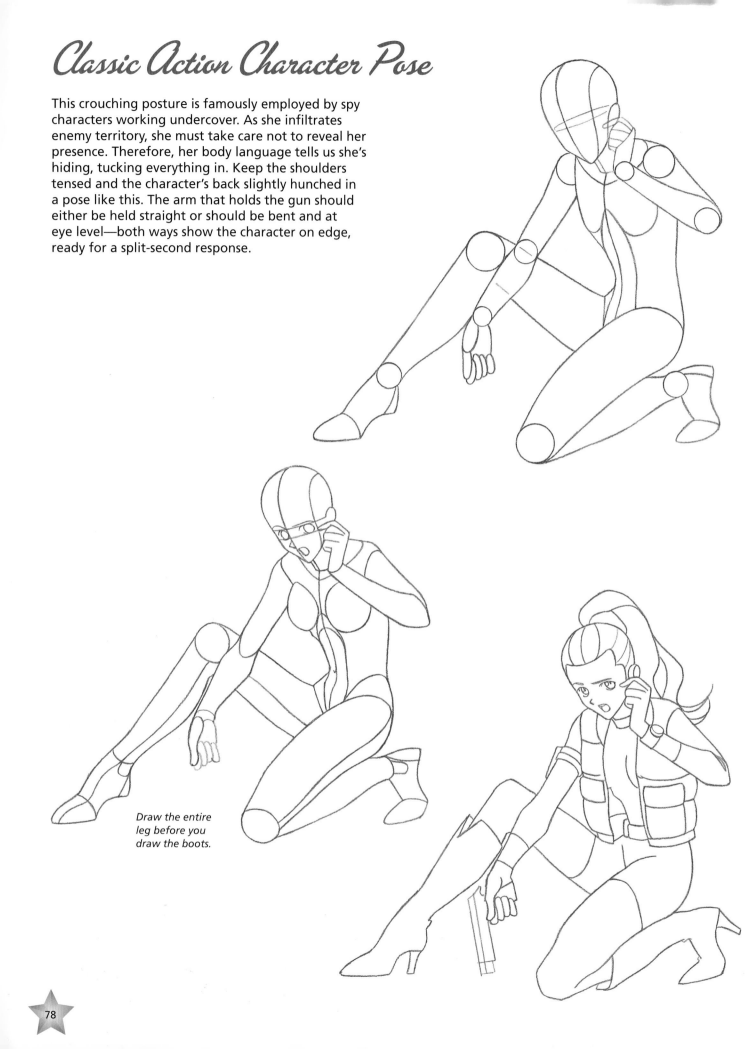

Draw the entire leg before you draw the boots.

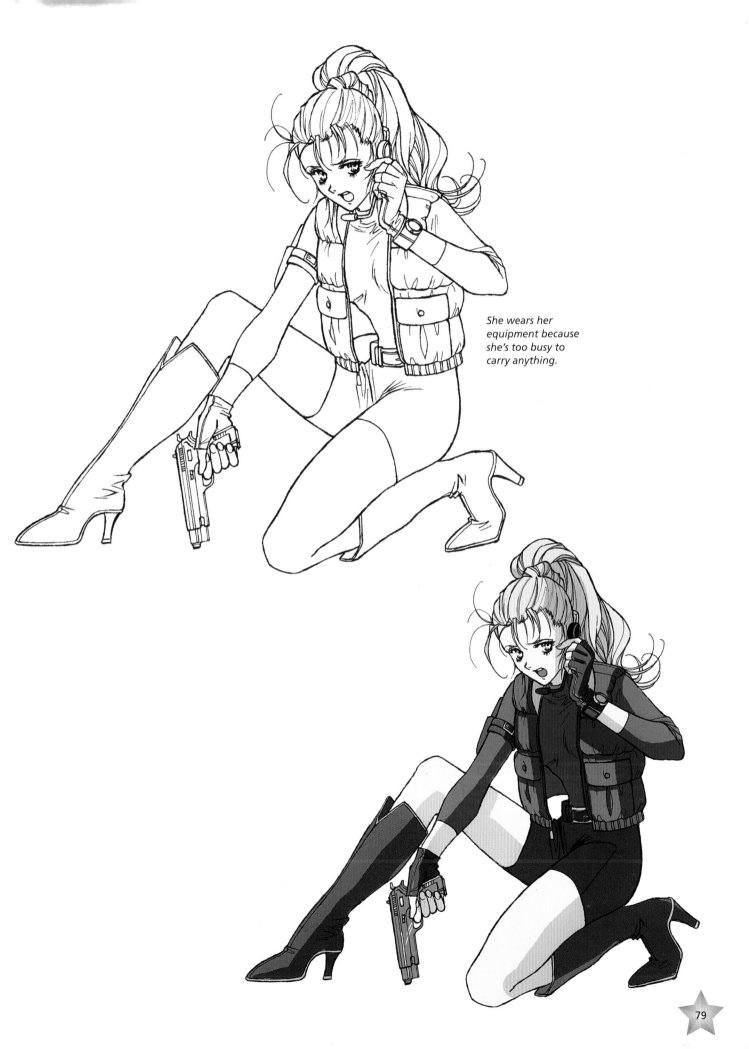

She wears her equipment because she's too busy to carry anything.

Running

Here's a good running pose. It's not the typical pose most artists think of. Instead of the legs being spread apart in the widest possible stride, they are depicted in a "crossover" position in midstride. While the open stride is very effective at showing a running character striving for speed, it also tends to make the character look frozen in time because it's so evenly balanced and symmetrical. The crossover position, on the other hand, looks like a quick snapshot—a moment captured in an action sequence.

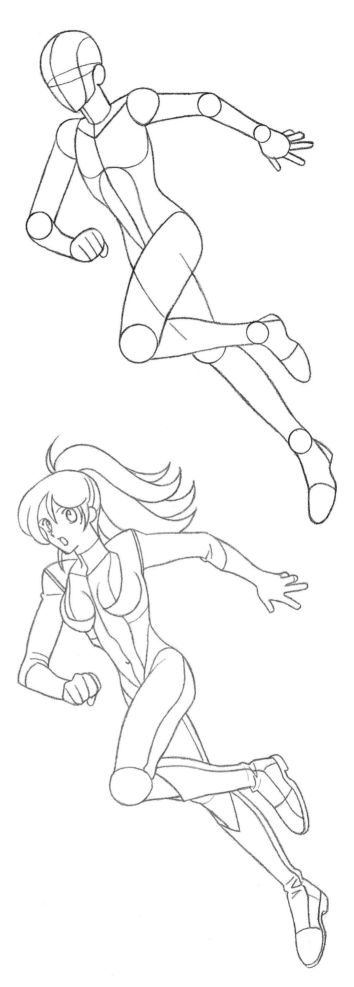

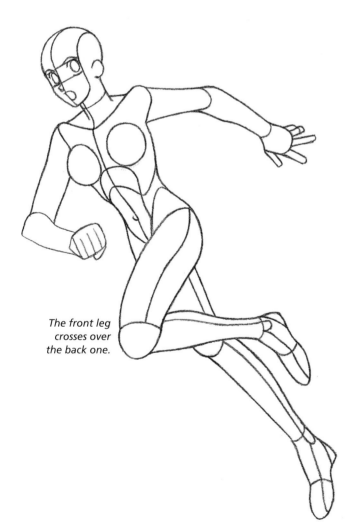

The front leg crosses over the back one.

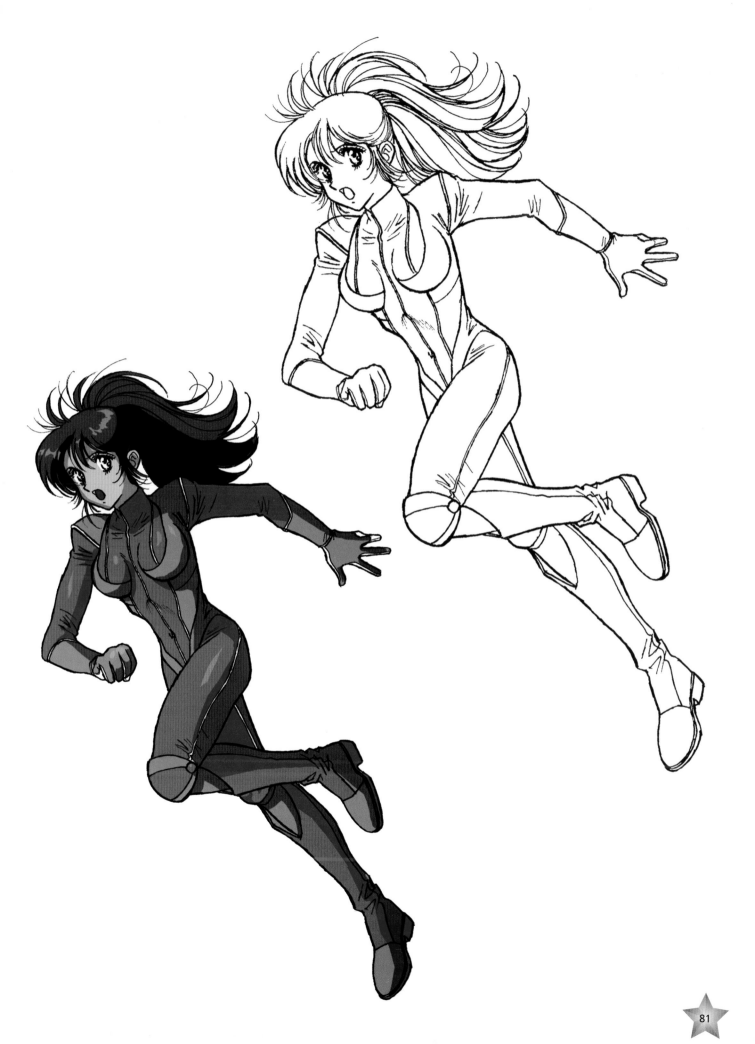

Running Variation

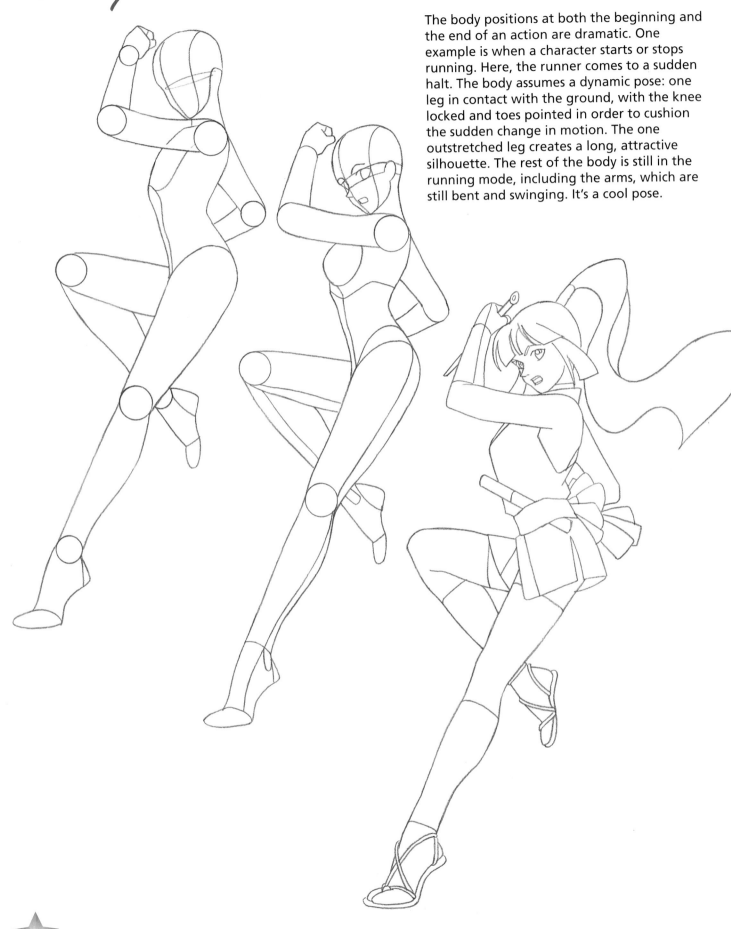

The body positions at both the beginning and the end of an action are dramatic. One example is when a character starts or stops running. Here, the runner comes to a sudden halt. The body assumes a dynamic pose: one leg in contact with the ground, with the knee locked and toes pointed in order to cushion the sudden change in motion. The one outstretched leg creates a long, attractive silhouette. The rest of the body is still in the running mode, including the arms, which are still bent and swinging. It's a cool pose.

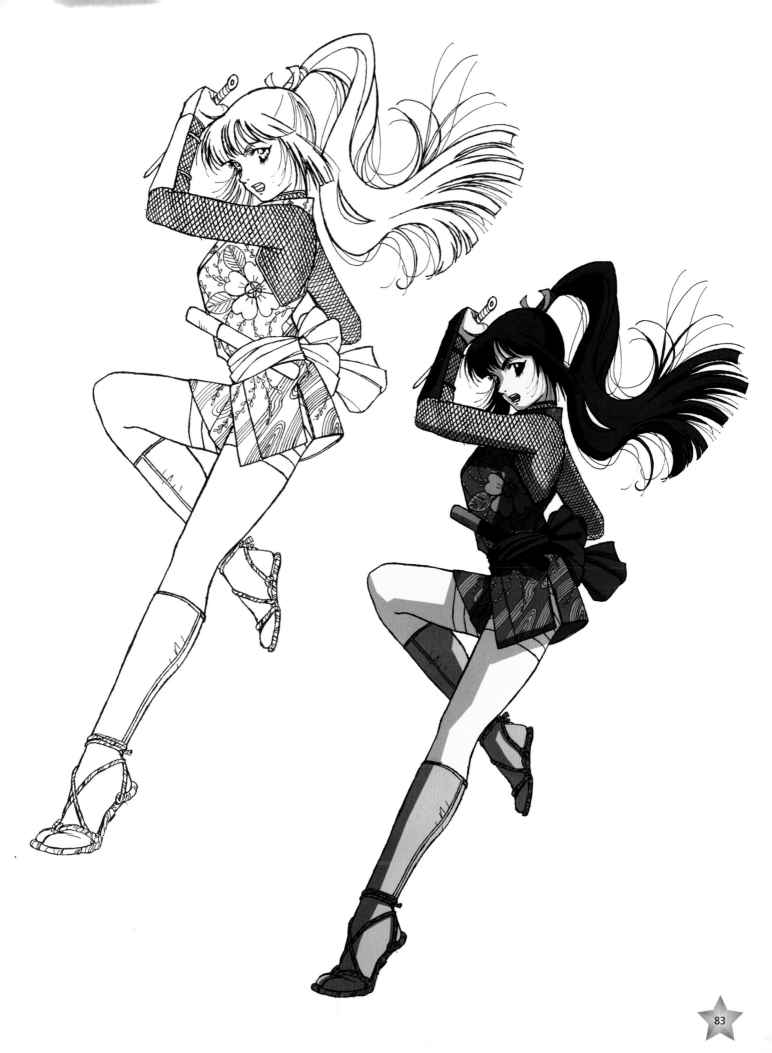

Martial Arts

In comics, martial arts should always look dramatic. Actual martial arts combat is more straightforward and far less flashy. But this is manga, and over-the-top action looks cool. More motion is always better than less. The stances should be open, with arms and limbs away from the body in mysterious positions. Vary the hand gestures between fists, knife-edges, and claws.

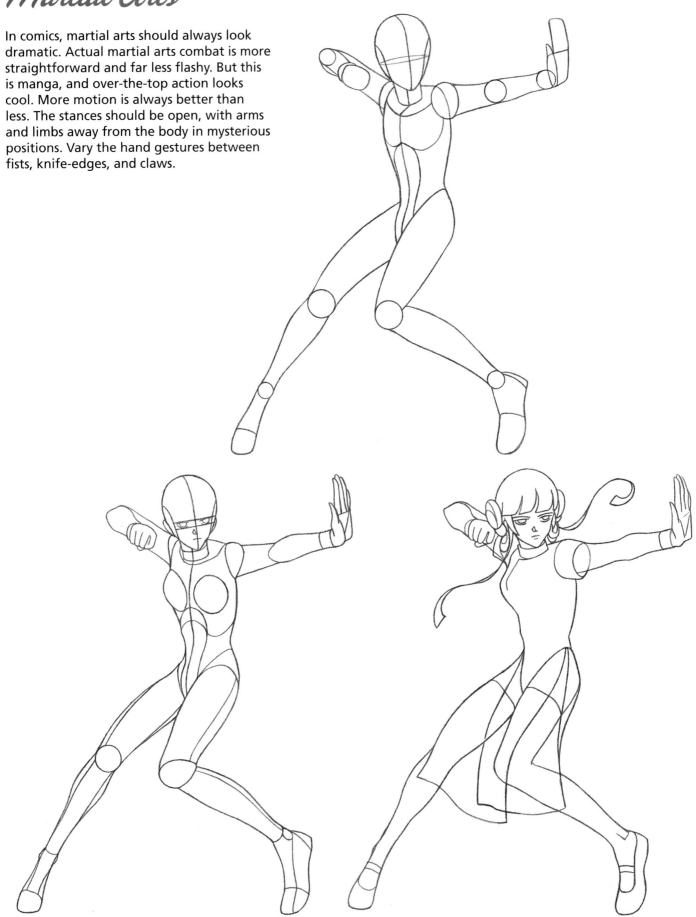

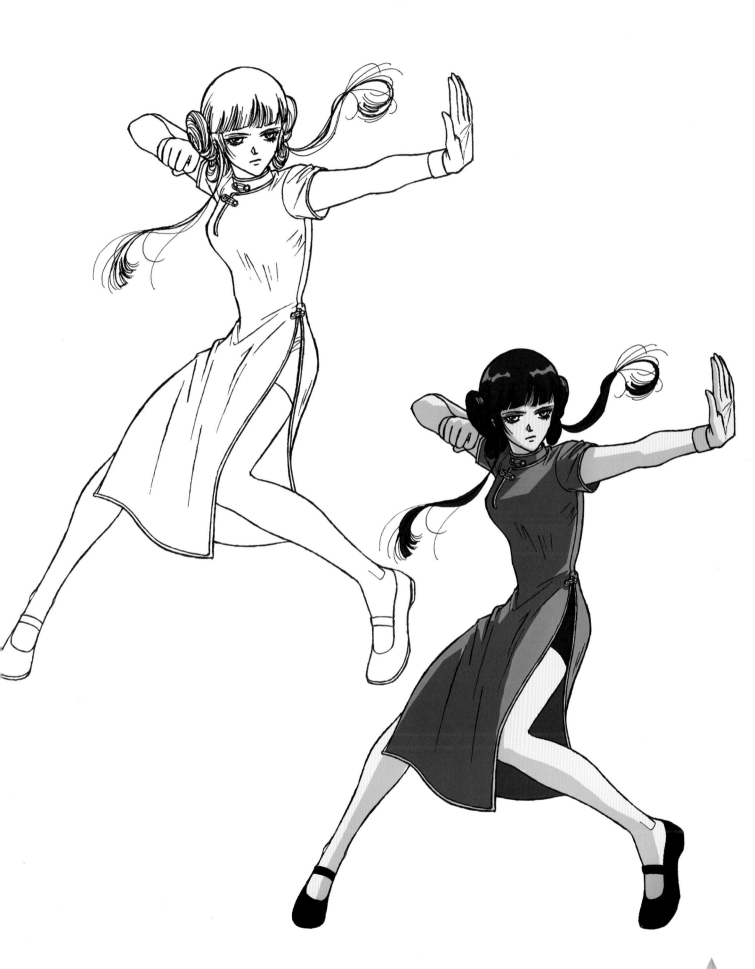

Dancing is Action, Too

Magicians and cabaret stars are a popular component of bishoujo. The lifted leg creates a common pose that reads "showgirl." It's reminiscent of chorus lines. Since she's a performer, she needs to twist her body to face the audience in front of her, even if she's walking sideways across the stage, as she is here.

BODY IN 3/4 VIEW

LEGS IN SIDE VIEW

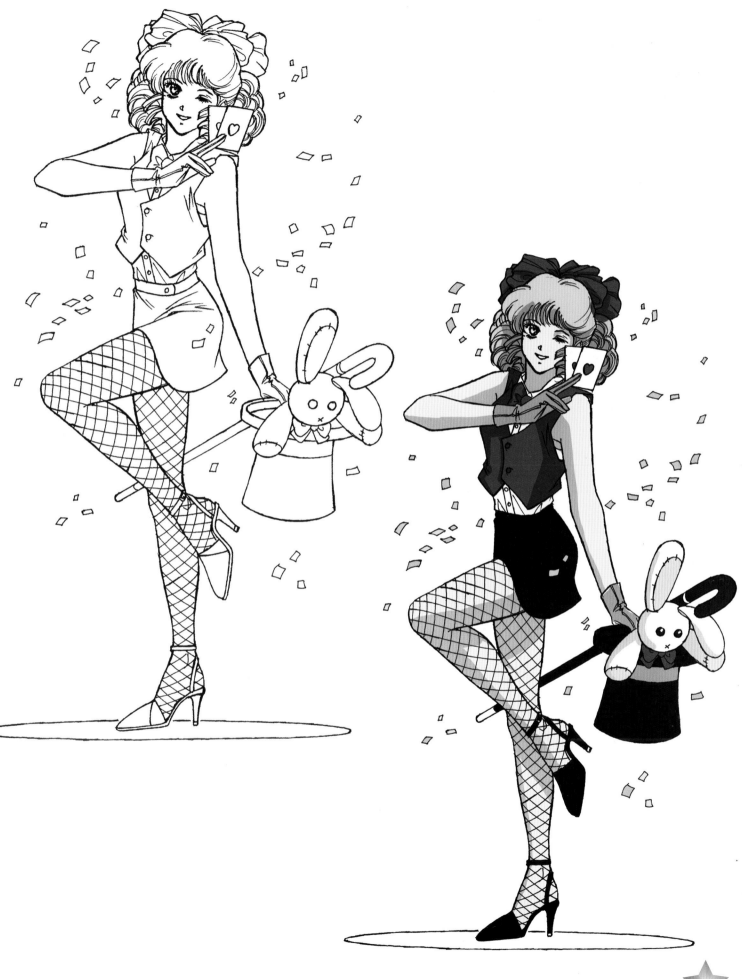

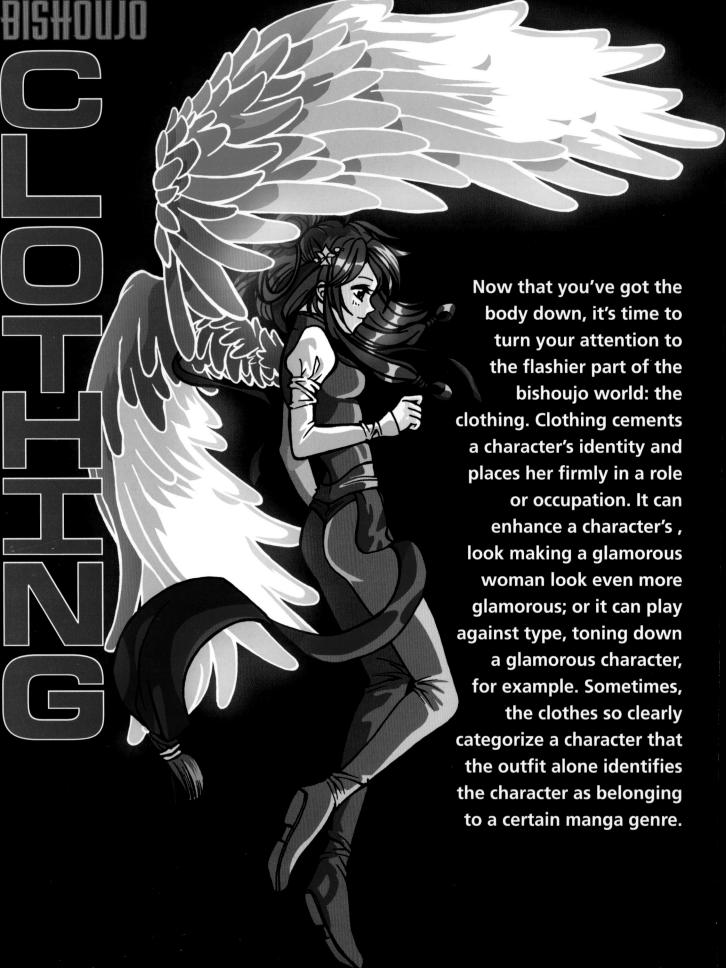

BISHOUJO
CLOTHING

Now that you've got the body down, it's time to turn your attention to the flashier part of the bishoujo world: the clothing. Clothing cements a character's identity and places her firmly in a role or occupation. It can enhance a character's , look making a glamorous woman look even more glamorous; or it can play against type, toning down a glamorous character, for example. Sometimes, the clothes so clearly categorize a character that the outfit alone identifies the character as belonging to a certain manga genre.

Fabrics and Other Clothing Elements

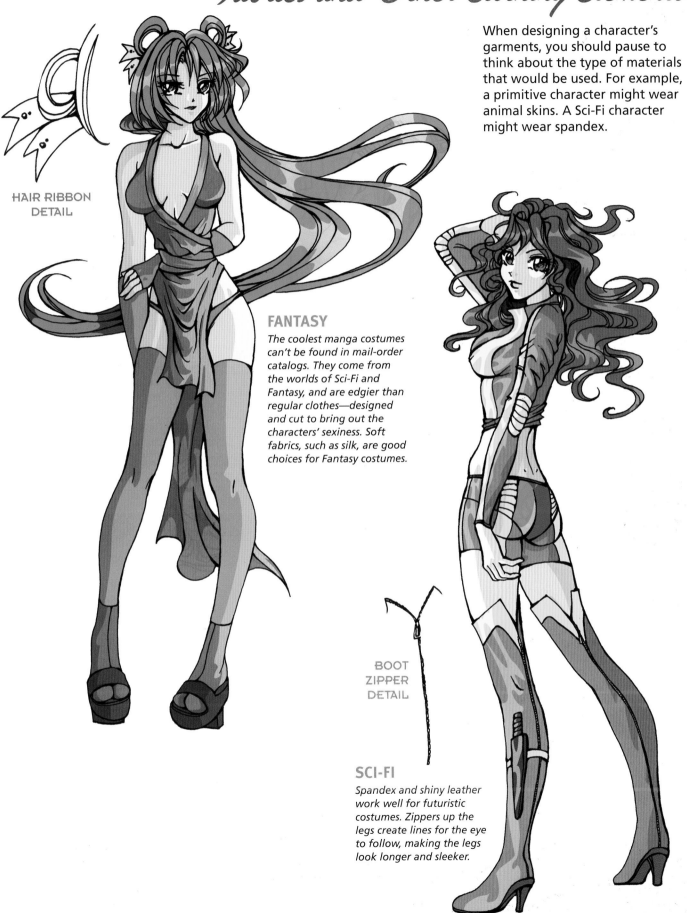

When designing a character's garments, you should pause to think about the type of materials that would be used. For example, a primitive character might wear animal skins. A Sci-Fi character might wear spandex.

HAIR RIBBON
DETAIL

FANTASY

The coolest manga costumes can't be found in mail-order catalogs. They come from the worlds of Sci-Fi and Fantasy, and are edgier than regular clothes—designed and cut to bring out the characters' sexiness. Soft fabrics, such as silk, are good choices for Fantasy costumes.

BOOT
ZIPPER
DETAIL

SCI-FI

Spandex and shiny leather work well for futuristic costumes. Zippers up the legs create lines for the eye to follow, making the legs look longer and sleeker.

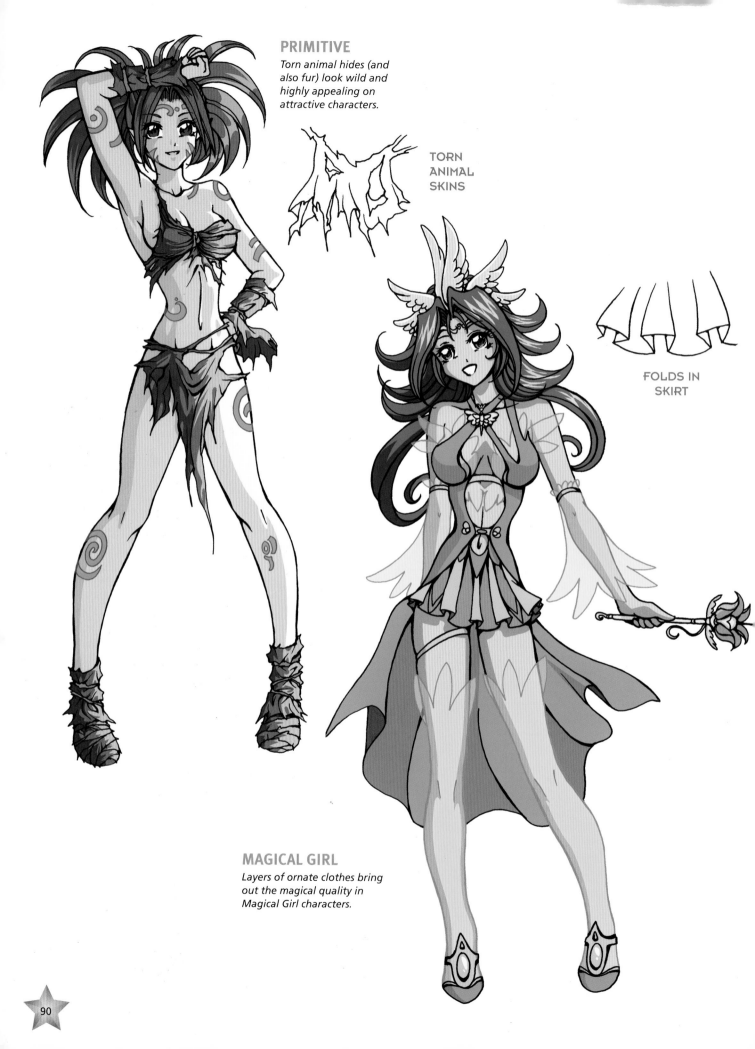

PRIMITIVE

Torn animal hides (and also fur) look wild and highly appealing on attractive characters.

TORN ANIMAL SKINS

FOLDS IN SKIRT

MAGICAL GIRL

Layers of ornate clothes bring out the magical quality in Magical Girl characters.

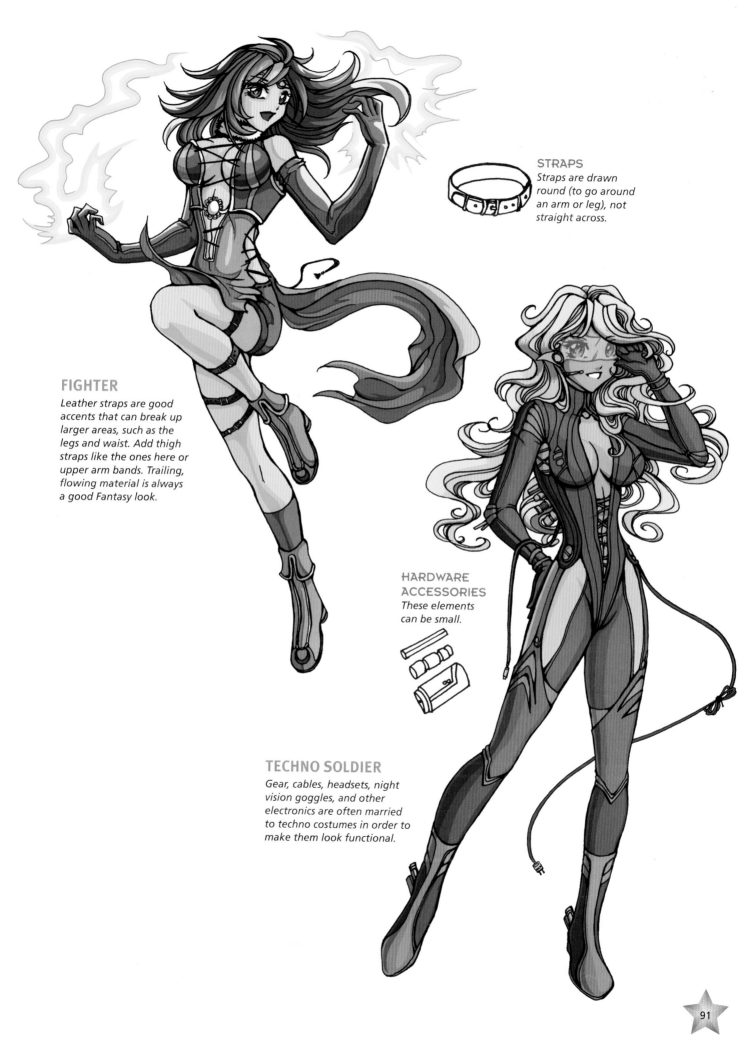

STRAPS
Straps are drawn round (to go around an arm or leg), not straight across.

FIGHTER
Leather straps are good accents that can break up larger areas, such as the legs and waist. Add thigh straps like the ones here or upper arm bands. Trailing, flowing material is always a good Fantasy look.

HARDWARE ACCESSORIES
These elements can be small.

TECHNO SOLDIER
Gear, cables, headsets, night vision goggles, and other electronics are often married to techno costumes in order to make them look functional.

School Uniforms

Schoolgirls are some of the most popular manga characters, and are seen in some of the most popular Japanese comics. School uniforms are quite typical in Japan, so they should be drawn correctly. These examples are based on authentic Japanese school uniforms. The two types are the private school uniform and the public school (sailor) uniform.

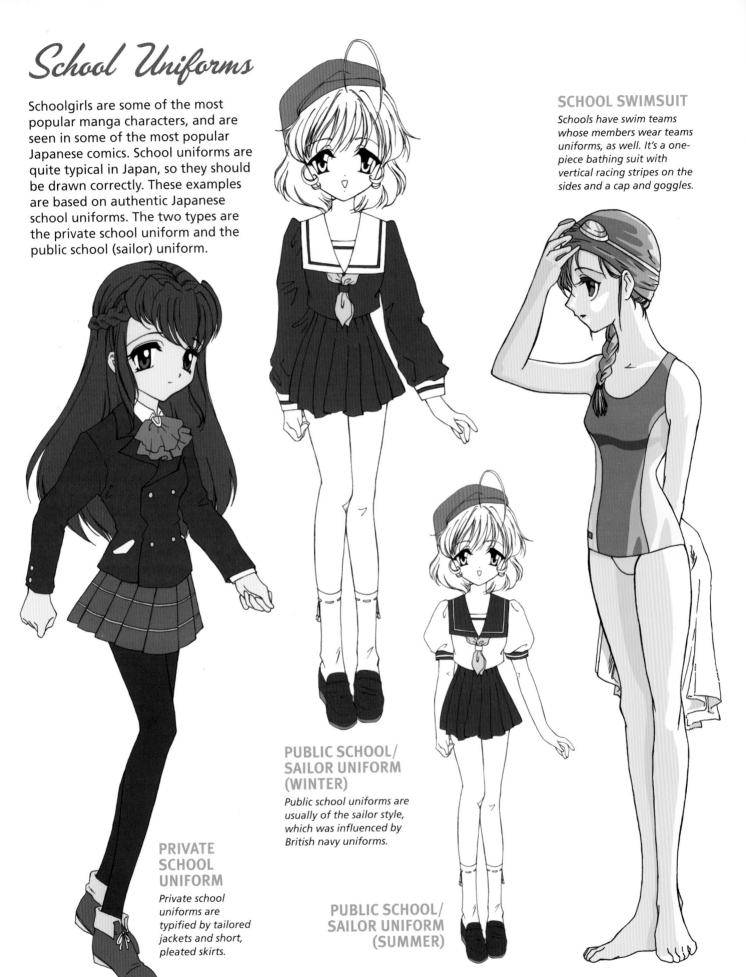

SCHOOL SWIMSUIT

Schools have swim teams whose members wear teams uniforms, as well. It's a one-piece bathing suit with vertical racing stripes on the sides and a cap and goggles.

PRIVATE SCHOOL UNIFORM

Private school uniforms are typified by tailored jackets and short, pleated skirts.

PUBLIC SCHOOL/ SAILOR UNIFORM (WINTER)

Public school uniforms are usually of the sailor style, which was influenced by British navy uniforms.

PUBLIC SCHOOL/ SAILOR UNIFORM (SUMMER)

Traditional Japanese Costumes

Traditional Japanese costumes are worn for special occasions and ceremonies. There are two main types of long robes made out of silk and satin.

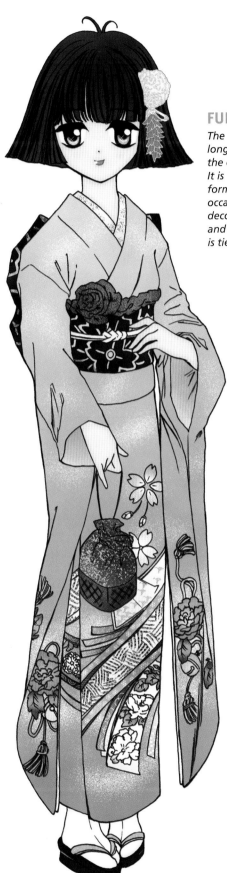

FURISODE KIMONO

The furisode kimono has long sleeves and shows off the character's sleek figure. It is worn by maidens on formal and ceremonial occasions, and is highly decorated with pictures and patterns. An obi (sash) is tied around the waist.

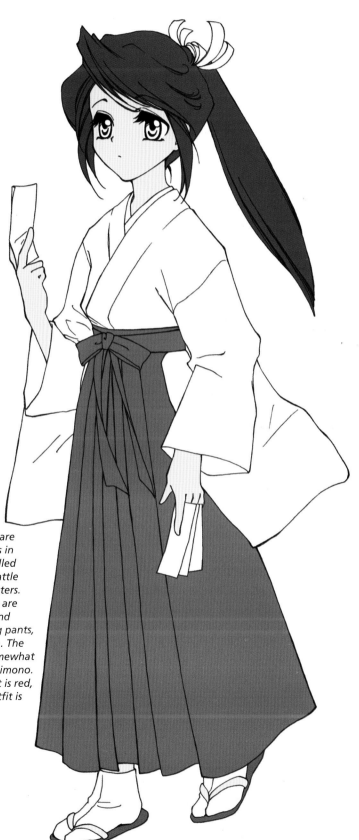

HAKAMA

Shinto priestesses are popular characters in manga and are called miko. The miko battle demons and monsters. Their skirts, which are crimson colored and look like billowing pants, are called hakama. The entire outfit is somewhat bulkier than the kimono. Although the skirt is red, the rest of the outfit is white to indicate purity of spirit.

Professional Uniforms

The costume is all-important in communicating the occupation of the character. Service professions—such as nurses, waitresses, and maids—are popular in bishoujo manga. For all of you politically correct folks out there, don't shoot the messenger! The culture is different in Japan, and these characters are not only perfectly acceptable there, but are very popular. And they're becoming quite popular over here, too.

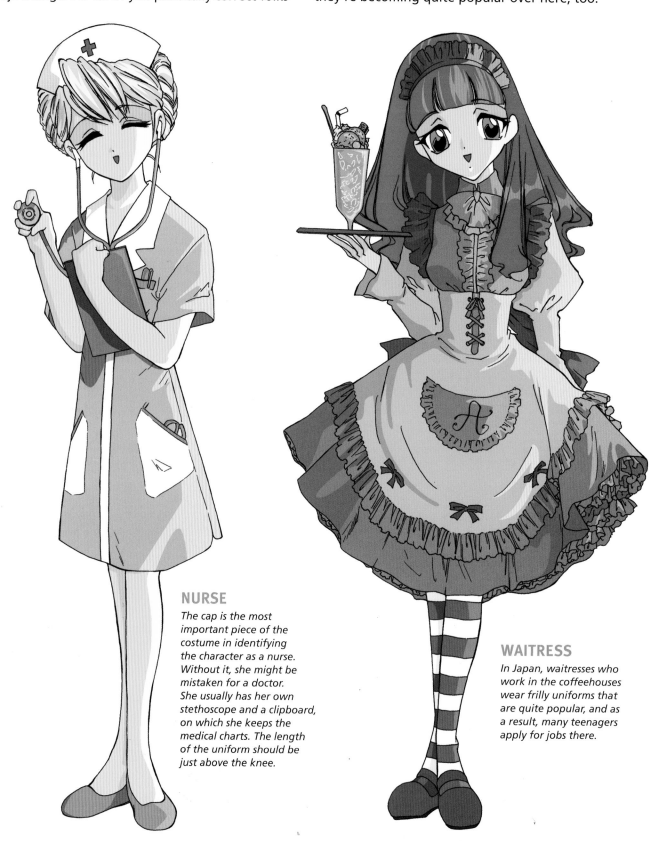

NURSE

The cap is the most important piece of the costume in identifying the character as a nurse. Without it, she might be mistaken for a doctor. She usually has her own stethoscope and a clipboard, on which she keeps the medical charts. The length of the uniform should be just above the knee.

WAITRESS

In Japan, waitresses who work in the coffeehouses wear frilly uniforms that are quite popular, and as a result, many teenagers apply for jobs there.

Uniforms for More Active Professions

Many popluar bishoujo characters have assertive professions, including those in the military and sports arenas.

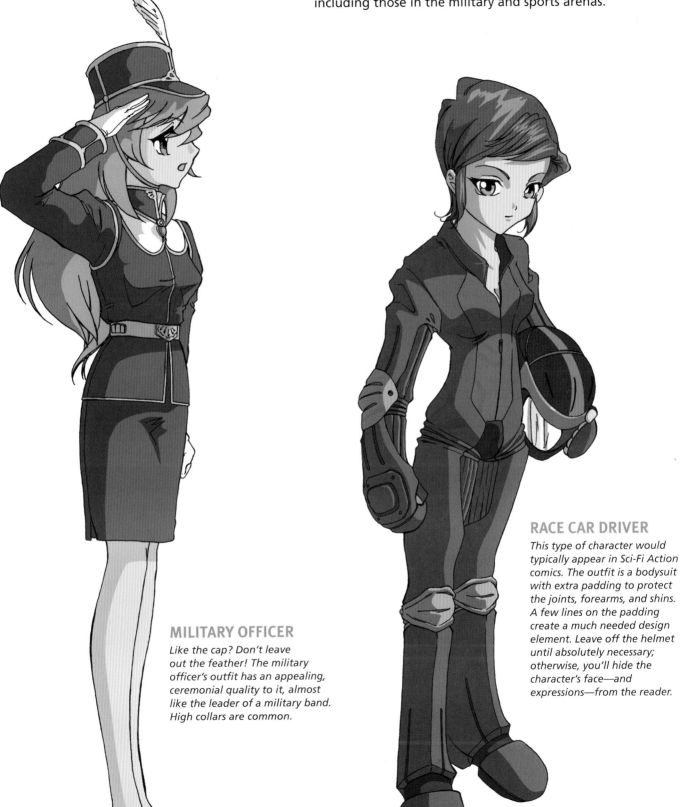

MILITARY OFFICER

Like the cap? Don't leave out the feather! The military officer's outfit has an appealing, ceremonial quality to it, almost like the leader of a military band. High collars are common.

RACE CAR DRIVER

This type of character would typically appear in Sci-Fi Action comics. The outfit is a bodysuit with extra padding to protect the joints, forearms, and shins. A few lines on the padding create a much needed design element. Leave off the helmet until absolutely necessary; otherwise, you'll hide the character's face—and expressions—from the reader.

Magical Girl Costumes

The Magical Girl genre uses costume as an integral part of the story. For example, the star of the story, a magical girl, may transform herself into a super marching band conductor who battles demons that are trying to take over the world by corrupting the youth through evil messages encoded in their music.

MASCOTS

Magical girls often have little mascots. These are cute creatures who don't reveal themselves to anyone except the magical girl herself. They offer comic relief, but can also help in defeating the bad guys.

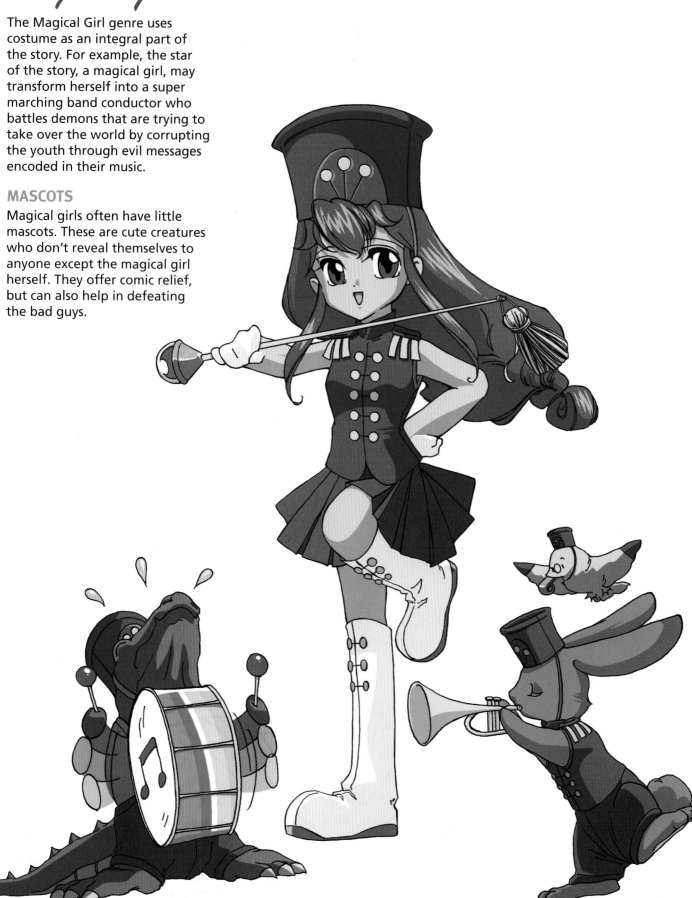

Nonhumans

Nonhumans run the gamut from cat people to elves, faeries, and even androids. They're popular and a lot of fun. They add novelty to a story and really stand out. Use them to inject a little visual spice.

Nonhumans are human-animal hybrids, but their costumes are always based on human clothing styles and character types.

CAT PEOPLE

Place furry cat ears and a tail on a cute bishoujo character and you've got a cat person. Sometimes, artists add tiny little fangs and claws as well, but these elements should be petite enough not to make the character look too feral and, therefore, unattractive. Cat people look more like humans than they do cats, but they retain more of their cat instincts. For example, they like to drink milk, curl up on the couch, and chase after a ball of yarn.

ANDROIDS

Only a few visual hints may be needed to indicate that a character is indeed a machine. The trend is to keep these characters looking much more human than robotic. They have incredible strength but one drawback: they've got to go for an oil change every so often. But seriously, if they don't recharge, they run out of juice and it's curtains for them. Also, if a single small part is damaged or lost, all of an android's programming can get corrupted.

ELVES

There are many different styles of elf ears, but all of them are pointy. This is an example of oversized ears. Some sort of jewelry on the forehead is an indicator of magic. The hair should be long and flowing. Note the difference between elves and faeries: faeries can also have wings, whereas elves do not.

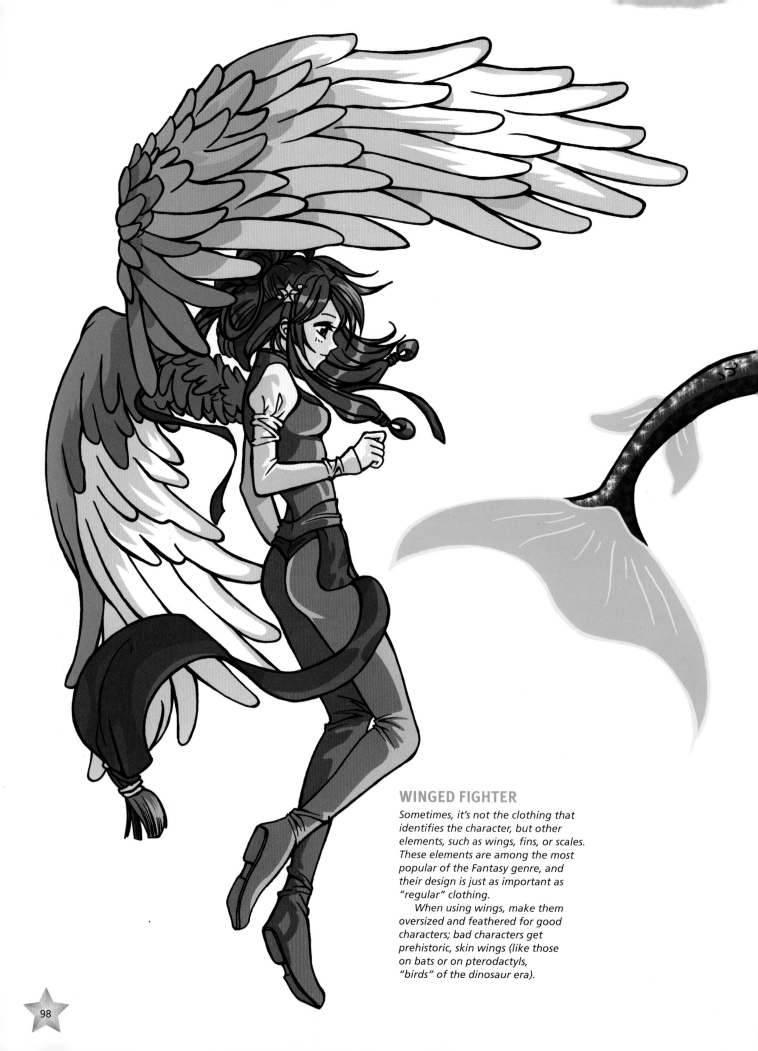

WINGED FIGHTER

Sometimes, it's not the clothing that identifies the character, but other elements, such as wings, fins, or scales. These elements are among the most popular of the Fantasy genre, and their design is just as important as "regular" clothing.

When using wings, make them oversized and feathered for good characters; bad characters get prehistoric, skin wings (like those on bats or on pterodactyls, "birds" of the dinosaur era).

MERMAID

Mermaids have a solid place in bishoujo. Their hair is always long and wavy as it moves with the gentle currents of the water. Note the seashell hair accessories that exploit the ocean theme.

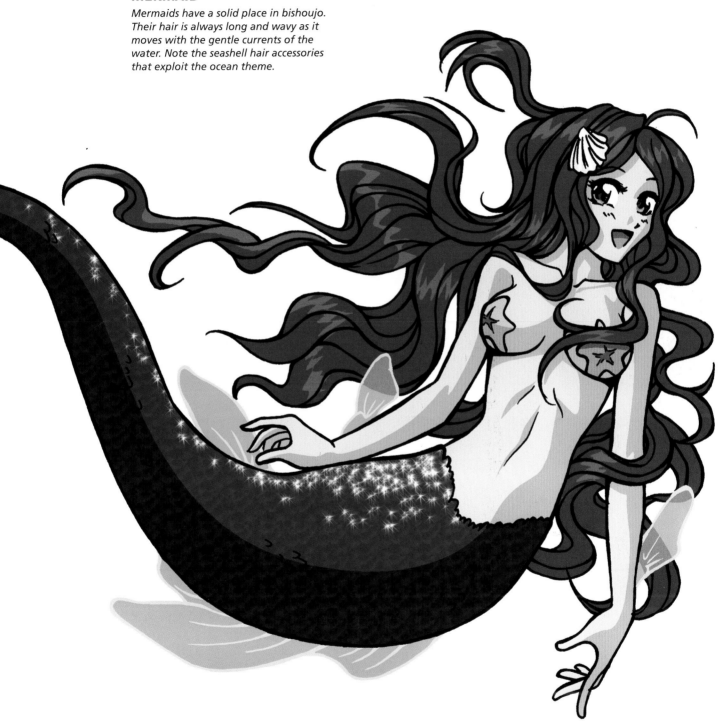

CHARACTERS IN COSTUME

This chapter outlines, step by step, just how to draw costumed characters, and also provides two different style and costume approaches to each character in order to show you just what you can do with clothes. You may favor one style over the other, or you may be able to put your own spin on a costume, turning it into something uniquely your own. It's almost always better to sketch out the underlying figures before adding the clothes. Pros adhere to this rule of thumb.

Futuristic Fighter

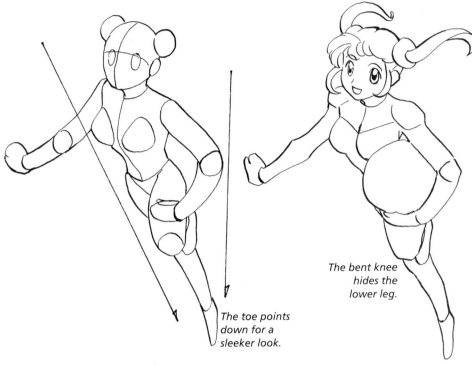

Block out the figure first, using this basic construction. Since she's coming toward the viewer, which is more dramatic than a neutral pose, her body must get smaller around the feet as the figure recedes.

The bent knee hides the lower leg.

The toe points down for a sleeker look.

VERSION 1 (SCI-FI)

She's a space pilot, perhaps even an on-board science officer. The long gloves, boots, and cape are gone. She wears an insignia on her chest and helmet that tells us she's part of the official space fleet. She would be more at home in a Sci-Fi manga than a Fantasy manga.

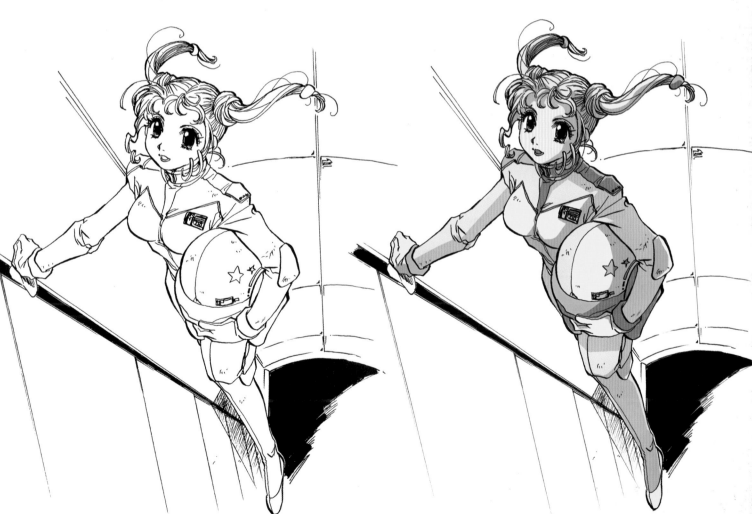

VERSION 2 (MEDIEVAL)

In manga, capes are more of a design element than a tool to show flying, as they are in American-style comics. It may be physically impossible, but having ponytails that are located above the helmet is a cool look—and if readers like it, they won't ask questions, so give it a try! Long gloves and high boots are frequent costume elements in Medieval-style futuristic stories.

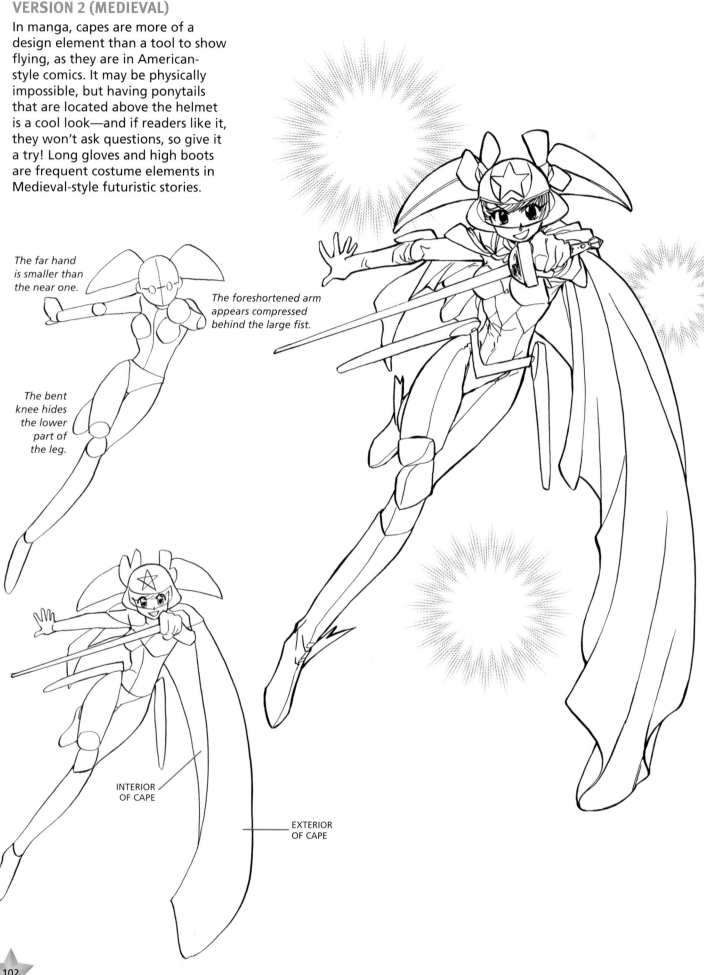

The far hand is smaller than the near one.

The foreshortened arm appears compressed behind the large fist.

The bent knee hides the lower part of the leg.

INTERIOR OF CAPE

EXTERIOR OF CAPE

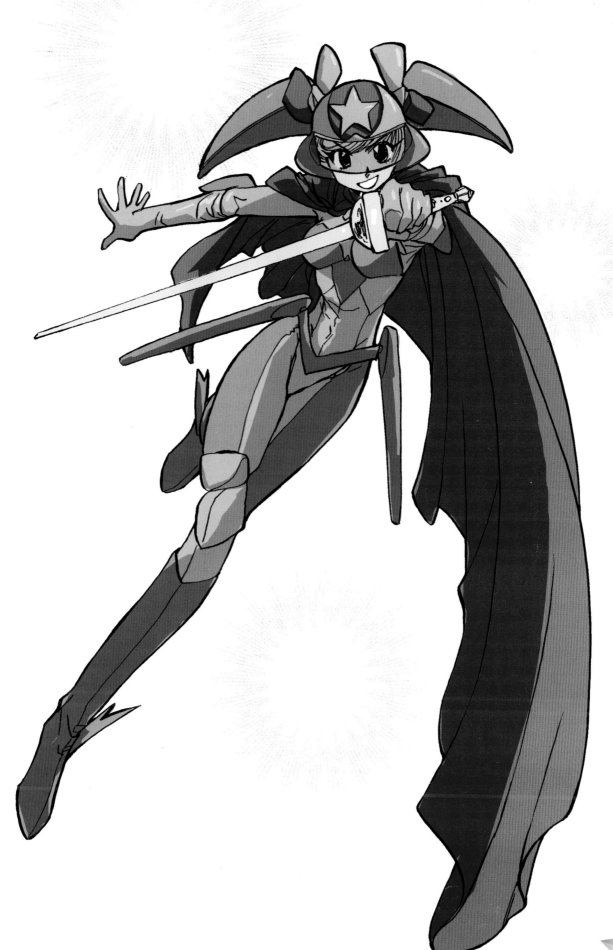

Elf Princess

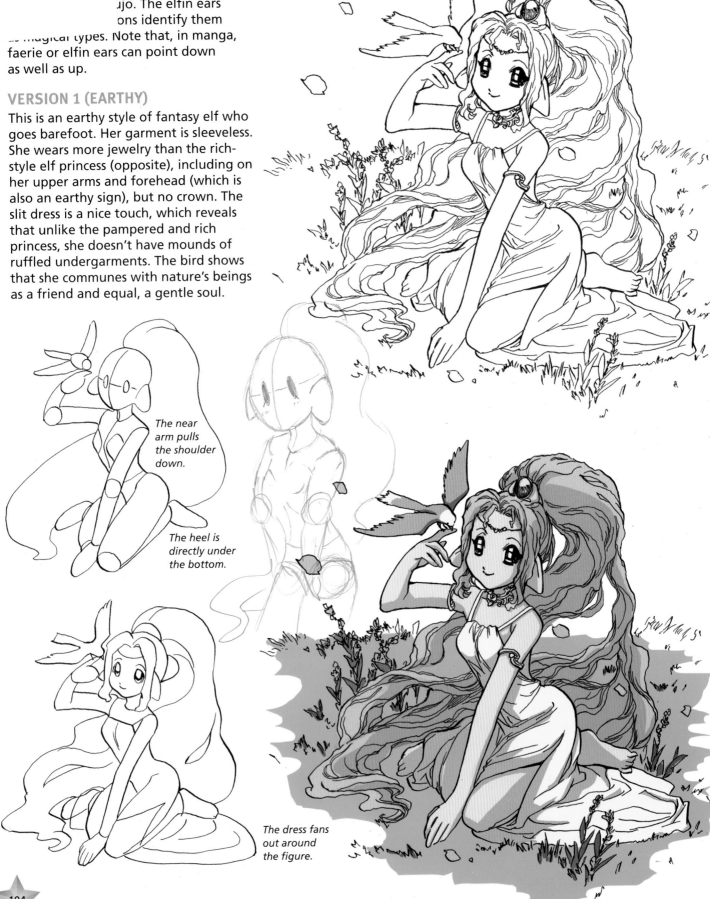

...ess is a favorite
...ujo. The elfin ears
...ons identify them
as magical types. Note that, in manga,
faerie or elfin ears can point down
as well as up.

VERSION 1 (EARTHY)

This is an earthy style of fantasy elf who
goes barefoot. Her garment is sleeveless.
She wears more jewelry than the rich-
style elf princess (opposite), including on
her upper arms and forehead (which is
also an earthy sign), but no crown. The
slit dress is a nice touch, which reveals
that unlike the pampered and rich
princess, she doesn't have mounds of
ruffled undergarments. The bird shows
that she communes with nature's beings
as a friend and equal, a gentle soul.

*The near
arm pulls
the shoulder
down.*

*The heel is
directly under
the bottom.*

*The dress fans
out around
the figure.*

VERSION 2 (RICH)

She wears a dramatically flowing or billowing dress that reveals the ruffles of the undergarments. The sleeves are long and also show ruffles. A princess never wears boots, but has dainty shoes instead. Note the amazing hair, ribbons, and petite crown that's almost a tiara.

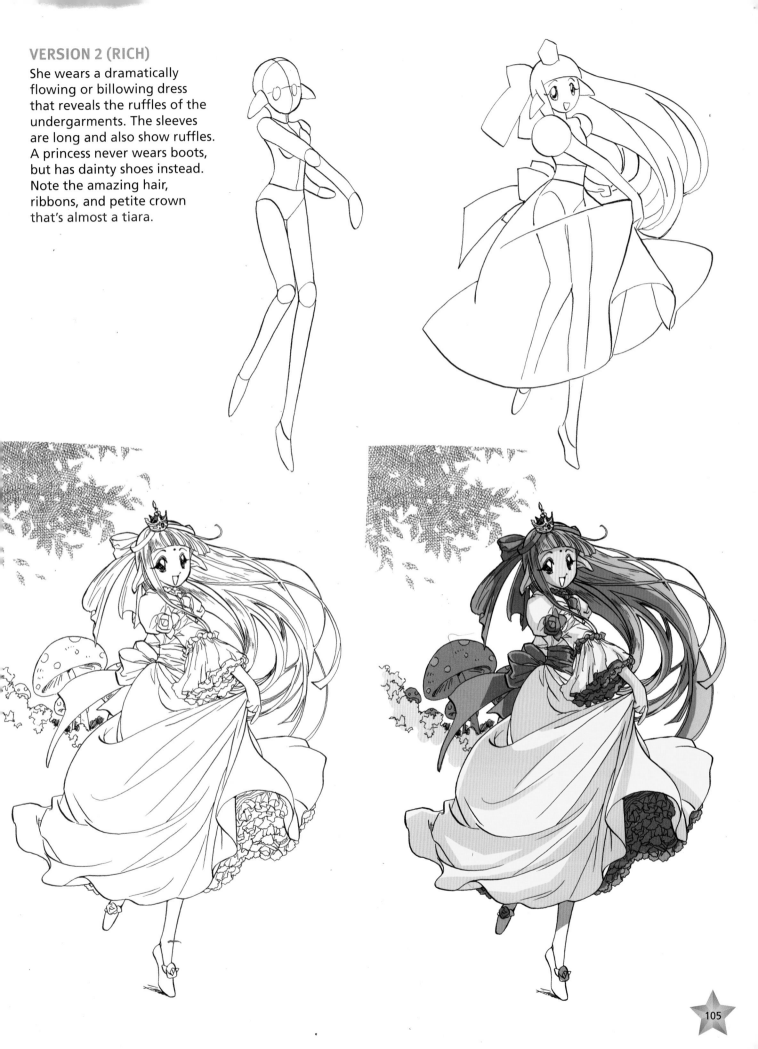

Traditional Figure

The design of traditional costumes is related to class structure. The higher the class, the finer the materials and the more ornate the dress.

VERSION 1 (COUNTRY)

The clothes are layered, but the fabric looks sturdy—nothing made of silk or anything too fine. The basket is a nice touch that indicates that she's doing chores, perhaps going to the local market. Another sign that she lives a simple life is her plain haircut.

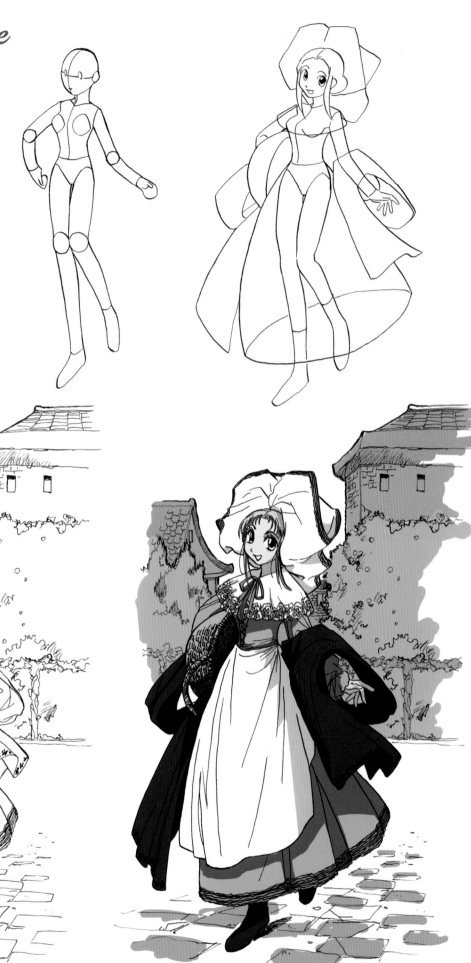

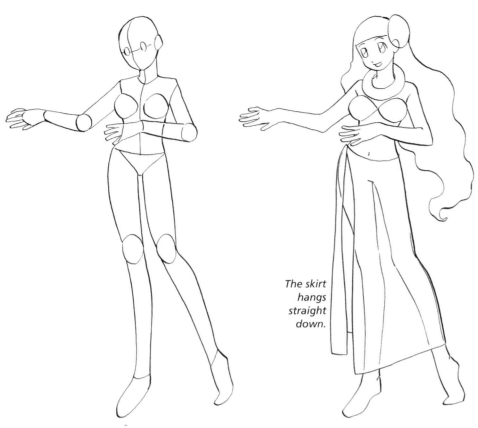

Typical tropical clothes are small tops combined with long skirts. Flowers are popular in Japanese comics, and this character wears a necklace of them (a *lei*) and one in her hair as well. This kind of character should have bare feet and an ankle bracelet, too.

The skirt hangs straight down.

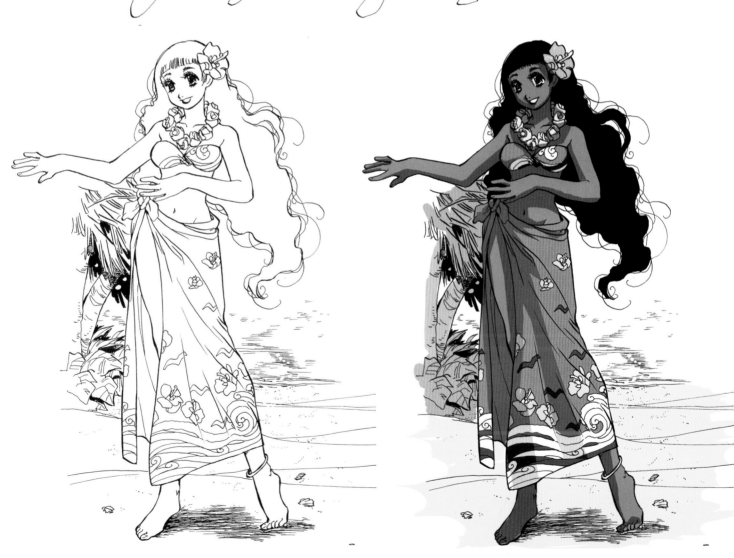

Athlete

Sports are a *big* part of Japanese culture and tradition. Uniforms are not flashy and are almost always traditional in look.

VERSION 1 (GYMNAST)

Athletic achievement combined with grace and beauty is what gymnastics are all about, and therefore, gymnasts make great characters for manga. The costume is easy. It's the swirls of handheld ribbon that provide the visual interest. Draw the ribbon in repeating spirals. The hair must be clipped back and neat. Long, flowing hair would interfere with the character's moves. Ponytails are the favored style.

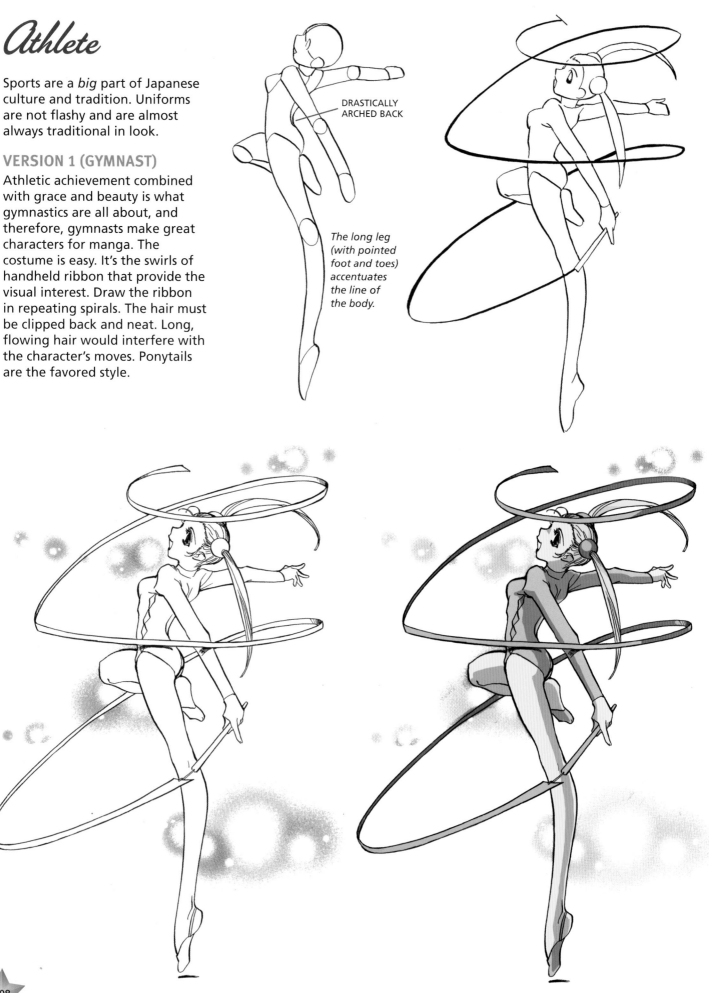

DRASTICALLY ARCHED BACK

The long leg (with pointed foot and toes) accentuates the line of the body.

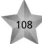

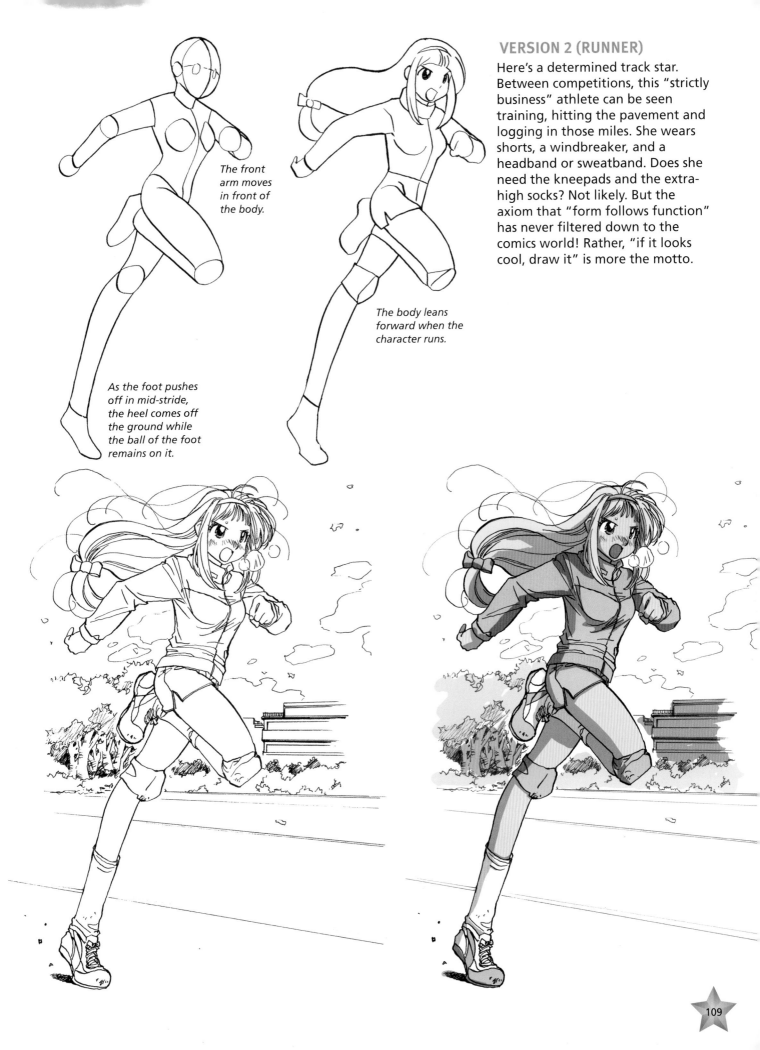

The front arm moves in front of the body.

As the foot pushes off in mid-stride, the heel comes off the ground while the ball of the foot remains on it.

The body leans forward when the character runs.

VERSION 2 (RUNNER)

Here's a determined track star. Between competitions, this "strictly business" athlete can be seen training, hitting the pavement and logging in those miles. She wears shorts, a windbreaker, and a headband or sweatband. Does she need the kneepads and the extra-high socks? Not likely. But the axiom that "form follows function" has never filtered down to the comics world! Rather, "if it looks cool, draw it" is more the motto.

Villainess

VERSION 1 (FANTASY)

Tall boots are a giveaway that she's in the Fantasy or Sci-Fi genre. But it's really the extreme ponytail and craggy tiara that put this villainess squarely into the Fantasy realm. She'd have to be wearing some kind of body armor (even if only a few shoulder pads) if she were to be a true Sci-Fi villain. The cutouts on the waist area of the outfit are a cool look—and a good alternative to straps. The double seam running down the front of the boots gives them a trendy look, and gloved hands are almost a requirement for villainesses. But it's the eyes—with their heavy-duty mascara treatment and slanting eyebrows—that really exude evil thoughts.

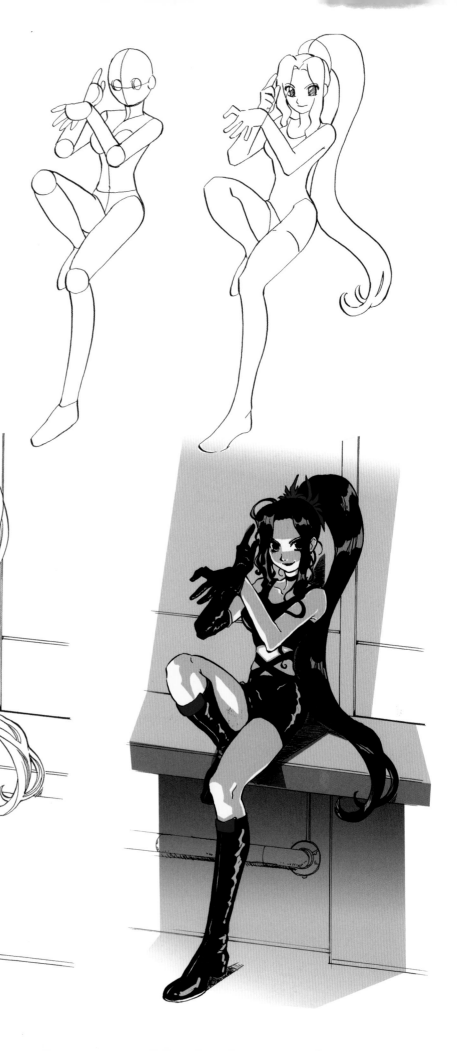

VERSION 2 (SCI-FI)

The full bodysuit typifies the assassin of the future. She has cool gadgets, too, like the earpiece and single-eye visor. Her hair is cut close in an extreme style. (*Note*: short hair is for Sci-Fi villainesses; long hair is for Fantasy villainesses.) In the Sci-Fi—as well as the Hard-Action—genre, female characters have narrow eyes that are longer horizontally than typical manga eyes. And just like the villainess opposite, gloves and boots are a must for this bad lady, too.

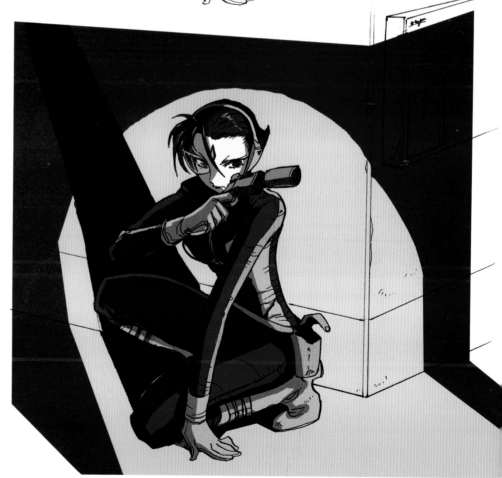

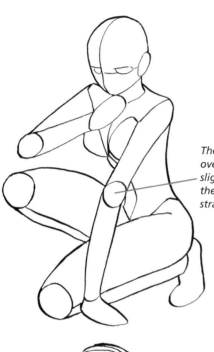

The elbow overextends slightly when the arm locks straight.

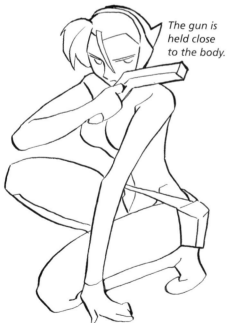

The gun is held close to the body.

Scientist

VERSION 1 (PRETTY)

Proper, seated characters sit with their backs arched and their feet tucked back under their chairs. The upper part of the outfit remains unaffected by the seated posture, but the bottom half bunches up and gets wrinkled.

Brainy characters often wear glasses in comics. And unfortunately for them, these are not cool lenses but large, rounded frames. Still, girls with glasses can be pretty. This lab technician looks pretty but is unaware of it. She has a long lab coat and wears her hair back so that there's nothing about her that could be considered sexually provocative. Plain shoes complete the look.

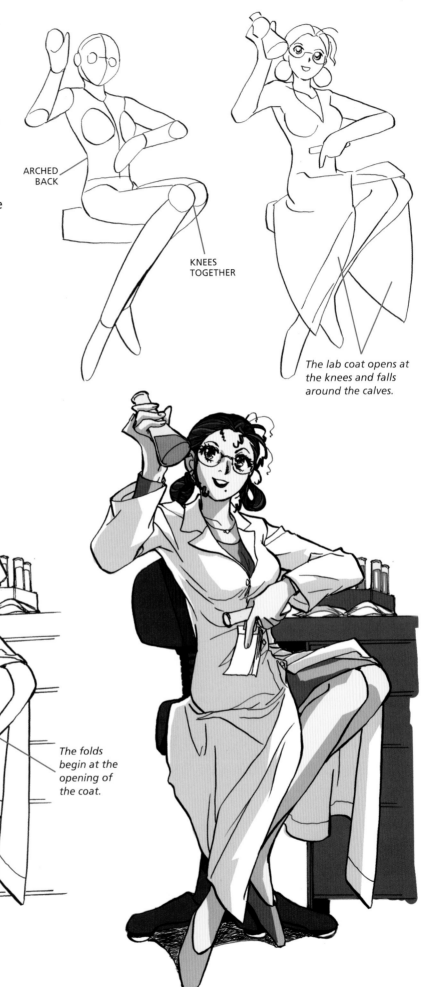

ARCHED BACK

KNEES TOGETHER

The lab coat opens at the knees and falls around the calves.

Sleeves are loose.

The folds begin at the opening of the coat.

The fabric tucks in under the bottom.

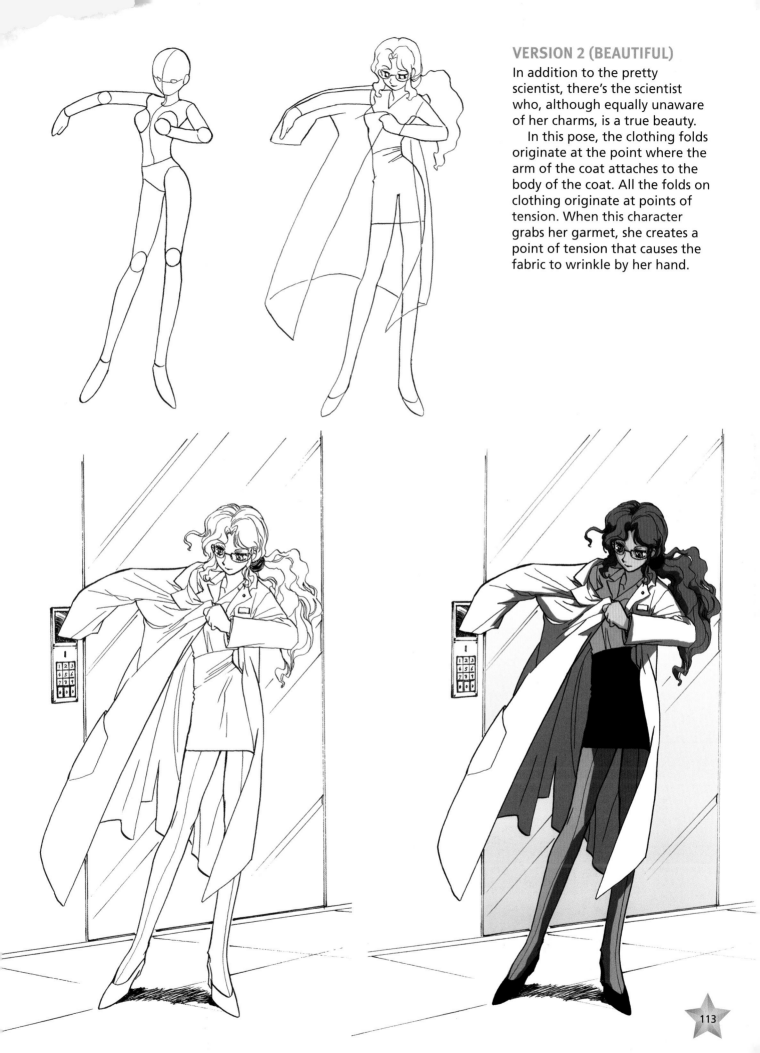

VERSION 2 (BEAUTIFUL)

In addition to the pretty scientist, there's the scientist who, although equally unaware of her charms, is a true beauty.

In this pose, the clothing folds originate at the point where the arm of the coat attaches to the body of the coat. All the folds on clothing originate at points of tension. When this character grabs her garmet, she creates a point of tension that causes the fabric to wrinkle by her hand.

Schoolgirls

A book on bishoujo would not be complete without information on how to draw character types based on what is arguably the most popular manga genre: Schoolgirl comics. Schoolgirls can be sweet or bratty, meek or heroic, ordinary or magical. In other words, they can be anything you want them to be! Teens and tweens love these characters because they relate to them. And through these idealized characters, the readers can see themselves triumph in romance, in social circles, and of course, in the never-ending battle against evil and demons!

In Japan, Schoolgirl comics are so popular, they're read by all ages and by both males and females. Remember, even though they're about girls, these stories offer plenty of compelling male costars, which broadens the appeal.

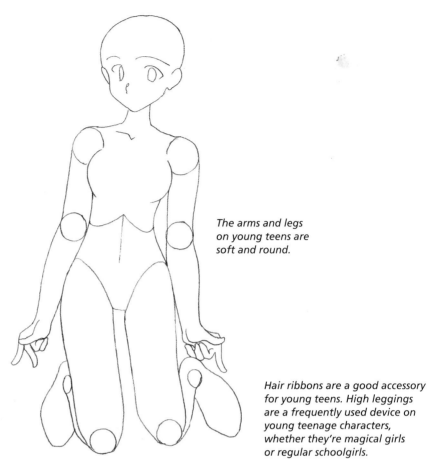

The arms and legs on young teens are soft and round.

Hair ribbons are a good accessory for young teens. High leggings are a frequently used device on young teenage characters, whether they're magical girls or regular schoolgirls.

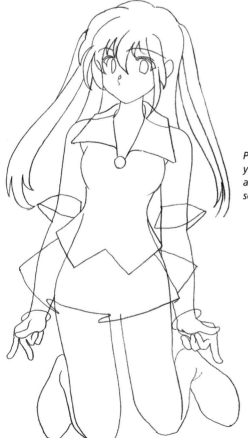

Ponytails create a youthful look and are popular on schoolgirls.

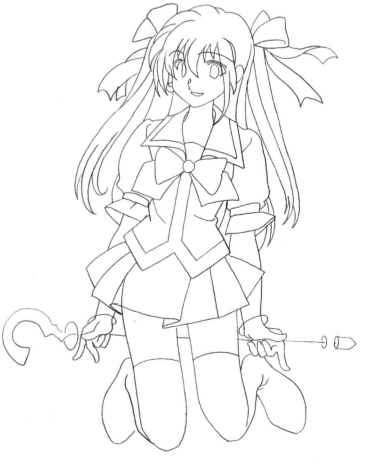

When drawing the Magical Girl type, it's important to base her outfit on the public school sailor-style uniform. But, create a super-elaborate version of it to place it in the Fantasy genre. For example, this character has flounces at the ends of her sleeves, a bow and a star on her jacket, and high boots. Fantasy characters always—always—have flowing, long hair. This character wears hers in long ponytails tied with fancy, oversized ribbons. To complete the look, she has a magical staff.

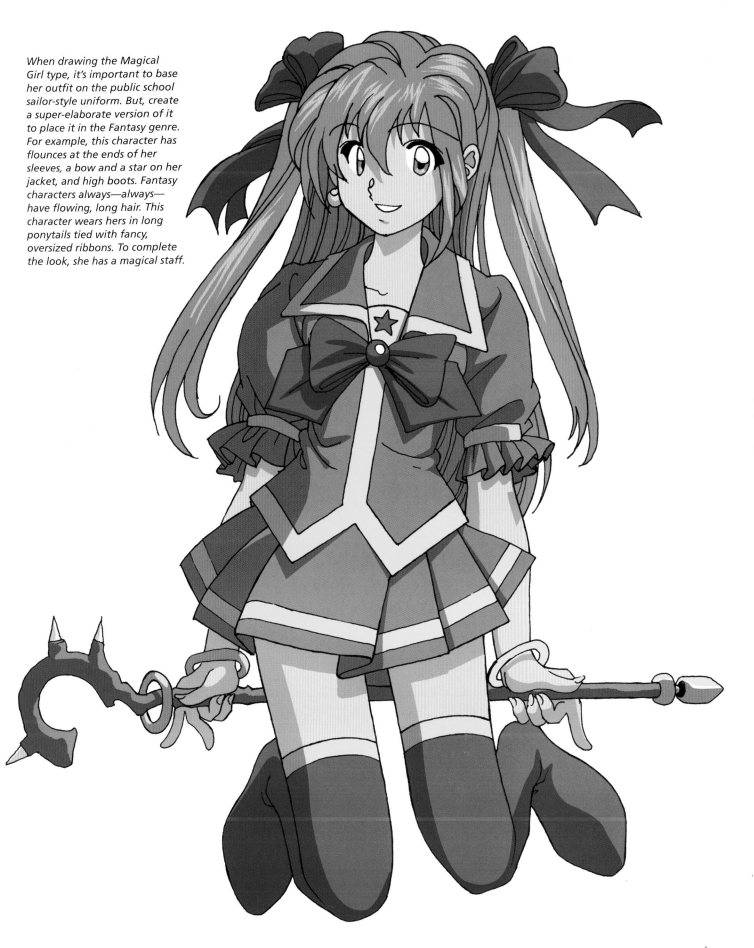

Other Popular Schoolgirl Types and Outfits

Of course, not every outfit a girl wears is designed to identify her as a character from a particular genre, such as Occult or Sports. But casual clothing must also be put together in an appealing way.

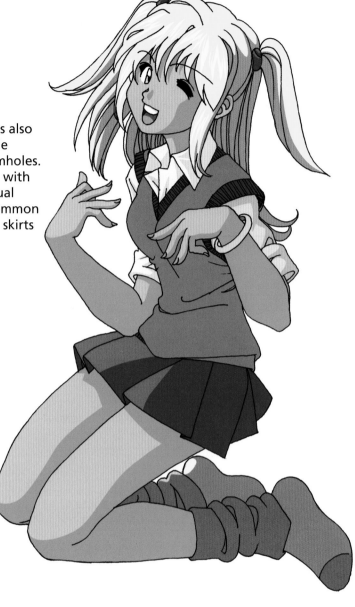

SWEATER-VEST OUTFIT
Instead of a jacket, a V-neck sweater-vest is also a good look for school uniforms. Put a little ribbing detail around the neckline and armholes. The schoolgirl can wear a long sleeve shirt with it or can roll up her sleeves for a more casual look. Pleated skirts are, by far, the most common look for schoolgirls in manga, followed by skirts with plaid patterns and sailor designs.

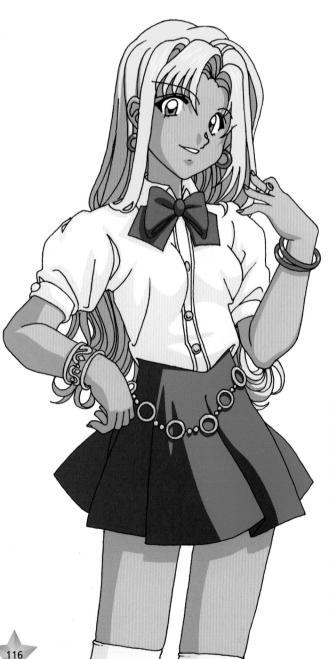

JACKETLESS
We often see schoolgirl uniforms that include jackets (for private school) or with sailor elements (for public school), but characters also appear without their jackets. For these occasions, avoid a plain white blouse. This one has puffed shoulders, short sleeves, and a bow at the collar. Schoolgirls in the same school all wear the same uniform. But that doesn't mean that they haven't cleverly figured out some ways to carve out their own identities. One way is to personalize their hairstyle. Another is to wear jewelry. This character, for example, wears two types of bracelets, a ring, hoop earrings, and a chain belt. This added glitz would be good for a lead character, who needs to stand out from the pack.

JACKET AND SWEATER

Combining a conservative jacket with a sweater-vest creates the formal look of the serious student. Large eyeglasses underscore this character type, as does the book she's holding. The shoes are appropriately conservative, and this points out how important it is to be consistent in your concept of the character when drawing the outfit. For example, if you generally like to draw flashy hairstyles or cool earrings, you should not do it on this character. Yes, it might look cool in a vacuum, but she would no longer be a well-conceived character. The reader wouldn't know which impression of her was correct: her conservative clothes or her extroverted flashy hair and jewelry. Strive for a clear, overall concept.

BUTTONED VEST WITH OPEN COLLAR AND TIE

This is an appealing look for a change of pace. It's a very authentic Japanese look. The menswear-style tie is a cool look, especially if it's worn loosely around an unbuttoned collar.

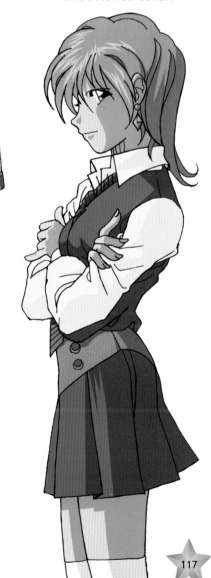

TOMBOY TYPE

No jewelry for her—that includes earrings. Often, she's athletic and can get herself into a few scrapes (note the bandage on the knee and the wrap on her forearm). A cool cap is a popular choice for pretty tomboy characters. This girl doesn't take the bus to school, preferring, instead, to race there on her Rollerblades, beating all of her school chums whose parents are stuck driving them in the morning traffic!

CREATING GLAMOUR

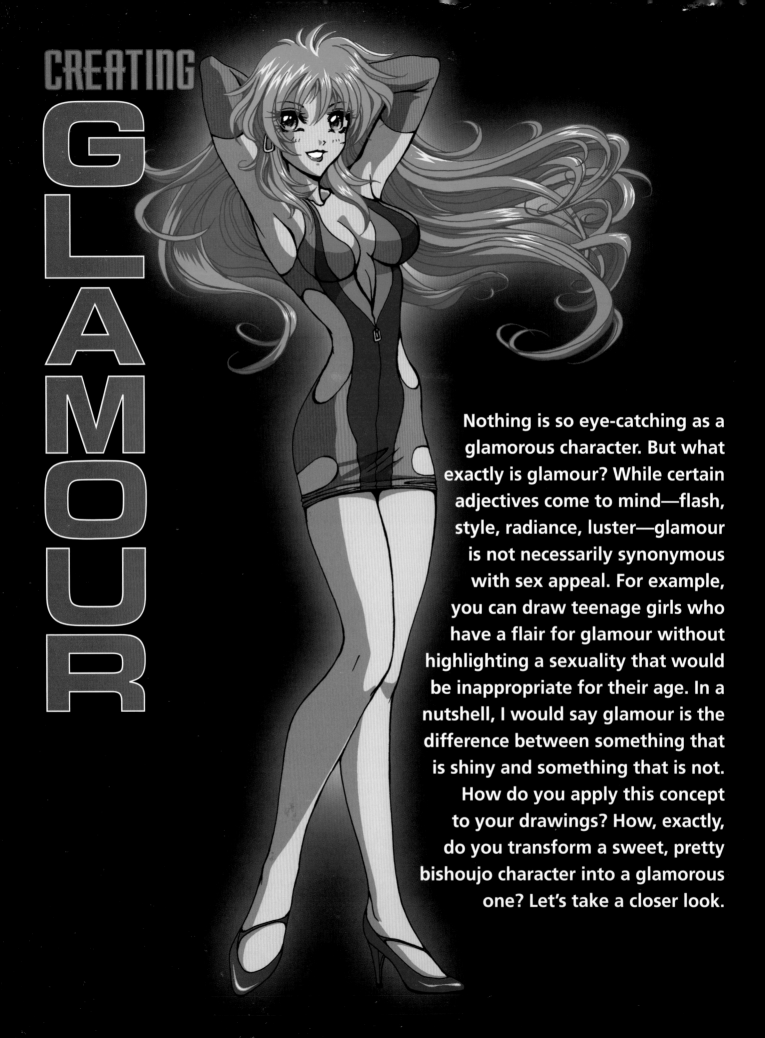

Nothing is so eye-catching as a glamorous character. But what exactly is glamour? While certain adjectives come to mind—flash, style, radiance, luster—glamour is not necessarily synonymous with sex appeal. For example, you can draw teenage girls who have a flair for glamour without highlighting a sexuality that would be inappropriate for their age. In a nutshell, I would say glamour is the difference between something that is shiny and something that is not. How do you apply this concept to your drawings? How, exactly, do you transform a sweet, pretty bishoujo character into a glamorous one? Let's take a closer look.

Glamour is in the details. You can easily turn a pleasant, plain character into a glamorous one by embellishing the eyes, lips, hair, posture, and costume. You don't have to start with an extravagant beauty. See? I've just made your life easier.

PLAIN

Nice, simple—but no head-turner.

BEAUTIFUL

The eyes are the focus of every manga face; but on a beautiful character, they must be especially radiant. Thicken the eyeliner (especially on the upper eyelid), as well as the eyelashes. Use light markings beneath the eyes, which make them stand out even more. The lips should have slightly heavier treatment, most notably becoming fuller (not wider) and showing a shadow under the lower lip. A slightly opened mouth is sexier than a tightly closed one. The nose remains the same—diminutive. And you need to give the hair more body, building up its size and letting it go wild.

PLAIN BODY VS. GLAMOROUS BODY

Compare this figure to the one on the opposite page. This is an average, nice-looking character that doesn't have enough charisma to captivate readers. You need to make changes in three main areas: posture, costume, and curves.

The figure opposite is not that drastically different, but the way she holds herself creates a dramatically new presence. Don't underestimate how important it is for a beautiful character to carry herself with confidence. In addition, note that attractive manga women are not built like American fashion models, who are skinny and usually on starvation diets. Manga women have curves. And while, yes, her curves are emphasized more here, the costume is also doing a lot of the work for her. And by the way, in case you haven't noticed, all beautiful manga women have great hair.

Glamorizing the Face

The larger you draw your character—in a close-up, for example—the more detail is required to maintain the reader's interest. When you draw something smaller, you try to simplify it so as not to clutter the image. Therefore, how do you add detail to a fairly simple girl's face in a close-up? By adding glamour.

In the full-length view, this girl is pretty. But in the close-up, a lot more detail has been added, and as a result, she's brilliant! What's the difference? The eyes have much more detail; specifically, the irises have been indicated with light, repeating lines. In addition, shines have been added to the pupils, causing them to glisten and appear moist. Because of the larger face size, the addition of extra eyelashes is now possible, and the eyelids have been darkened. Full lips have replaced the single line for the mouth, and blush lines have been added to the upper cheek areas. Lastly, the eyebrows have been given thickness, rather than being just lines.

A NOTE ABOUT PRETTY VS. GLAMOROUS CHARACTERS

Pretty, plain girls make great supporting characters, but for the main character—the star—whether she's bad or good, a glamorous character is hard to beat. The eye will naturally be drawn to her, and a certain excitement will surround her wherever she is in the story.

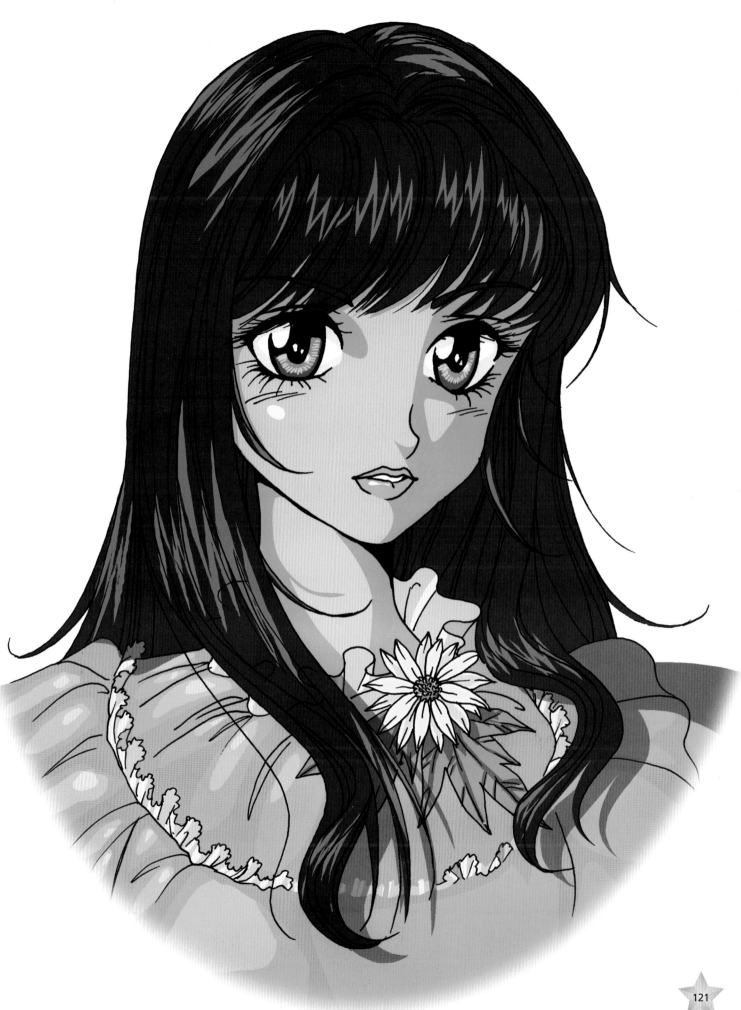

Adding Sex Appeal

The figure on the left starts out with an attractive pose, a shapely figure, and beautiful eyes. And although she is certainly stylish, she exudes no real glamour. But with only a few adjustments, her look can be retooled into one of glamour and sex appeal without changing one pencil stroke of her posture. First, the figure on the left is covered from head to toe, while the sexier figure on the right is not so hidden by her outfit. The wide cut of the lapels reveals a low-cut camisole top that mimics a bra. The sleeveless shirt and short skirt also reveal more of her shape. The shoes are minimal, revealing more of the foot. A sexier look is usually a more relaxed look; therefore, the figure on the right, with hair down and flowing, has more appeal. The full, darkened lips also add to the effect.

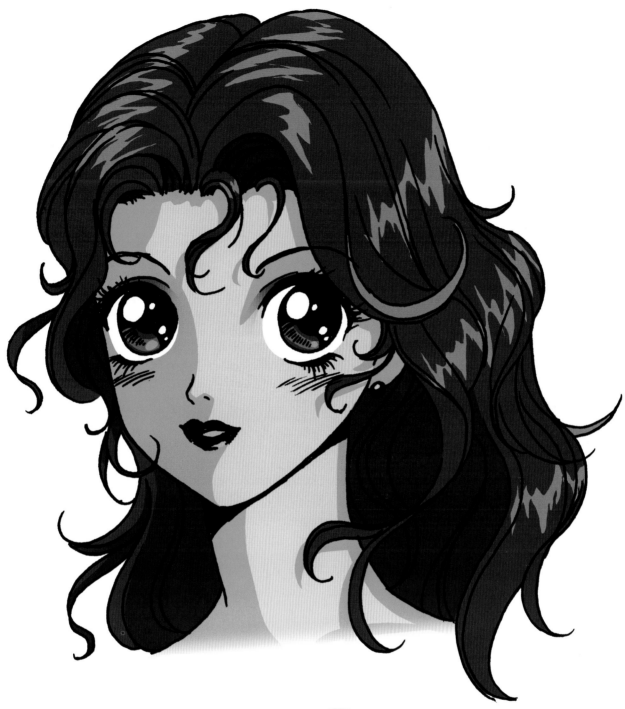

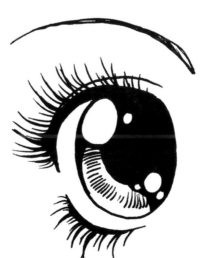

There's a large shine that falls into the upper part of the pupil area, and two smaller shines punctuate the lower part. The iris contains small, repeated lines. The upper part of the eye is a pool of black, which serves to mimic the shadow that naturally occurs under the eyelid, creating a sexy look.

Swimsuits

Swimsuits are common glamour attire. A full-body wet suit might keep her warmer, but it won't warm the readers as much as a bikini. In keeping with what we've covered so far in this section, when a female character has an attractive shape, it's more glamorous and appealing to reveal it, rather than to cover it up.

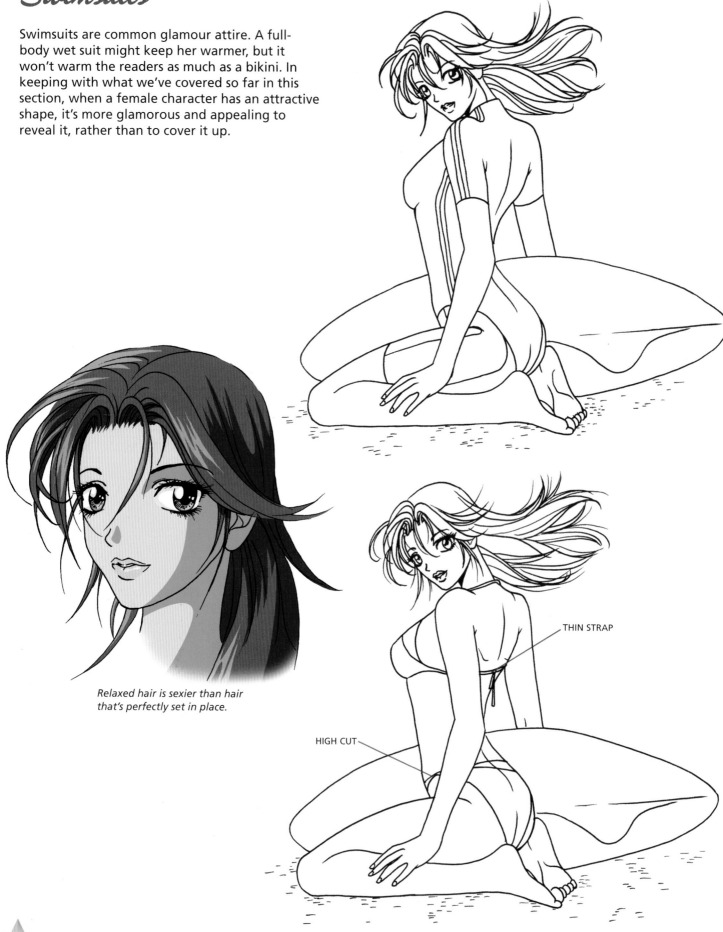

Relaxed hair is sexier than hair that's perfectly set in place.

THIN STRAP

HIGH CUT

The space suit on the left is basically a simple unitard. It's fine for its purpose, but it doesn't do much for the attractiveness of the character. It's so undefined and long that it turns the body into a large, bland area.

You need to add accessories in order to define various parts of the body, which will give the eye certain landmarks in order to help better digest such a long figure. Shoulder pads are always a good choice for space suits, as are forearm guards of any size. The waist-grip is a cool look for fighter pilots. And instead of drawing one long bodysuit, divide it into two pieces, resulting in high-cut leg openings.

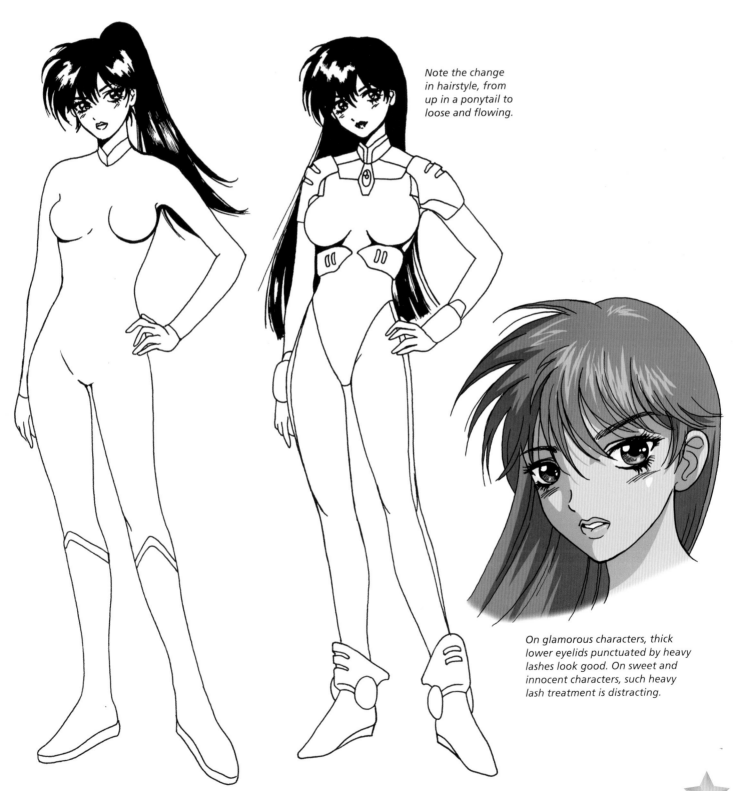

Note the change in hairstyle, from up in a ponytail to loose and flowing.

On glamorous characters, thick lower eyelids punctuated by heavy lashes look good. On sweet and innocent characters, such heavy lash treatment is distracting.

Elfin Glamour

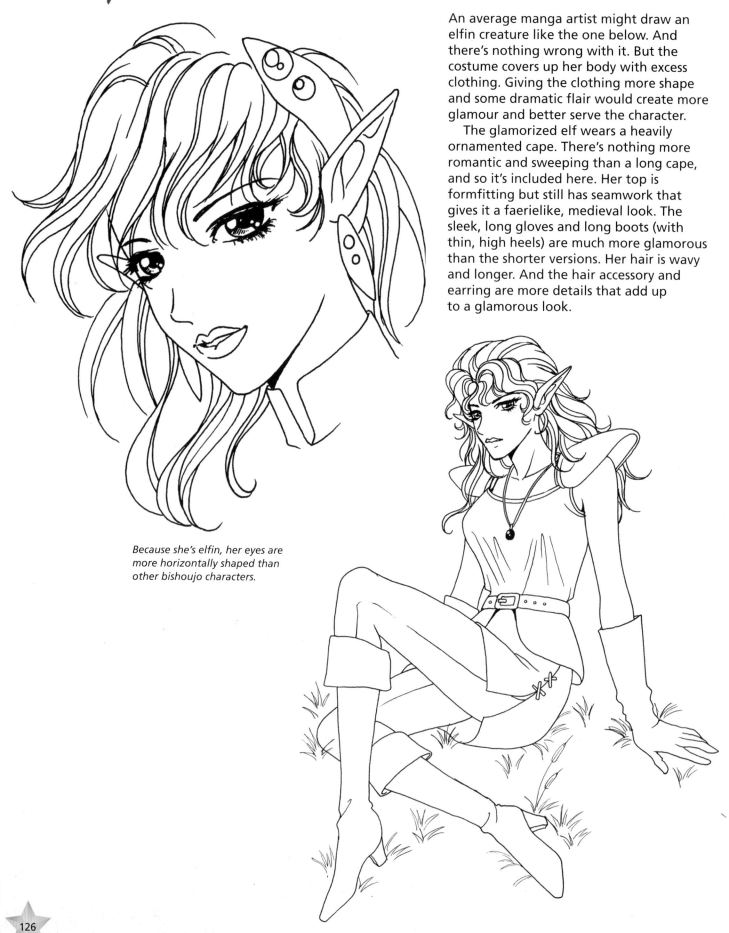

An average manga artist might draw an elfin creature like the one below. And there's nothing wrong with it. But the costume covers up her body with excess clothing. Giving the clothing more shape and some dramatic flair would create more glamour and better serve the character.

The glamorized elf wears a heavily ornamented cape. There's nothing more romantic and sweeping than a long cape, and so it's included here. Her top is formfitting but still has seamwork that gives it a faerielike, medieval look. The sleek, long gloves and long boots (with thin, high heels) are much more glamorous than the shorter versions. Her hair is wavy and longer. And the hair accessory and earring are more details that add up to a glamorous look.

Because she's elfin, her eyes are more horizontally shaped than other bishoujo characters.

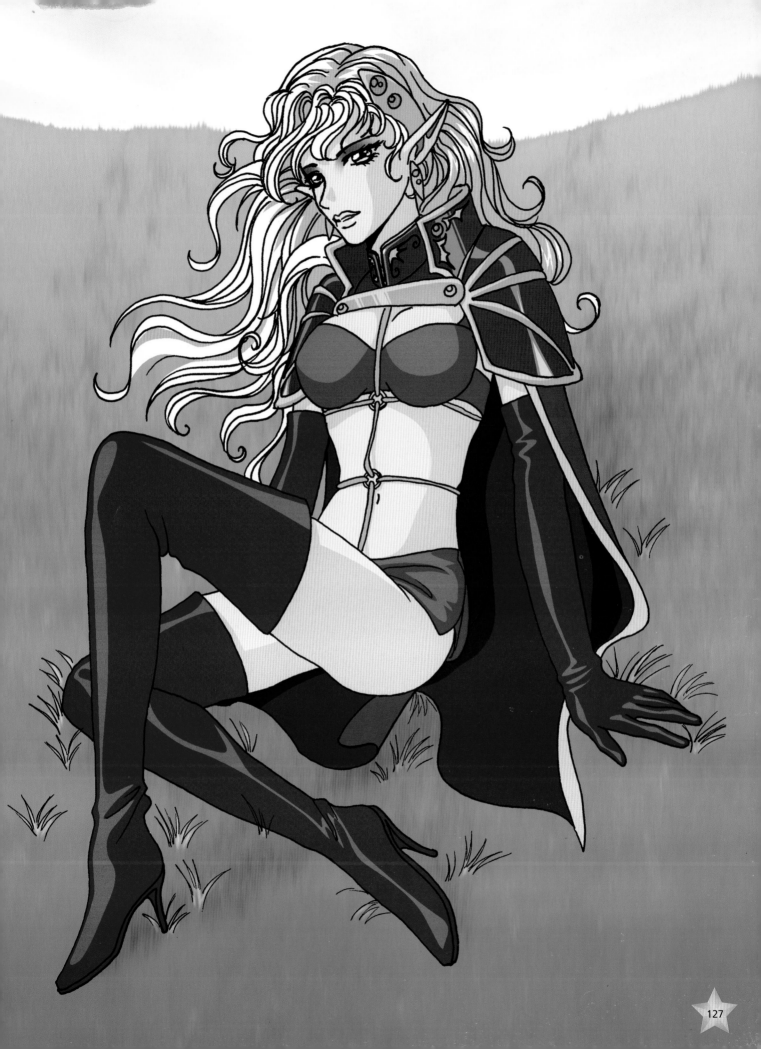

CREATING CHEMISTRY

When you create an attractive female lead character, readers expect that sparks will fly between her and a story's leading man. There should be romantic tension, giving the story an underlying edge and a subtext to a lot of the dialogue. Comic books are primarily a visual medium, and so this magnetic attraction must be effectively communicated by your drawings. How do you show something that is just a feeling between two people? That's what we're going to find out.

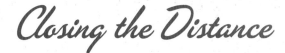

Closing the Distance

Eye contact (see page 130) certainly helps when trying to communicate the attraction between two people. But sometimes, two people who like each other try not to look at each other, for fear of being too obvious. And eye contact alone can't sustain that heat across numerous sequential panels. No, there's more to it than that—a lot more.

Attraction is like gravity, the closer two objects are to each other, the stronger the pull. Two characters sharing a park bench for a chat won't ignite any sparks if they're too far away from each other. But closer together, the chemistry starts to happen. So, before you worry about eye contact, pay attention to the distance between your characters.

Eye Contact

Now that your characters are closer together, have them lock eyes. This brings the romantic tension up a notch. A deep stare, straight into each other's eyes, creates the most riveting, intimate moments. It helps to put them on the same wavelength, emotionally, and to establish a bond between them.

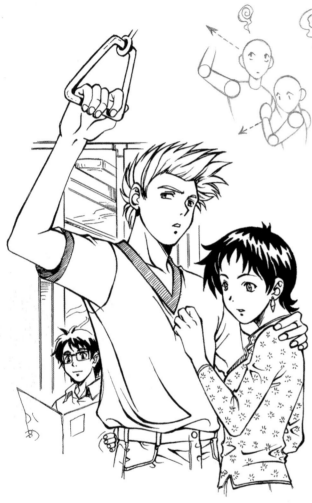

INEFFECTIVE
Here, the couple looks off in opposite directions. There's no connection.

EFFECTIVE
Here, the couple turns toward each other so that you can see the chemistry between them.

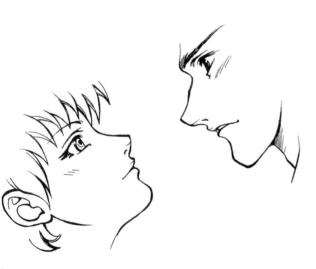

Eye Contact and Character Positioning

Making eye contact doesn't require two characters to face each other, especially if it's an initial meeting. It's more inventive—and more natural—for people to initiate eye contact without committing themselves overtly. After all, if a boy is rebuffed, he would want to regain his dignity; and he wouldn't be able to do that if he walked up to a girl and stared straight at her. There must be some hesitancy, either from him or her. And that should show in the oblique way you position the characters in relation to one another.

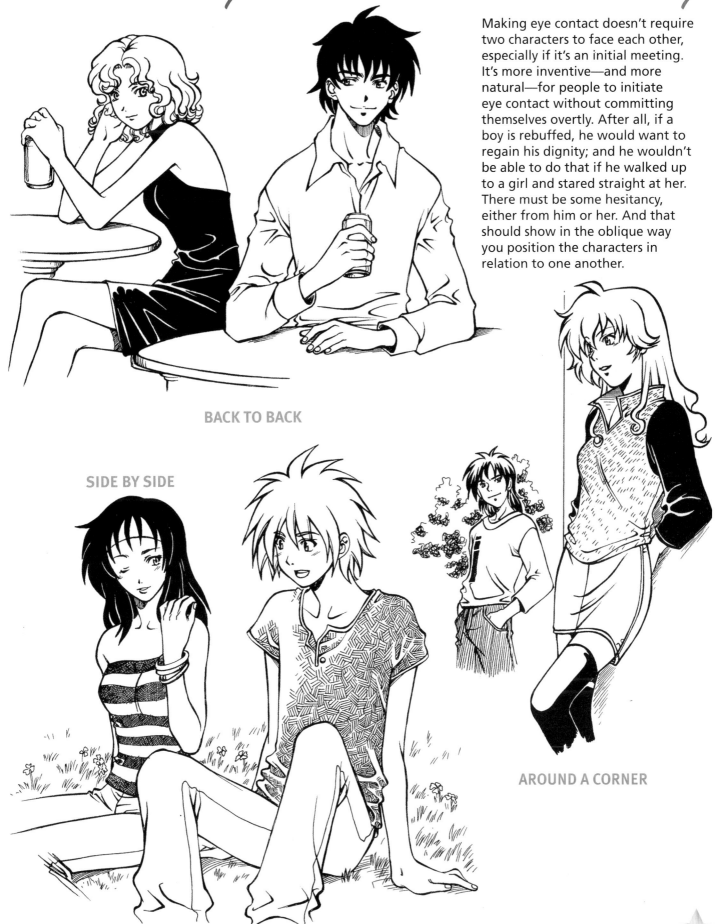

BACK TO BACK

SIDE BY SIDE

AROUND A CORNER

Touching

There are many ways that you can signify your characters' romantic attraction to each other by touching. Not all touch is meant to be overtly intimate. Sometimes, it's just a sign of affection. Here are a few prime examples of displays of affection that do not stop the story in its tracks.

CARESSING THE HAIR

HUG FROM BEHIND

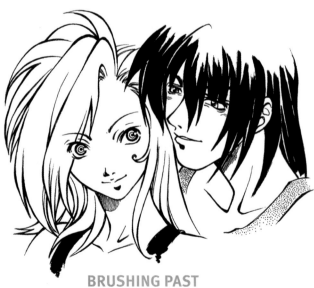

BRUSHING PAST

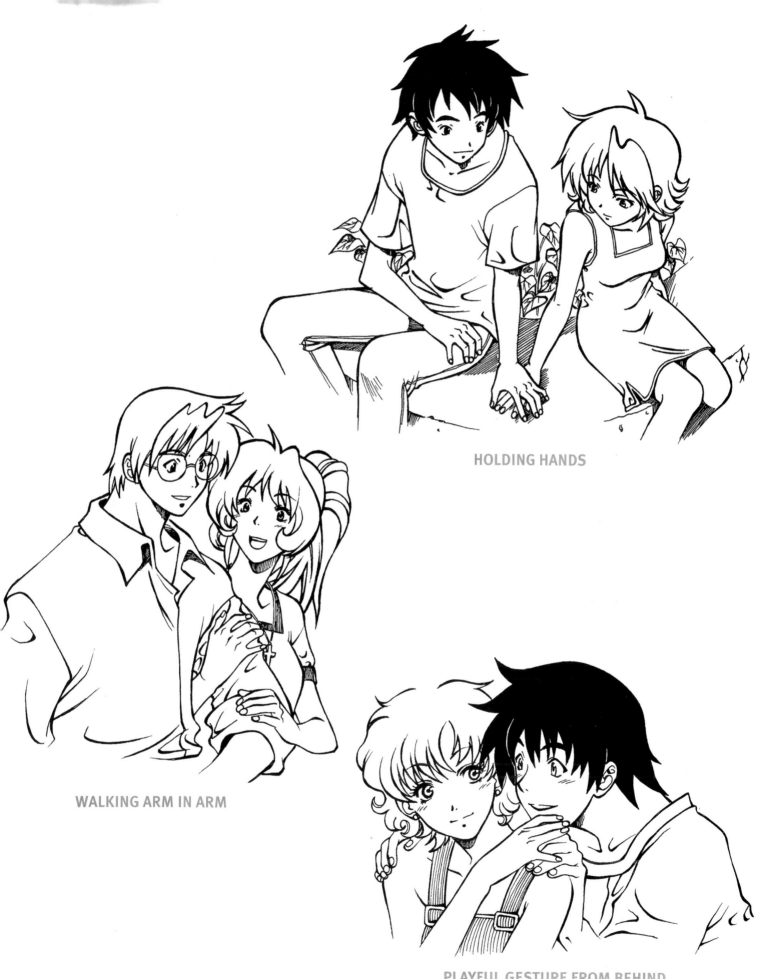

HOLDING HANDS

WALKING ARM IN ARM

PLAYFUL GESTURE FROM BEHIND

The Kiss

To draw an effective kiss, you need to have the faces overlap each other, with noses side by side. The eyes must be shut. If one character has an eye open, they will read as a person who is deceiving his or her lover (which can also be an effective gesture). When two characters kiss, they must also embrace each other and be close together. There should be no space between them. Creating a height difference between the characters makes the image more dramatic than if they were both the same height. Generally, the man (being the taller of the two) tilts his head down, while the woman tilts her head up, creating a long line for the neck, an attractive position for female leads.

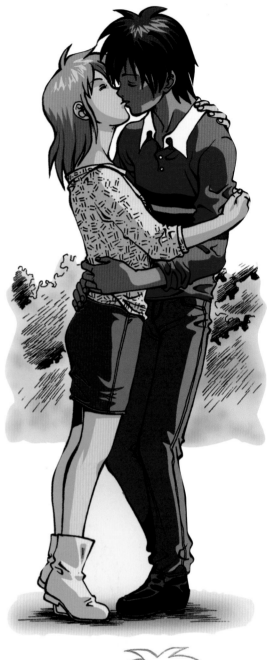

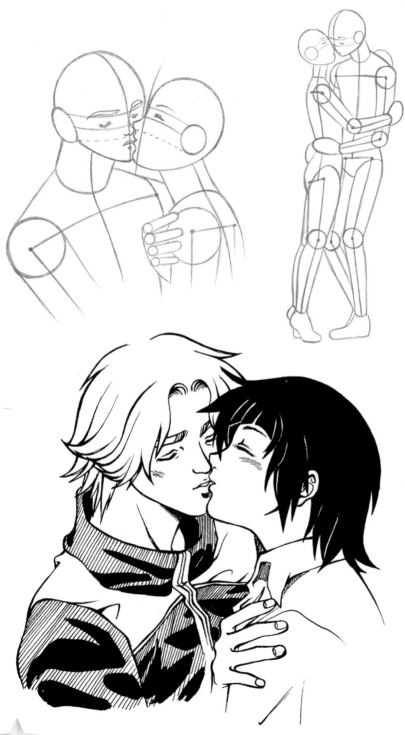

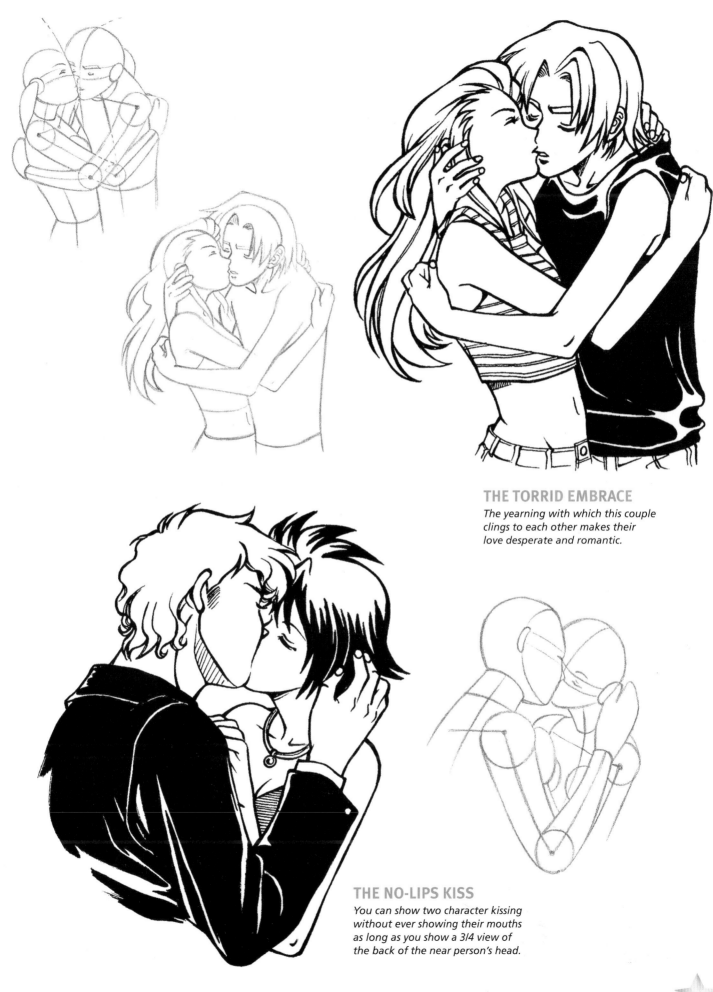

THE TORRID EMBRACE

The yearning with which this couple clings to each other makes their love desperate and romantic.

THE NO-LIPS KISS

You can show two character kissing without ever showing their mouths as long as you show a 3/4 view of the back of the near person's head.

135

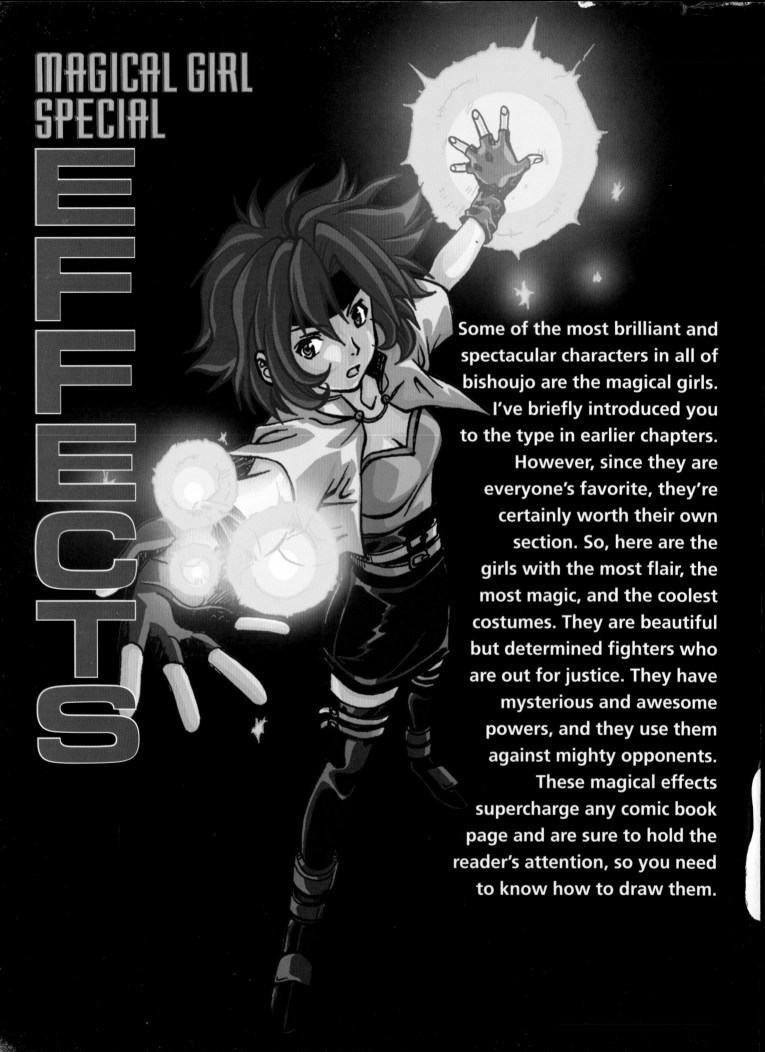

MAGICAL GIRL SPECIAL EFFECTS

Some of the most brilliant and spectacular characters in all of bishoujo are the magical girls. I've briefly introduced you to the type in earlier chapters. However, since they are everyone's favorite, they're certainly worth their own section. So, here are the girls with the most flair, the most magic, and the coolest costumes. They are beautiful but determined fighters who are out for justice. They have mysterious and awesome powers, and they use them against mighty opponents. These magical effects supercharge any comic book page and are sure to hold the reader's attention, so you need to know how to draw them.

Cool Magic Effects

There are as many types of magical effects as there are people with imaginations. Some have become so popular that they're eagerly anticipated by loyal readers. Let's put a few of them into your drawing arsenal.

ELECTRICAL STORM

When she flies off to bring justice to a world in chaos, her powers are sometimes so great that they set off electrical charges around her, like wakes that follow a boat cutting through the water. This is a very cool look, and I would urge you to use it in your drawings of magical girls.

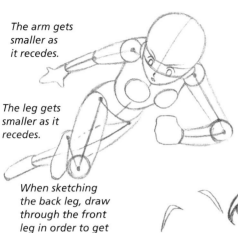

The arm gets smaller as it recedes.

The leg gets smaller as it recedes.

When sketching the back leg, draw through the front leg in order to get the correct position.

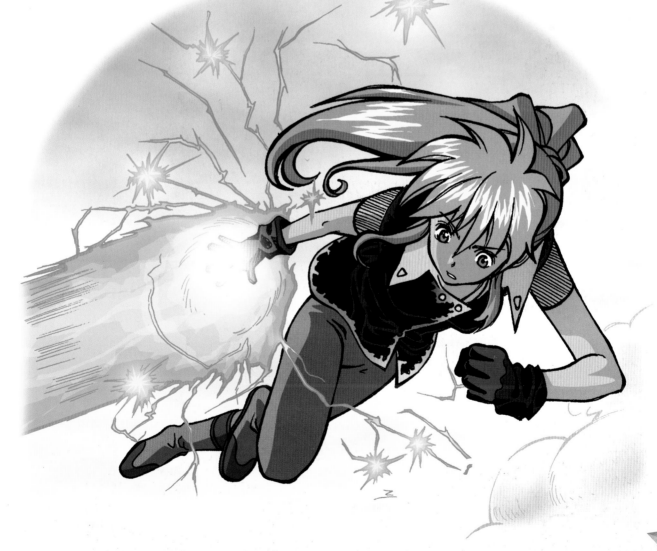

Manipulating Natural Forces

Magical girls can use their powers to direct the very forces of nature, even causing major storms if necessary. (But they still have trouble cleaning their rooms. Hey, they're still teenagers, after all!)

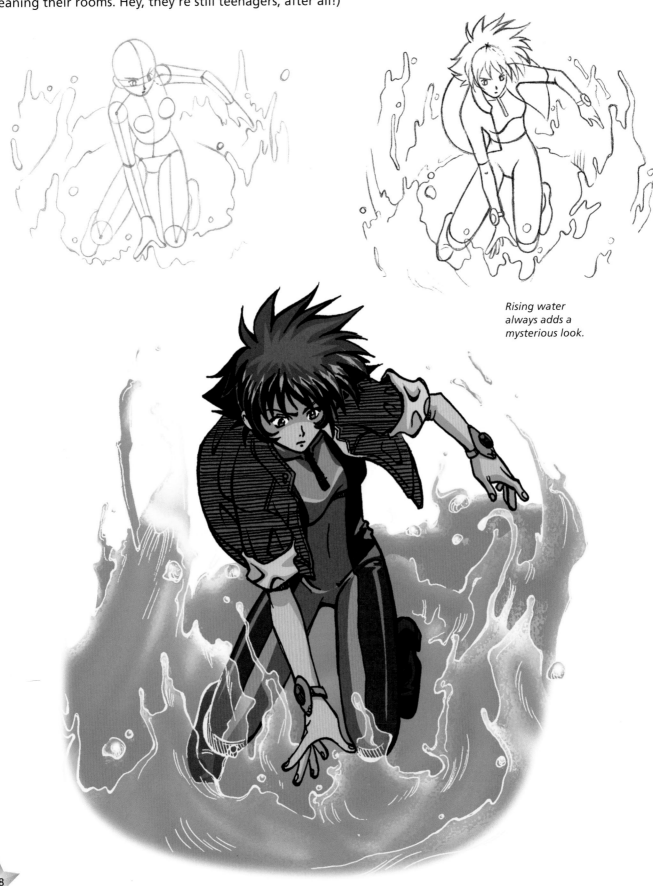

Rising water always adds a mysterious look.

Her magical ring supplies all the power she needs, but only she knows how to make it work. Her costume is reminiscent of the public school sailor uniform, but it's styled for an Action heroine. Note the long ponytail. . . so long, in fact, that it takes two bands to hold it! The forearm guards and boots are part of all Action characters' outfits. (I think it's in their union's charter.) The open skirt reveals spandexlike shorts, spandex being a favorite material of Action characters. And the flowing quality of the skirt adds the dramatic flair that a cape otherwise would, without being too cumbersome or overwhelming.

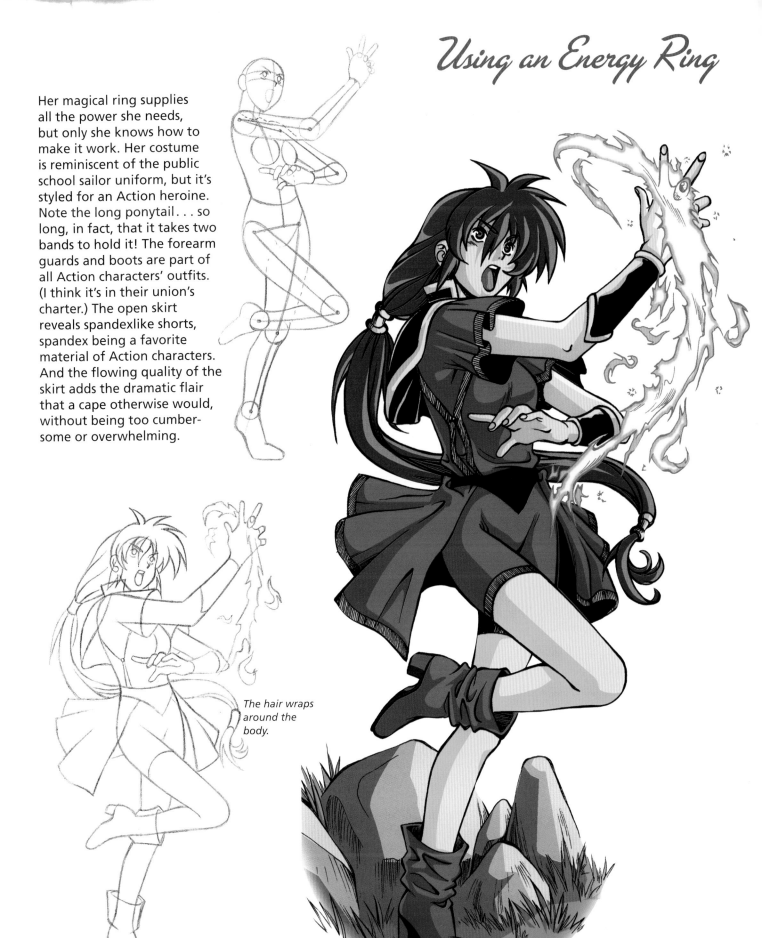

The hair wraps around the body.

Creating Matter

When giving shape and form to matter, start with glows and bubbles of effervescent energy. Little sparkles of energy should crackle all around these bubbles, as if the process of creating were filling the air with static electricity.

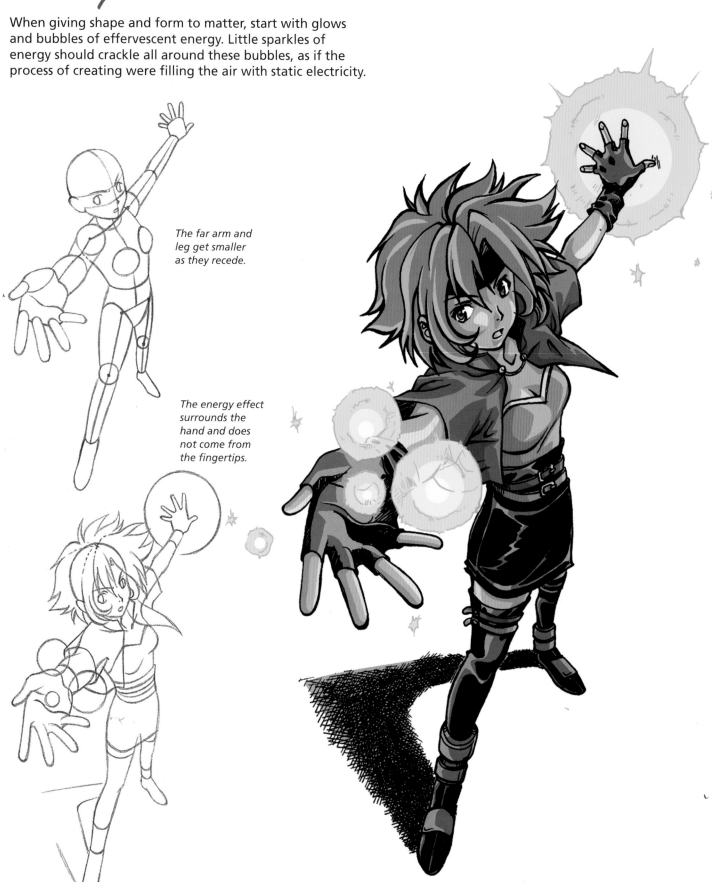

The far arm and leg get smaller as they recede.

The energy effect surrounds the hand and does not come from the fingertips.

Making Storms

Want to know what the weather will be like? Ask her. You don't want to get her ticked off if you're planning a picnic. When she summons a powerful storm to wreak havoc upon her enemies, the storm always brings darkness of night, thunder, wind, and rain. Always place her at the center of the storm, and make it surround her. (It's not dramatic to have her summon a storm far away where we can't see it.) Therefore, you must show the effects of the storm on her by having her hair and clothing flap violently.

Forces of nature swirl upward; they never rise in a straight line.

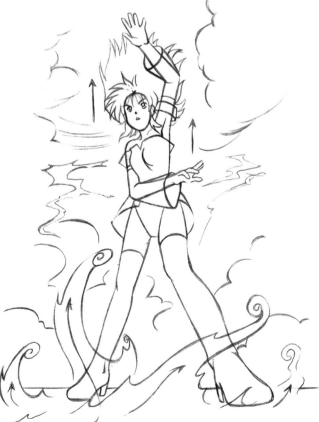

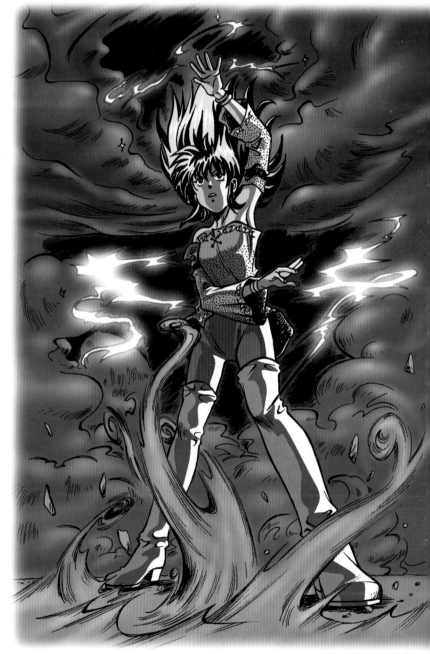

Making Fire

You can try keeping the matches away from her, but it won't help. She has a talent, one might say. To make fire, she whips her hand in an arc around her body, creating a circle of flames. The circle of flames is a very strong, ancient motif that is embedded in fantasy culture. When a bishoujo character brings her power to life—whether it be the ability to make fire, lightning, water, or wind—you shouldn't make it look too easy. That would rob the event of its dramatic element. It should look as if it takes real work to pull this off. This concept has its basis in Greek mythology. The ancient Greek gods were said to have become tired after using their powers, and they would retire to their domains to rest and become renewed. As you can see from her pose, she's using effort and skill, crouching down to release the flames.

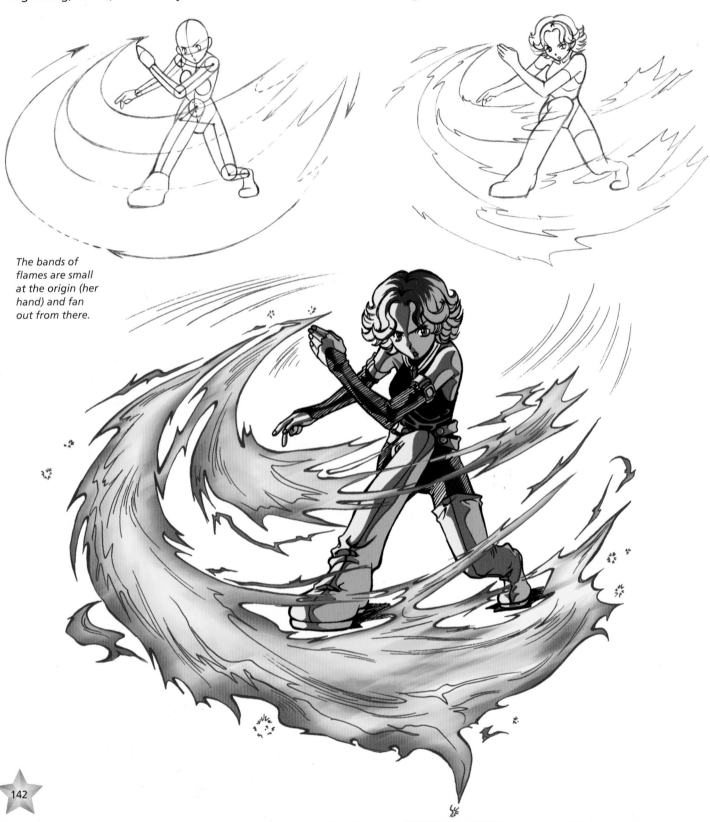

The bands of flames are small at the origin (her hand) and fan out from there.

Flairs of energy radiate from the bursts.

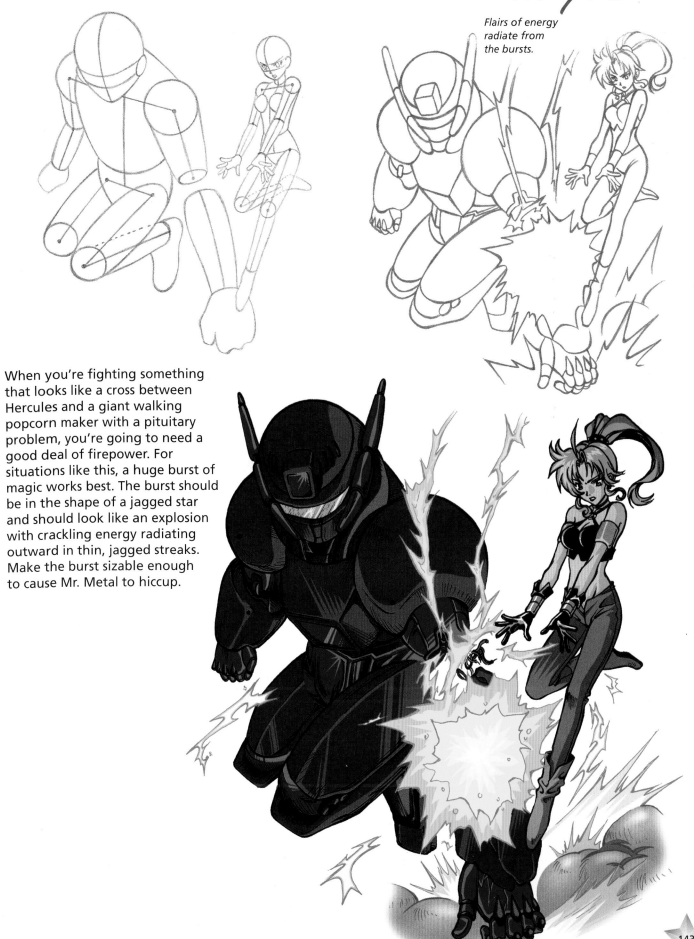

When you're fighting something that looks like a cross between Hercules and a giant walking popcorn maker with a pituitary problem, you're going to need a good deal of firepower. For situations like this, a huge burst of magic works best. The burst should be in the shape of a jagged star and should look like an explosion with crackling energy radiating outward in thin, jagged streaks. Make the burst sizable enough to cause Mr. Metal to hiccup.

INDEX